The Icon Handbook

THE ICON HANDBOOK

*A Guide to Understanding Icons and the
Liturgy, Symbols and Practices of the
Russian Orthodox Church*

David Coomler

Templegate Publishers
Springfield, Illinois

ISBN 0-87243-210-6

Library of Congress Catalog Card Number 95–60055

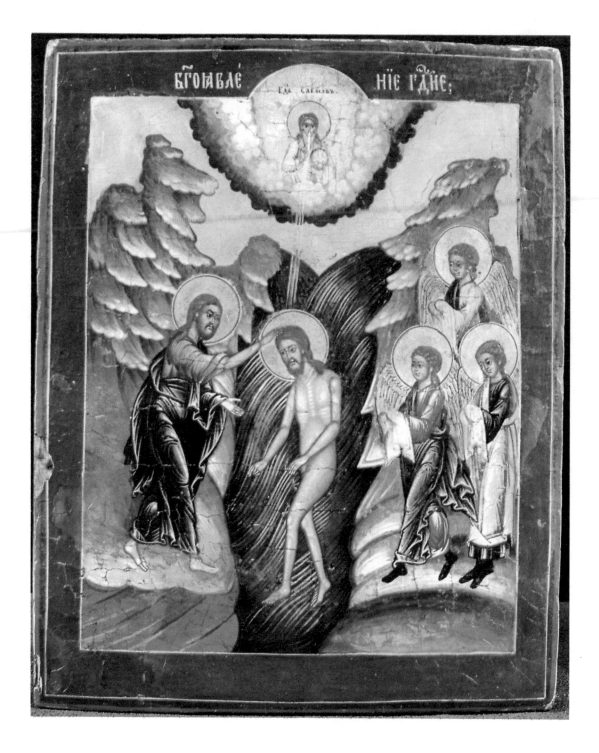

Contents

Preface

This book is for those interested in Russian icons but puzzled by the often unfamiliar subjects and mysterious inscriptions. The reader who becomes familiar with its contents should be able both to identify the majority of icon types encountered and to read the names of previously unidentifiable saints.

Icons were produced by Eastern Orthodox believers in a number of countries, but in Russia the art reached its pinnacle of complexity and beauty. "Russia" is used here in its broadest historical sense, meaning all areas once included in the Tsarist "Empire of All the Russias."

Most of the illustrations are line drawings or *prorisi* from old books printed in Russia before the Revolution. Though often faded, foxed and worn, they are a great treasury of authentic iconography. Some come ultimately from early guides for painters such as the *Siya Icon-painting Manual* that takes its name from the Antoniy Siyskiy Monastery, and the *Stroganov Icon-painting Manual,* named for a wealthy family whose name is also given to the distinctive Stroganov style. The latter book is a hand-written manuscript with drawings of saints and fixed festivals accompanied by terse descriptions such as this for the Holy Fool Isidor, commemorated on May 14th:

> *"On the same day Isidor the Fool,*
> *fair, robe* sankir *[ochre-black].*

Contrast that with the description for the same saint given in one non-illustrated, handwritten manual:

> *"The Holy, Blessed Isidor the Fool for Christ's Sake, Wonderworker*
> *of Rostov; Fair, beard of Nikita the Martyr, much hair, right shoulder*
> *bare, in the hand a cross, robe in ochre/reddish-black. One leg bare,*
> *and in the Kiev pages Isidor is young."*

Other illustrations in this book, many faded and indistinct, come from some of the many works published by icon researchers near the end of the 19th Century, when Russia began to rediscover its ancient heritage of Orthodox art. Some of the great names of that time are Kondakov, Filimonov, Buslaev, Pokrovskiy, and of course the Uspenskiys, whose books of line drawings were prepared from old icons in prominent collections. In some of the line drawings of the icons you will observe that the positions of the figures have occasionally been reversed in the copying of these 19th Century plates. At that time the study of icons was often viewed as a form of archeology, which

shows how far the intelligentsia of Russian society had become removed from the still-living icon painting traditions of less "sophisticated" folk.

Use this book as a foundation for further research. Add your own informational discoveries to it. Copy down "new" inscriptions, and sketch or photograph unfamiliar types you find elsewhere. Carefully examine icons wherever and whenever you can. Soon you will find that this book has helped to make you something of a minor "expert" in Russian iconography.

PART ONE
THE TRINITY, FESTIVALS, AND SAINTS

THE OLD TESTAMENT TRINITY I *p. 30*

Three Angels seated at a table; in the background a tree; buildings on the left, a hill on the right; with these simple elements Russian iconography symbolically depicts the Trinity as the three angels who appeared to the Patriarch (praotets*)* Abraham at the Oak of Mamre, as recorded in chapter 18 of the book of Genesis.

Russians generally do not distinguish the three persons of the Trinity in this type by inscription, though some understand them thus: Christ at center, above whom is the tree, signifying the wood of the Cross; the Father at left, before a building symbolizing the Church; the Holy Spirit on the right, below a hill signifying spiritual ascent. But such detailed interpretation is somewhat fanciful and misleading; hills, buildings, and trees are found in icons of many types.

Some early examples give the central angel the specific cross-halo of Christ the Son, a practice forbidden by the Stoglav Council in the 16th century. The Stoglav Council also specified that the correct title for the type is, as written here, SVYATAYA TROITSA, "The Holy Trinity." It is abbreviated on the illustration as S T A YA T R o TS A. The curved lines above each word indicate abbreviation. The o of TROITSA is written under the abbreviation sign.

This type is often used to represent Pentecost (Trinity Sunday) in icons of the twelve major festal days of the year.

THE OLD TESTAMENT TRINITY II *p. 31*

This "Old Testament Trinity" is more influenced by the art of Western Europe than the preceding example. The usual three angels are in the center, but Abraham has been added on the left and his wife Sarah on the right, as well as a servant (note the absence of a halo) slaying a calf.

The background buildings look like a fairy-tale castle (remember, Abraham lived in a tent!), and the hill on the right is no longer so stylized.

Added scenes illustrate other related events in the life of the Forefather (Russian praotets) Abraham. At upper left he bows before the three arriving angels; at lower left he washes the dust from their feet; at middle right he watches the angels depart; at lower right an angel comes to Abraham, Sarah, and their newborn son Isaac; at upper right Abraham takes his son to the mountain of sacrifice. Beside that is the final scene, in which the Angel of the Lord appears and stops the sacrifice just as Abraham puts the knife to the throat of Isaac. The addition of such secondary scenes to the main image became popular after Western influence seeped into Russia. It is called "combined representation" (slozhnuiy perevod), to distinguish it from the traditional practice of adding related scenes in squares about the outer edges of the central image. The "Old Testament Trinity" is the only Church-approved Trinity pattern, but others were also used.

THE NEW TESTAMENT TRINITY I *p. 32*

This Holy Trinity pattern was officially unacceptable, but is nonetheless very common in icons of both State Church believers and of the Old Believers who separated from the State Church after the liturgical revisions of Patriarch Nikon in the mid-17th century.

God the Father is the venerable old white-bearded fellow on the left; painting him in the form of a man was condemned by the Seventh Ecumenical Council and forbidden by the Council of Moscow in 1666. The eight-pointed design in his halo symbolizes the six days of Creation, the seventh day on which God rested, and the eighth day, the Day of Eternity.

Christ is seated beside the Father, holding the Gospels. His distinctive halo has the beams of the cross inscribed with the Greek letters OMICRON OMEGA-NU, spelling HO ON, "Who Is," the Greek form of the name of God translated in the King James Version as "I Am That I Am."

Other inscriptions are, on the Father: O TS = OTETS, "The Father"; GD SAVf = GOSPOD SAVVAOF (i.e. SAVAOF), "Lord Sabaoth."

On the Son: SN = SUIN, "The Son"; IC XC = IISUS KHRISTOS (State Church form) or ISUS KHRISTOS (Old Believer form), "Jesus Christ" (Greek form I[esou]S KH[risto]S).

Father and Son hold a starry globe symbolizing the cosmos. It is surmounted by the traditional Russian "eight-pointed" cross. Above them the Holy spirit appears as a dove in an eight-pointed halo called a slava, meaning "glory."

THE NEW TESTAMENT TRINITY II *p. 33*

This version is more stylized and complex than the preceding example. In the center are the persons of the Trinity — God the Father with his eight pointed slava, God the Son with his cross-halo, and the Holy Spirit in the form of a dove (looking like a pigeon, which gave rise to an inordinate respect for pigeons among the peasantry). Father and Son are seated on six-winged seraphim, and fiery winged wheels called "thrones" are beneath their feet.

In the four points of the star on which the central circle is set are the symbols of the Four Evangelists — Matthew (angel), Mark (eagle), Luke (winged ox), and John (winged lion). In this example each evangelist is shown in human form as well, standing beside his symbol.

The image is surrounded by heavenly clouds; angels are gathered at the top. The cross, spear, and sponge on a reed (between Father and Son) recall the Crucifixion of Christ.

Many contemporary Orthodox (like some earlier theologians) consider the depiction of the Holy Spirit as a dove inappropriate in any icon except that of the "Theophany,"

the Baptism of Christ. The biblical account justifies it only in that instance. Nonetheless the dove set in an eight-pointed star has been widespread in Russian iconography for centuries and remains in common use today.

THE NEW TESTAMENT TRINITY "AMONG THE POWERS" *p. 34*

The "New Testament Trinity" is in the center. At left on the surrounding ring is Mary, called the Mother of God. At right is John the Forerunner (Baptist). The ring is filled with six-winged Seraphim (usually painted red). In the four points of the star are the symbols of the Four Evangelists. The angel is Matthew, the winged lion St. John, the Eagle is St. Mark, and the winged ox is St. Luke. Sometimes, however, the Western system is followed. The lion then becomes St. Mark and the eagle St. John. Inscriptions generally indicate which system is used.

The winged, fiery wheels beneath the feet of the Trinity are a rank of angel called "Thrones."

The "Powers" among which the Trinity is set are the ranks of angels as listed in The Celestial Hierarchy of (Pseudo-) Dionysius the Areopagite. In this image they are the "Seraphim" already mentioned, and at the base are four-winged "Cherubim" (usually painted blue); those at upper right, wearing crowns and holding sceptres, are "Authorities"; those at center right, holding censers, are "Dominions"; those at bottom right, dressed as warriors with swords, are "Powers"; those at center left, robed like bishops, are a variant of "Thrones"; the others, not clearly distinguished in this pattern, comprise the remaining "Angels," "Archangels," and "Principalities."

THE FATHERHOOD *p. 35*

This type, called Otechestvo, is sometimes also titled "The Paternity" in English. It represents the Father as an old man seated on Seraphim, with fiery winged wheels beneath his feet. His halo bears the eight-pointed "glory" (slava) signifying the Day of Eternity.

Christ Immanuel is seated on the Father's lap. He has the characteristic cross in his halo. Both Father and Son hold out their hands in blessing.

The four outer points of the image contain the symbols of the Four Evangelists.

The inscription beside God the Father is GD SAVAOF = GOSPOD SAVAOF, "Lord Sabaoth."

The Holy Spirit as a dove in an eight-pointed slava is set on the Father's breast.

Icons of the "New Testament" Trinity are also sometimes titled Otechestvo, (see "The New Testament Trinity" entry), but to avoid confusion that title is best restricted to the type illustrated here.

In addition to images of the "Old Testament Trinity," the "New Testament Trinity," and the "Fatherhood," one sometimes encounters icons (often from the southern

Ukrainian border regions) depicting the Trinity as a bearded man with three faces on one head — three beards, three mouths, three noses, and four eyes. These remarkable images, found also in the West, were frowned on by the Church but illustrate the problems many had with the complex Trinity concept of three persons in one God.

THE FATHERHOOD WITH THE NINE RANKS OF ANGELS *p. 36*

The Father in the central "Fatherhood" is identified as GD BG SAVAOF = GOSPOD BOG SAVAOF, "Lord God of Armies/Hosts." Six-winged Seraphim are beneath his feet instead of the usual fiery rings. The top inscription is OBRAZ SVYATUIKH DEVETI CHINOV ANGELSKHIKH, "The Image of the Holy Nine Ranks of Angels."

In the outer edges are the nine ranks of angels, with "Archangels" at bottom left, "Thrones" at center left, "Dominions" at upper left, and Cherubim (Kheruvim) at top left. At right are "Angels" at the base, "Powers" at center, "Authorities" at upper right, and "Seraphim" (Serafim) at top right. The symbols of the Four Evangelists are in four rays below the central circle.

The double circle contains the "Guardian Angel" (Angel Khranitel)" at bottom with spread wings. He is a generic figure representing the angel guarding each believer, and is found as a secondary figure on many icons as well as having icons devoted especially to him. Moving clockwise, next is the Archangel Yegudiel (Egudiil); then the Archangel Uriel (Uriil), the Archangel Gabriel (Gavriil), the Archangel Michael (Mikhail), the Archangel Raphael (Rafail), the Archangel Selaphiel (Selafiil), and the Archangel Barachiel (Varakhiil). These seven are considered to be the "seven holy angels" of Tobit 12:15 and the "seven angels who stand before God" of Revelation 8:2.

ON THE SEVENTH DAY GOD RESTED *p. 37*

God the Father rests on a bed in Heaven after six days of creating the world. Around him are angels, the Holy Spirit as a dove, and (in the small circle) Mary with the Christ Child.

The Father is shown again on the right (this pattern is reversed), leaning out toward the "Angel of Great Counsel," that is, Christ as a beardless, winged angel, here consenting to be born as man. On the left of the circle is a variant of the "Crucified Seraph" type, prefiguring Christ's crucifixion.

On earth below is Christ as "Angel of the Lord" (note the eight-pointed slava). We see the creation of Adam, and above it an angel with the symbols of the crucifixion, signifying the Plan of Redemption. God stands with Adam and Eve at the portal through which he expelled them from Paradise.

Angels (winds) of the four cardinal directions blow trumpets toward the post-fall world, in which we see an angel sent by God to instruct Adam; Cain (urged on by a

demon) killing his brother Abel; Cain in remorse over slaying Abel; Adam and Eve mourning Abel, and Adam naming the beasts.

Some versions of this type include the Archangel Michael casting Satan and the fallen angels out of heaven.

The Creator in some icons is God the Father, in others (as here) Christ as "Angel of the Lord." Inscriptions at top and bottom summarize the events of creation.

ON THE SEVENTH DAY GOD RESTED / THE CRUCIFIED SERAPH *p. 38*

The "Crucified Seraph" type is here joined with a simple version of "On the Seventh Day God Rested," to illustrate that the crucifixion of Christ was preordained.

Many suspect that the "Crucified Seraph" was adapted from Western depictions of the seraph who appeared to Francis of Assissi when that saint received the stigmata. There is also a connection with Western images of God the Father holding his crucified Son.

Note that in this example Christ as "Crucified Seraph" has only two wings; in some he appropriately (for a seraph) has six. Behind him is Lord Sabaoth, enthroned on seraphim, with fiery winged "thrones" beneath his feet, and the Holy Spirit as a dove on his breast.

The "Crucified Seraph" is sometimes called "The Soul of Christ" in keeping with Isaiah 53:12, which, as understood by Orthodoxy, speaks of Christ's soul being "given over to death."

There was much controversy over these types in the 16th century, with some asserting that they were merely Russianized "Western heresies." Ivan Viskovatyi, Chancellor of the Foreign Office, was so distraught by the appearance of such icons that his complaints reached the highest levels of the Church. He held that the "Crucified Seraph" was derived from Roman Catholics who believed that when Christ was crucified, seraphs covered his nudity with their wings.

In spite of his complaints such images continued to be painted, though they were never very common.

YOU ARE A PRIEST FOREVER AFTER THE ORDER OF MELCHIZEDEK *p. 39*

This type, obviously related to the "Crucified Seraph," adds bishop's robes and a sword to the figure of God the Father behind the cross. Some examples give the Father the face of King David; here he has the long beard of the Old Testament priest Melchizedek.

Another addition is the small seated figure atop the cross, who in some versions is crowned, colored red, and may hold a sword. He represents Christ, victorious over death.

The imagery of both is taken from Hebrews, and relates to that of the "Crucified Seraph" and "On the Seventh Day God Rested" types: "And God did rest on the seventh day from all his works" (4:4); "For the Word of God is living, and powerful, and sharper than any two-edged sword" (4:12); "So also Christ did not glorify himself to be made an high priest; but he that said to him, 'You are my son, today I have begotten you'" (5:5); "And in another place he says, 'You are a priest forever after the order of Melchizedek" (5:6).

The small image at the top, God the Father seated on a throne with Christ, illustrates Hebrews 8:1: "...we have such an high priest, who is set on the right hand of the throne of the Majesty in the heavens."

The interpretation of highly symbolic icons such as this was confused and controversial from their first appearance.

THE LORD ALMIGHTY I *p.40*

The "Lord Almighty" (Gospod Vsederzhitel) is Christ as ruler of the universe: "I am the Alpha and the Omega says the Lord, Who Is, Who Was, and Who Is To Come, the Almighty" (Revelation 1:8).

Christ sits on a throne and points to the opened Gospels in his left hand. A painter using this pattern would give Christ's head the distinctive cross-halo inscribed with the Greek words HO ON, meaning "Who Is," found in Revelation 1:8 and given in Exodus 3:14 as a title of God.

Any of several texts may be written on the pages of the opened Gospels. The most common is: "Come unto me, all ye that labour and are heavy laden, and I will give you rest" (Matthew 11:28).

In simplified transliteration the Slavonic text is PRIIDITE KO MNYE VSI TRUZH-DAIUSHCHIYSYA I OBREMENNENNIY, I AZ OPOKOIU VUI. Once you have learned the Church Slavonic alphabet this text will be easy to recognize.

Christ as "Lord Almighty" may be shown full length, or to the waist, the chest, or even just the head.

THE LORD ALMIGHTY II *p. 41*

This pattern, like the preceding example, depicts Christ as the "Lord Almighty," but here the image is very Westernized, with an elaborate rococo throne.

Christ blesses with his right hand. The position of the fingers is significant. They are in the second of two symbolic gestures. The first has thumb, ring finger and little finger bent together and touching, while the forefinger and slightly-bent middle finger are held upright. The three joined fingers symbolize the divine and human natures of Christ. The slight bend in the forefinger symbolizes the descent of Christ to earth to

become incarnate as a man. This is the sign of blessing common in icons of the Old Believers. In the second position the fingers form the abbreviated name "Jesus Christ" (IC XC). The index finger is straight and the middle finger is bent slightly, forming the letters IC; the ring finger is bent down and the thumb passes across it to form the X, and the little finger is bent to form the C. Icons with such a sign formed by the fingers of Christ or of the saints are by painters belonging to the State Church, though such icons may also use the gesture favored by Old Believers.

State Church Believers and Old Believers also use different hand positions in making the sign of the cross.

THE ALMIGHTY LORD *p. 42*

In this half-length example two words of a sample text are written on one page. The text in full is:
"Judge not according to the appearance, sons of men, but judge righteous judgment; for with what judgment ye judge, ye shall be judged."
(John 7:24 modified and combined with Matthew 7:2)
In transliteration this is NE NA LITSA SUDITE SUINOVE CHELOVECHESTIY NO PRAVEDNUIY SUD SUDITE. IMZHE SUD SUDITE, SUDIT VAM.

Other standard texts found on Christ's Gospels are these: John 13:34: "A new commandment I give unto you, that ye also love one another..." (ZAPOVYED NOVUIU DAIU VAM, DA LIUBITE DRUG DRUGA...); John 8:12: "I am the light of the world: he that followeth me shall not walk in darkness...(AZ ESM SVYET MIRU; KHODYAI PO MNYE, NE IMAT KHODITI VO TMYE...); Matthew 11:27: "All things are delivered to me of my Father..." (VSYA MNYE PREDANA BUISHA OT OTSA MOEGO...); Matthew 25:34: "Come ye blessed of my Father, inherit the kingdom prepared for you from the foundation of the world" (PRIIDITE BLAGOS-LOVENNIY OTSA MOEGO, NASLYEDUITE UGOTOVANNOE VAM TSAR-STVIE OT SLOZHENIA MIRA).

THE "FIERCE EYE CHRIST" *p. 43*

This is a shoulder-length variant of the "Lord Almighty." The type is distinguished by his grim expression, thus the popular title "The Christ (Khristos) of the Fierce (Yaroe) Eye" (Oko). Note also the arrangement of the hair, which flows behind the head and falls in curls on the left shoulder (the illustration is a mirror image and would be reversed on the finished icon).

Though the title "Fierce Eye" is commonly used of this type, it is generally not written on icons as the title, which is the standard "Lord Almighty" (Gospod Vseder-zhitel).

Again, because this image is a pattern, Christ's distinctive cross-halo is not shown,

but would be added to a finished icon.

This image shows Christ not as comforter, but as the fierce judge of the world, calling all to account for their sins, rewarding the righteous but severely punishing the wicked.

Icons in the home:

Every Russian home had its "beautiful corner" (krasnuiy ugol) in which the family icons were placed. It often contained a corner shelf holding icons draped with beautiful cloths. Guests entering a house customarily venerated the icons in the corner by crossing themselves before them.

THE SAVIOR OF SMOLENSK *p. 44*

An icon of this type was once placed above a gate through which soldiers passed on their way to liberate the city of Smolensk, thus the popular title.

This example shows Christ standing in the center, the Gospels in one hand, and his other in the sign of blessing. Two angels hover above him, their hands cloth-covered in veneration. In the finished icon they would bear the cross, spear, and sponge on a reed of the Crucifixion.

The figures about Christ vary from example to example. Usually two monk-saints, Sergei of Radonezh and Varlaam Khutuinskiy, are seen at his feet (they prostrate themselves; kneeling is not a traditional Orthodox prayer position). Among others who may appear are the martyred Tsarevich Dimitriy of Ustiuzh and the soldier-saint Dimitriy of Thessalonica (both shown here), as well as Church fathers dressed in bishop's robes.

The popular title is generally not written on the type, which is inscribed simply "The Lord Almighty."

A Definition:

An icon is a standardized religious painting. It is usually a re-creation of an existing image or pattern — a copy, but not necessarily exactly the same in size, coloring or style. Some icon patterns have been handed down for many centuries. An icon may also be cast or embossed in metal, carved in wood or stone, sewn on cloth, or painted on porcelain or other materials.

THE CHURCH OF CHRIST *p. 45*

This type is called both the "Church of Christ" (Tserkov Khristova) and the "Preaching of the Apostles" (Apostolskaya Propovyed).

Christ stands in the center of a circle divided into fourteen segments. Twelve of these enclose scenes representing the preaching and manner of death of each of the Apostles.

The remaining segments depict (at top) the Crucifixion of Christ and Christ seated before the altar, an unrolled scroll in his hands.

In the upper corners are the two segments of the type called the "Communion of the Apostles." In the lower corners, among hills and buildings, are assembled saints.

The Wooden Panel:

Icons were painted on gessoed, seasoned wood panels. Softwoods such as pine, fir and larch were common in northern Russia. Hardwoods, among them lime, birch, oak and alder, were used where available. Cypress, a southern wood with a distinctive incense-like odor, was very desirable wherever it could be obtained. Resin-free wood was preferred when supply permitted a choice.

Many icons were painted on single boards, but large icons often required panels composed of two or more boards glued together. Many of the vertical splits seen in old icons extend along the line of joining, the weakest point. Joined panels were sometimes used for small icons as well.

THE IMAGE "NOT MADE BY HANDS" *p. 46*

An interesting story explains the traditional origin of this type. In New Testament times King Abgar of the Syrian city of Edessa fell ill and sent a messenger to Jesus to request healing. Christ pressed a cloth to his own face, miraculously imprinting it with his image, and sent the cloth to Abgar. It was brought to the ruler by his court painter, Ananias. Abgar was healed through the miraculous cloth, but retained a slight touch of his former illness until Thaddeus, a disciple of Christ, came and baptized him.

Because the image appeared miraculously and was not painted, it is called "The Image 'Not Made by Hands.'" In Slavonic that is OBRAZ ("The Image") NERUK-OTVORRENUIY ("Not-by-Hands-Made"). Sometimes the words "Holy Cloth" (SVYATUIY UBRUS) are added to the image, or the Greek word for "cloth," Mandylion. Many examples of the "Not Made by Hands" type show the cloth being held by two angels.

This image should not be confused with the Roman Catholic story of "Veronica's Veil," which is a later development of the Abgar legend.

The removal of the sacred cloth from Edessa to Constantinople in 944 is celebrated on August 16. It is the third of three August "Feasts of the Savior," the other two being the Procession of the Life-giving Cross (August 1) and the Transfiguration of Christ (August 6).

The image was very popular with the Russian army.

THE SAVIOR OF THE WET BEARD *p. 47*

This variant of the "Image Not Made by Hands" shows no cloth background, just

the face of Christ. It is called the "Savior of the Wet Beard." (Spas Mokraya Boroda) because Christ's visage is depicted with the hair and beard still wet from the water in which he washed his face prior to the miraculous imprinting of his image on the cloth. The hairs of the beard are pulled down to one side and end in a sharp point or close fork.

How Icons were venerated:

Traditional believers made the sign of the cross and bowed from the waist before an icon. The hand (in either the Old Believer two-fingered position or the State Church three-fingered position) was first touched to the head, which signifies Christ; then to the abdomen, showing his descent to earth for incarnation in the womb of Mary; then to the right shoulder, meaning that Christ sits at the right hand of God; and finally to the left shoulder, indicating that Christ will come again in judgment, punishing those at his left hand and rewarding those at his right. After two crossings and bows, the icon was kissed. If full length, it was kissed on the feet or blessing hand; if half-length, on the hand. If only the head was shown, the hair was kissed. Kissing garments was also permitted, or the cloth of the "Not Made by Hands" image. Kissing the face or lips was thought extremely disrespectful.

CHRIST IMMANUEL *p. 48*

The Lord Immanuel (GOSPOD EMMANUIL) type (Christ as a youth) takes its name from Isaiah 7:14:
"Behold, a virgin shall conceive, and bear a son, and shall call his name Immanuel."
Immanuel may be depicted alone, as in this example, but he is also found in many other types, often full length. He is shown as a child of varying age, up to twelve years.
Immanuel is a representation of the Son "begotten of the Father before all worlds."
A painter using this illustration as a pattern would add the circle of the halo and the words HO ON to the cross within it.

WARP PREVENTION:

Thick crosspieces or slats called shponki were often inserted across the back of the wooden panel on which an icon was to be painted. They were added to prevent warping, but were not very effective. Alternatively, thin slats were inserted across the top and bottom edges of a panel. In spite of such efforts many old icons are convex when seen from the front, due to uneven wood shrinkage.

THE UNSLEEPING EYE *p. 49*

Christ is shown as a youth lying on a bed in a paradisiacal landscape of trees and flowers. At his feet is the Archangel Michael, who often bears the cross, spear, and

sponge on a reed, symbols of the Passion. In this example they are held by an angel and a seraph hovering above. On the right is Mary, Mother of God.

The Slavonic title is NEDREMANNOE OKO, "The Unsleeping Eye." It is based on two biblical texts:
"Behold, he that keeps Israel shall neither slumber nor sleep."
Psalm 121:4
"...he couched as a lion, and as an old lion; who shall rouse him up?"
Genesis 49:9

The second text is clarified by the old belief (expressed in the writings of Simeon Metaphrastes) that the lion sleeps without closing his eyes, and that the young of a lion are born dead but are brought to life by the parent on the third day, an obvious allegory of Christ's resurrection. The second Stikheron of Matins for Holy Saturday says, "You have lain down; you have slept like a lion; who shall awaken you, O King?" This shows us that the "Unsleeping Eye" is a symbolic icon of Christ entombed after the Crucifixion, who as God is both sleeping and eternally awake.

THE ALL-SEEING EYE OF GOD *p. 50*

This very odd type varies from example to example. Christ as Immanuel, the pre-existent *Logos*, is the center of a circle from which four star-like rays extend outward, with the symbols of the Four Evangelists within the rays or at their terminating points.

The central "sun" on which Immanuel is placed has a face, sometimes with two eyes, sometimes with four. Around it is a ring containing seraphim, with the Mother of God at the top. Above her, beyond the outer ring, is Lord Sabaoth, God the Father as an old man.

Some versions include two Old Testament prophets at the base — Isaiah at left and Ezekiel on the right, with his "wheel in the middle of a wheel" (Ezekiel 1:16). The connection with Isaiah gives this type its alternate title, "The Coal of Isaiah's Enlightenment."

Various inscriptions may be found around the circles, the most common of which is "my soul does magnify the Lord, and my spirit has rejoiced in God my Savior" (VELICHIT DUSHA MOYA GOSPODA I VOZRADOVASYA DUKH MOY O BOZIYE SPASYE MOEM), Luke 1:46-47.

The icon signifies not only the incarnation of Christ, but also the perpetual watchfulness and mind of God, which, like the sun, illumines all the land.

The VSEVIDYASHCHEE OKO BOZHIE ("The All-Seeing Eye of God") title is sometimes found as VSEVIDESHCHIA OKA GOSPODA NASHEGO ISUSA KHRISTA — "The All-Seeing Eye of our Lord Jesus Christ."

This type is sometimes classified as a Mother of God icon celebrated on August 15th, and related iconographically to the "Unburnt Thornbush" Mother of God type.

WEEP NOT FOR ME, MOTHER *p. 51*

This type, called NERUIDAY MENE MATI in Slavonic, is the Orthodox equivalent of the Western Pietà. The dead Christ is depicted upright in an open sarcophagus that conceals his body below the waist. His head inclines to the side and his arms are crossed in front. The cross from which he has been removed is often seen behind him. His mother either supports him with her hands, as here, or stands beside him holding a cloth.

The example shown bears the abbreviation for Jesus Christ (IC XC = IS KHS), and that for the Mother of God, MR FU, short for the Greek Meter THeou (Greek "TH" becomes "F" in Slavonic pronunciation). In the illustrated example the THEOU abbreviation is incorrectly written backwards.

The Inscription at top is OUNUINIE G[ospod]A NASHEGO IC XC, "The Sorrow of our Lord Jesus Christ."

The title "Weep Not For Me, Mother," is taken from Canticle Nine of Matins for Holy Saturday:
"Weep not for me, Mother, seeing in the sepulchre the son you conceived without seed in your womb — for I shall rise and be glorified, and, as God, shall exalt those who praise you, with faith and love, in glory everlasting."

THE ONLY-BEGOTTEN SON *p. 52*

This type illustrates the second antiphon of the Liturgy of Saint John Chrysostom, which begins, "Only Begotten Son and Word of God..." (EDINORODNUIY SUINE I SLOVO BOZHIE...). That is also the type title.

God the Father is at the top. Below is Immanuel in a circle supported by angels. A scroll is in his left hand, and in his right are the symbols of the Four Evangelists (some examples place the Holy Spirit as a dove in his right hand, or simply a flame). At left and right are structures in which stand angels. Two flying angels hold aloft red and blue discs bearing images of Seraphs. Some versions identify the discs as the sun and moon.

At lower right Death rides out of a dark cave on a lion, trampling bodies beneath him. Beasts and a carrion bird prey on the dead.

At lower left is a cross on which Christ robed as a warrior is seated, symbolizing his victory over death. Below him an angel overcomes Hades, shown under the cross as a fallen figure in human form.

Because of the complexity of images such as this, and the variations within the type, interpretations of details often differ.

THE BLESSED SILENCE *p. 53*

The BLAGOE (Good) MOLCHANIE (Silence) depicts Christ as an angel with an

eight-pointed "glory" imposed on the halo, the eighth point being hidden by the head. The seven points, as we have seen, symbolize the six days of Creation and the day on which God rested. The eighth point is the Day of Eternity.

Christ's head may be bare or crowned; a small cherub is often shown on his breast and on each arm. Christ may hold a cross in his right hand a scroll in his left with Matthew 11:28 upon it. Here he holds a key probably derived from Revelation 3:7: "These things says he that is holy, he that is true, he that has the key of David, he that opens and no man shuts, and shuts and no man opens."

The type represents Christ as the Word in Eternity, and iconographically it is usually associated with the Creation and the Plan of Salvation, ordained from Eternity. Isaiah 9:5, considered by Orthodoxy as referring to Christ, calls him (in the Greek Septuagint version) the "Messenger/Angel of Great Counsel." The attributes given in Isaiah 11:2 are sometimes inscribed on the image.

The Biblical texts usually associated with this type are: Isaiah 42:2: "He shall not cry, nor lift up, nor cause his voice to be heard in the street"; and Isaiah 53:7: "He was oppressed, and he was afflicted, yet he opened not his mouth; he is brought as a lamb to the slaughter, and as a sheep before her shearers is dumb, so he opens not his mouth."

THE DEISIS I *p. 54*

The type is called Deisus in Russia, from the Greek Deisis, meaning "Prayer."

Christ is enthroned as "Lord Almighty." Mary and John intercede with him on behalf of humanity, beseeching him for mercy.

Additional saints are often added at both sides. In this example they are St. Peter at upper left, St. Paul at upper right, and two angels, generally Michael and Gabriel.

Mary sometimes bears a circle on her breast in which Immanuel is depicted. She may also carry a scroll like that held by John.

The Deisis is found on the iconostasis (accent on third syllable), the great screen covered with icons which separates the congregation from the altar in Russian churches. There many saints form two rows approaching Christ in intercession from both sides.

The Orthodox attitude toward Icons:

Icons are considered the word of God in paint. They are also believed to be linked with the holy persons they depict. Consequently some Orthodox are offended by the more casual Western attitude toward icons, and are not pleased to find them displayed in museums or being bought and sold as collectors' items or art objects. Old Believers in particular find such practices offensive, and may not permit photographing of icons in their possession.

THE DEISIS II *p. 55*

This is a waist-length version of the common type. It is used in many painted icons (both on one panel and divided into one panel per figure), and is also preferred on cast brass three-panel icons.

Christ in the center holds the Gospels open to the text "Judge not according to appearance...". At his right (the example shown is a mirror image of the type) is Mary, the Mother of God, who often holds a scroll beginning "Ruler Most Gracious, Lord Jesus Christ..." (VLADIKO MNOGOMILOSTIVE, GOSPODI ISUSE KHRISTE). At his left is John the Forerunner, holding in one hand a scroll reading "Behold the Lamb of God who takes away the sins of the world (CE AGNETS BOZHIY VZEMLYAY GRYEKHI MIRA) joined to the beginning of a second text associated with John, "Repent, for the kingdom of heaven is at hand" (POKAITESYA, PRIBLIZHIBOSYA TSARSTVIE NEBESNOE).

In his other hand John holds a diskos, an implement used in the liturgy. The most important piece of Eucharistic bread placed on the diskos is called the "Lamb of God." It represents Christ, and consequently is shown here as the nude Christ Child.

A peculiarity of this particular illustration is that John's name is written Ivan (Russian) rather than the customary Ioann (Church Slavonic).

THE GREAT HIGH PRIEST *p. 56*

In the Book of Hebrews Christ is repeatedly called a high priest, and in Hebrews 4:14 is written "...we have a great high priest that is passed into the heavens, Jesus Christ the Son of God...".

This type depicts Christ as a bishop in the robes of office. He wears a bishop's crown, as well as the characteristic omofor (Greek omophorion), the stole which passes about his neck. It is decorated with crosses.

When shown thus, Christ is called VELIKIY ARKHIEREY, "The Great High Priest."

Notice that the illustration, like many in this book, is a mirror image. If one were to prick tiny holes along all the lines with a needle, it could then be placed on a prepared, unpainted panel; then powdered charcoal pounced through the holes would reproduce the image in its correct form on the blank panel. That is how many icon painters re-created icons according to the accepted patterns. To see the image as it would correctly appear, hold it to a mirror.

THE KING OF KINGS *p. 57*

This type, the TSAR (King) TSAREM (of Kings) depicts Christ alone, as described in chapter nineteen of the Apocalypse (Revelation).

He wears a red robe ("he was clothed with a vesture dipped in blood"), and on his head is a many-tiered crown ("and on his head were many crowns").

Christ blesses with his right hand and holds in his left a sceptre terminating in a cross. A round medallion suspended from his neck contains the words SLOVO BOZHIE, "The Word of God."

A sword extends from his mouth ("And out of his mouth goeth a sharp sword").

There is an inscription on his garment ("And he hath on his vesture and on his thigh a name written, King of Kings and Lord of Lords"). The inscription reads in Slavonic TSAR TSAREM I GOSPOD GOSPODEM (Revelation 19:16).

Christ, when shown full-length as a king enthroned, is also often called "King of Kings," though his crown in some examples is actually that of a bishop rather than a ruler.

THE QUEEN DID STAND AT YOUR RIGHT *p. 58*

This Deisis variant is also sometimes called "The King of Kings." The "Queen did Stand at your Right" title (PREDSTA TSARITSA ODESNUYU TEBE) is taken from Psalm 45:9: "…upon your right did stand the queen in gold of Ophir." That text is often written on the icon. The queen is, of course, Mary, Mother of God.

The example illustrated shows Christ robed as a bishop (he may also be robed as a king). John the Forerunner is at his left hand, and two angels, generally Michael and Gabriel, are behind him holding seals bearing the IC XC abbreviation for "Jesus Christ."

The Value of Icons:

To an Orthodox believer the value of an old icon is primarily spiritual. Icons are, however, now a part of the international art market. In general values are set by age (the older the better), by painting quality (beautiful, skillfully-painted icons are worth more), by size (large icons are worth more, but paradoxically so are small, microscopi-cally-detailed works), by condition (the greater the damage or restoration the less the value), and by subject (icons of Christ, Mary, or better-known saints tend to be more popular than those of obscure saints). Finely-crafted ornate metal covers can also greatly affect the value of an icon.

Buyers should be alert for fakery. Even before the Revolution early icons were faked for sale to Old Believers. Buyer caution should increase in proportion to price.

THE QUEEN DID STAND AT YOUR RIGHT ("Wisdom" variant) p. 59

In this example Christ, also associated with Holy Wisdom (see "Sofia, Wisdom of God"), is enthroned and wears a sword. Many fallen enemies lie at his feet.

The type illustrates more of Psalm 45, already mentioned as the source of "The Queen Stands at your Right": "Gird thy sword upon thy thigh, O most mighty" (Psalm

45:3), and "Thine arrows are sharp in the heart of the king's enemies; whereby the people fall under thee" (Psalm 45:5).

High in the building on the left stands King David, traditionally the author of the Psalms. Opposite him, on the right, is King Solomon, traditional author of the Proverbs, which speak of Holy Wisdom (Sofia/Christ) in chapters eight and nine.

The Gesso Ground:

In preparing a wooden panel to be painted upon, it was first roughened on one surface to increase bonding. Then a cloth was glued on the rough side. Layer after layer of a gesso consisting of rabbit skin glue or fish glue mixed with powdered chalk (or more expensive and durable alabaster) was applied. The final surface was polished smooth.

Some icons have gesso laid directly on the wood with no cloth between. Others, particularly in the nineteenth century, may use paper instead of cloth. Russians called the white gesso levkas, which was a transliteration of the Greek leukos, meaning "white."

THE LAMB OF GOD *p. 60*

This may be classified, for convenience, as another Deisis variant, but instead of the mature Christ in the center, we find here the "Lamb of God" (AGNETS BOZHIY) of the Eucharist. He lies, as does the piece of bread that is also called the "Lamb," on the diskos used in celebrating the Eucharist. Beneath it, in this example, are the fiery winged rings that are the rank of angel called "Thrones."

Three Seraphim hover above Christ as "Lamb of God." One on the right holds the lance-shaped knife used to take particles from bread used in the Eucharist. It is called the KOPIE, the "lance," because it symbolizes the lance that pierced Christ's side. The seraph on the left holds the prosfor loaf. Above are two angels carrying fans (ripida) used in the liturgy, and above them are two more, one holding the cross and the other holding the spear and sponge on a reed of the Crucifixion. God the Father is seated on Seraphim in the circle at the top.

Readers familiar with the Bible will recall that John the Forerunner called Christ "the Lamb of God, which takes away the sin of the world" (John 1:29). In Western art Christ is often depicted symbolically as a lamb, but in Orthodoxy this is not done except in some illustrations of the Apocalypse.

The "Lamb of God" iconographic type is customarily engraved on the plate of the diskos, which corresponds somewhat to the paten of the Western Christian Eucharist.

The wings seen on Mary in this example are often traced to Revelation 12:14.

SOFIA, WISDOM OF GOD I *p. 61*

This is yet another Deisis variant. It depicts "Sofia, Wisdom of God" (SOFIA

PREMUDROST BOZHIY), an aspect of Christ before the Creation, in Eternity — "I was set up from everlasting, from the beginning, or ever the earth was" (Proverbs 8:23).

In the type shown, commonly called the "Novgorod" form, Sofia, a winged angelic figure with a flame-red face, is seated on a throne set on seven pillars ("Wisdom hath builded her house, she hath hewn out her seven pillars" — Proverbs 9:1).

Above her is Christ in his usual form; still higher, the heavens are shown like a scroll (Isaiah 34:4, Revelation 6:14), behind which are angels, and above them is the "New Testament Trinity." The table set in the center of the scroll is an altar called the "throne" in iconography, because in an Orthodox church the altar is considered the throne of Christ. The "throne" has implications of the Last Judgment, because the "Preparation of the Throne" (Greek Hetimasia) signifies that the time of Judgment is near.

Though Sophia is generally considered a representation of Christ, it has also been seen over the centuries as a manifestation of the Trinity, as representing the Holy Spirit, and under Western influence it was sometimes confused with Mary.

SOPHIA, WISDOM OF GOD II *p. 62*

This pattern is a slight variant of the usual "Novgorod" image.

Sophia is in the center, seated on the seven-pillared throne. Above her is Christ in a mandorla (almond-shaped, full-length halo) of light. The odd "leaf" shapes on the inside edge of the mandorla are stylized clouds.

Two angels hold the Scroll of Heaven, with the sun and moon flanking Lord Sabaoth, God the Father.

At Wisdom's right hand stands Mary robed as a queen and winged, relating this pattern not only to the "Deisis" but specifically to the "Queen Stands at your Right" variant. Christ Immanuel can be seen on her breast.

On the other side of Wisdom is John the Forerunner, also winged and crowned. In Orthodoxy he is often called the "heavenly man and earthly angel." He holds the "sword of the Spirit, which is the word of God" (Ephesians 6:17). In his other hand is a disk bearing the face of Wisdom.

The inscription at the top reads, with missing letters added, SVYATAYA SOFYEA PREMUDROST BOZHIYA — "Holy Sofia, Wisdom of God" (SOFYEA is a variant spelling of SOFIA).

WISDOM HAS BUILT HERSELF A HOUSE *p. 63*

This type depicts another Sofia-related image, called in Slavonic PREMUDROST SOZDA SEBYE DOM — "Wisdom Has Built Herself a House." Sometimes the word KHRAM, "Temple," is used in place of DOM, "House." Here the house Wisdom/Christ built is seen as a church supported on seven pillars (Proverbs 9:1). The seventh pillar is Christ crucified. From his side blood streams into a chalice on the altar,

recalling the Eucharist.

John the Forerunner is on the right, Mary on the left, and on both sides a multitude of saints are gathered, representing the Church, the Body of Christ. Below the altar is a small arch in which many small figures stand, illustrating Revelation 6:9: "I saw under the altar the souls of them that were slain for the Word of God." Angels descend from heaven with crowns for the saints. Above them are Lord Sabaoth and the Holy Spirit as a dove, set among the nine ranks of angels, the Heavenly or "Bodiless" Powers.

A related type shows Mary with the Child Christ on her breast, standing in a seven-pillared temple. In later years (under Western influence) she was sometimes identified with Wisdom, though this is contrary to traditional teaching, which considers her the "temple" of the incarnation of Christ. The six temple steps signify the Spirit of Wisdom, Understanding, Counsel, Might, Knowledge, and Fear of the Lord (Isaiah 11:1-3). Also associated with Sophia are the gifts of the Spirit in Galatians 5:22 — Love, Joy, Peace, Patience, Kindness, Goodness, Faithfulness, Gentleness, and Temperance.

THE PROCESSION OF THE PRECIOUS AND LIFE-GIVING CROSS *p. 64*

This type originated in a yearly ritual that took place in Constantinople, originally the chief center of Orthodoxy. The Cross of Christ (or what was believed to be a piece of it) was carried out of the Church of Holy Wisdom and through the city. Then a spring was blessed with it to which the ill could come for healing. A chapel stood beside the spring, and outside the chapel was painted an image of the "Deisis."

At the top of the example shown is the chapel, seen as a large church with typically Russian domes and crosses. In front of it is the "Deisis," shown not as a painting but as a real heavenly scene.

Below the clouds is the tank (sometimes cross-shaped) out of which the healing waters flow, and behind it is an angel. On both sides are the afflicted, waiting to be healed. Compare this with the biblical tale of the healing pool of Bethesda in chapter five of the Gospel of John.

Icon shops:

Russians felt uneasy about making icons objects of commerce, so they eased their consciences by often speaking of "exchanging money" for an icon rather than "buying" one. Early icons were painted by monks, but 18th and 19th-century icons were frequently purchased through shops, some of which painted the shop name on the front of the icon.

LET ALL THAT BREATHE PRAISE THE LORD *p. 65*

This type takes its name (Slavonic VSYAKOE DUIKHANIE DA KHVALIT GOSPODA) from the "Praise the Lord" lines of Psalms 148, 149, and 150, with the

title taken from 150:6.

Christ is enthroned as "King of Kings" in a circle. Around him are nine angels. Below, on both sides, are rows of saints and ordinary humans.

The lower half is a landscape filled with trees and all kinds of animals and birds, which as "breathing things" are also admonished to "praise the Lord." The inscription says, "Let All that Breathe Praise the Lord; Praise [Him] From the Heavens, Praise Him in the Heights."

Patterns:

Painters generally kept a collection of patterns in the form of outline drawings pierced with pinpricks to form stencils. When such a stencil was laid over a blank, gessoed panel, powdered charcoal or coal in a loosely-woven pouch was pounced through the stencil, forming a dark outline on the gesso beneath. This was then gone over with a pencil and the outlines were scratched permanently into the gesso with a pointed stylus.

A stencil could be taken from an existing icon by tracing over the painting with a small brush dipped in garlic juice or a colored sugar mixture. When a sheet of paper was pressed to the icon surface, the tacky outline adhered to the paper, which could then be pricked to form a stencil.

THE CRUCIFIXION *p. 89*

At the top is "Lord Sabaoth" and the sun (SOLNTSE), which has darkened, and the moon (LUNA), which has become as blood (Joel 2:31, Acts 2:20). The Mother of God, Mary Magdalene, Mary Clopas, the Centurion Longinus (Loggin/Longin Sotnik) and the Apostle John look on.

The superscription above Christ's head reads I N TS I, abbreviating "Jesus of Nazareth, King of the Jews" (ISUS NAZORYANIN TSAR IUDEISKIY).

The inscription above the main crossbeam is RASPYATIE TSAR SUIN BOZHIY SLAVUIY GOSPODNE; by alternating words from left to right (giving Raspyatie Gospodne, Tsar Slavuiy, Suin Bozhiy) this reads "The Crucifixion of the Lord, the King of Glory, the Son of God." Below the beam are words from Matins on the Sunday of the Cross: KRESTU TVOEMU POKLANYAEMSYA VLADIKO I SVYATOE VOSKRESENIE TVOE SLAVIM, "We Venerate Your Cross, Lord, and Glorify Your Holy Resurrection."

At Christ's right is the spear (K = KOPIE) and on his left the sponge on a reed (T = TROST, "reed"). Above the slanting footboard is the Greek word NIKA, meaning "He [Jesus] Conquers." The letters M L R B on the footboard abbreviate MESTO LOBNOE RAY BUIST, "The Place of the Skull Becomes Paradise." The letters G G stand for GORA GOLGOFA, "The Hill of Golgotha," and the G A for GOLOVA ADAMA, "The Head [skull] of Adam." In tradition Adam's tomb is said to have been at Golgotha, and his skull and bones were exposed by an earthquake during the Crucifixion.

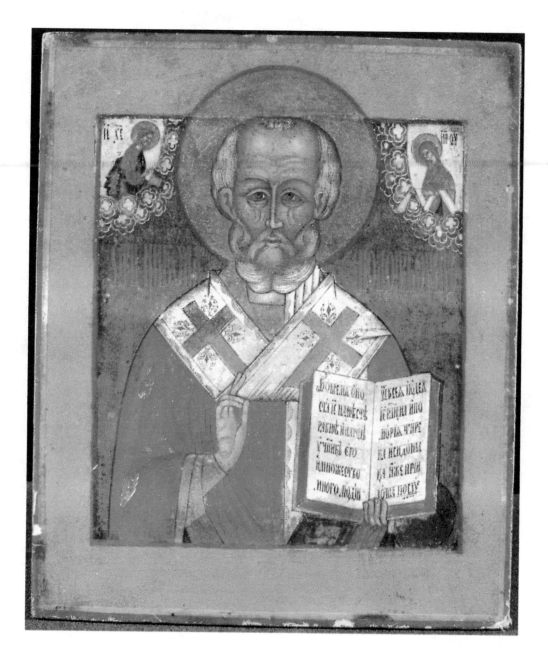

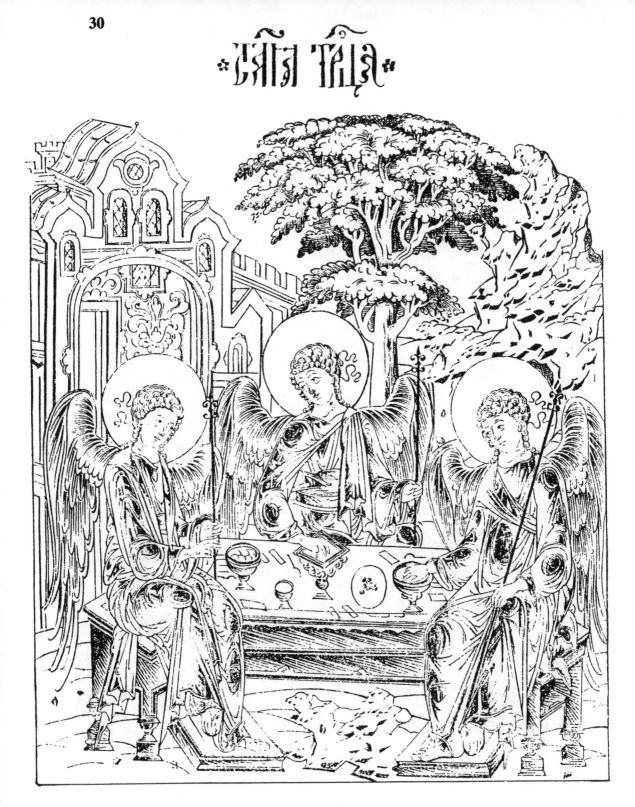

cf. p. 10

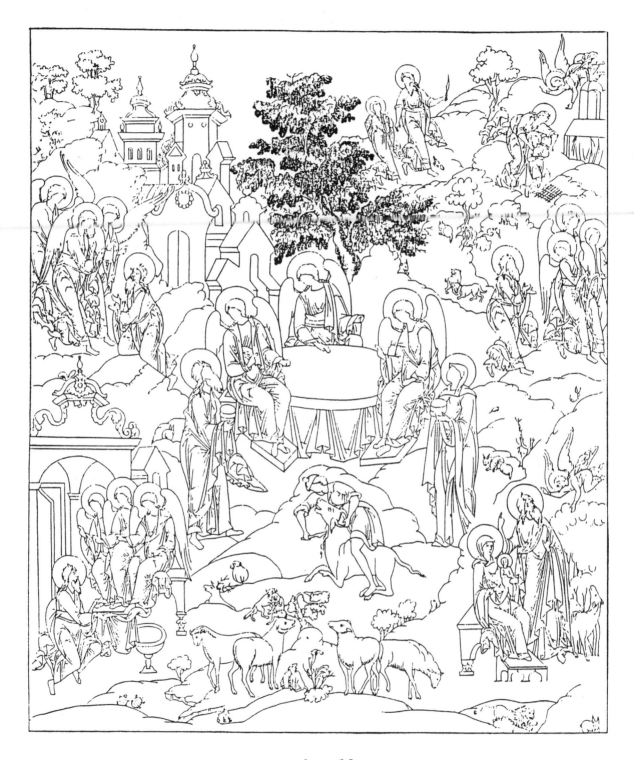

cf. p. 10

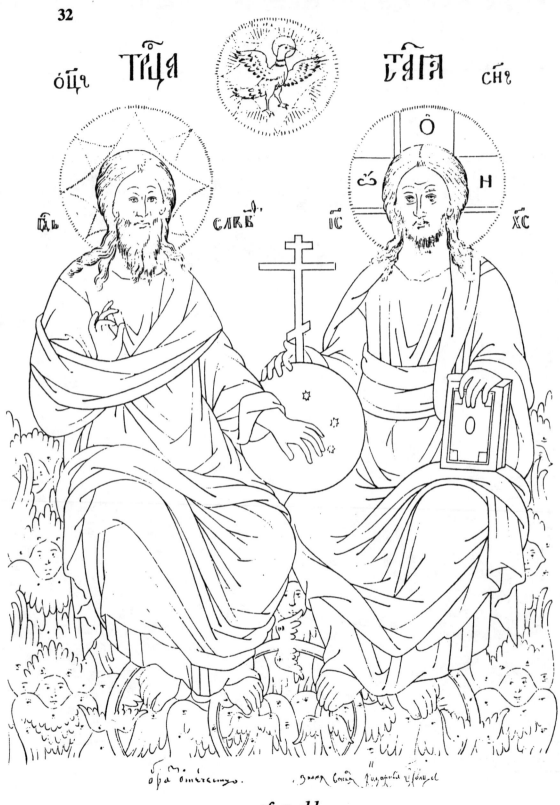

cf. p. 11

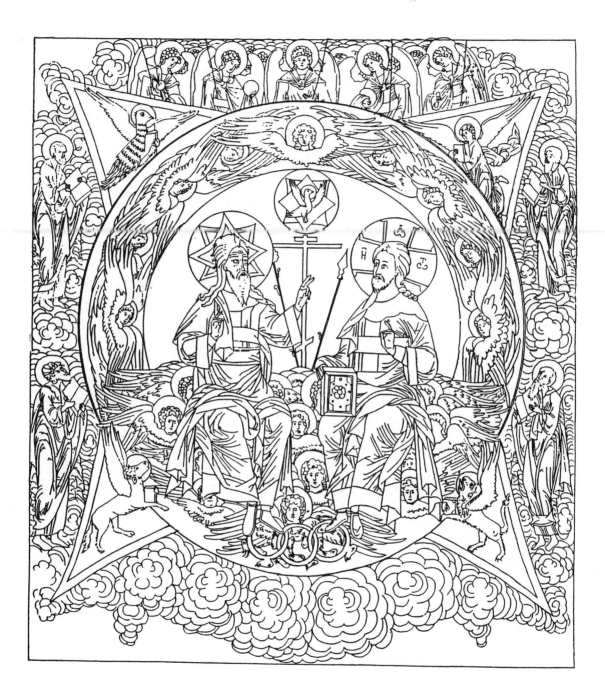

ОТЕЧЕСТВО.

cf. p. 11

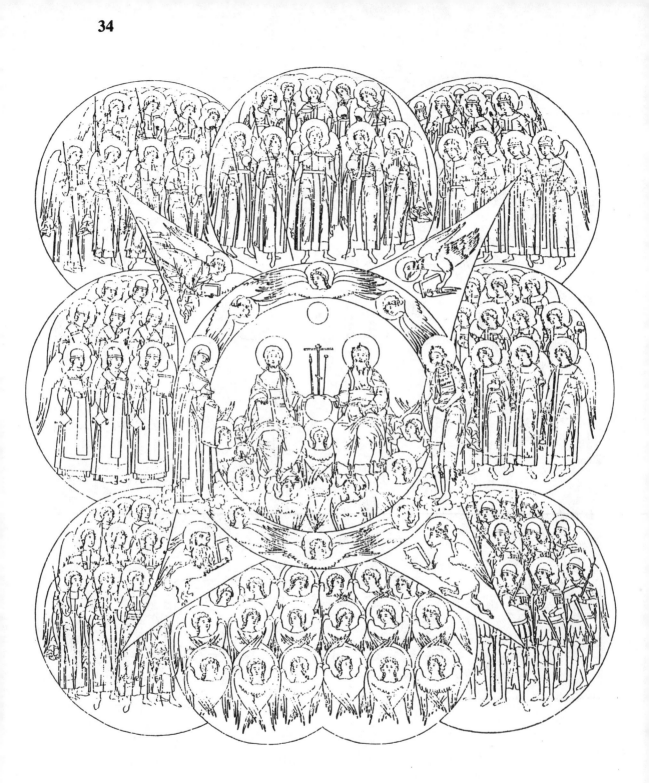

cf. p. 12

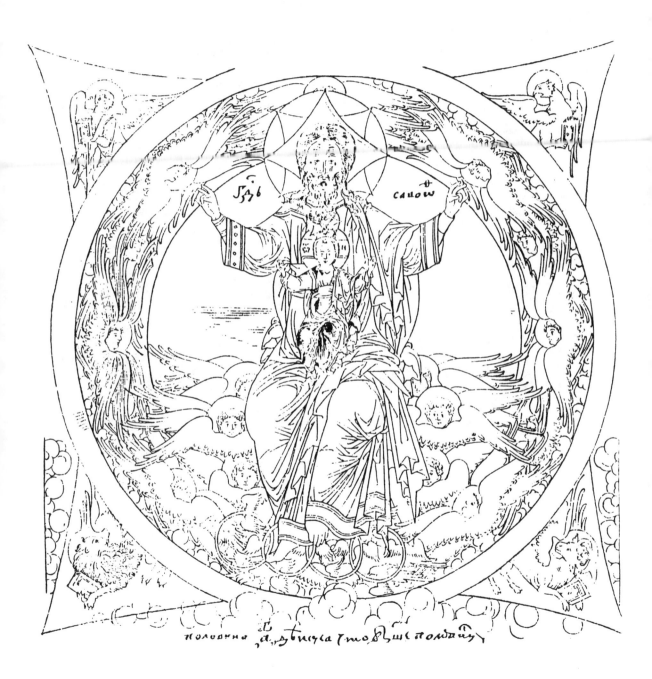

cf. p. 12

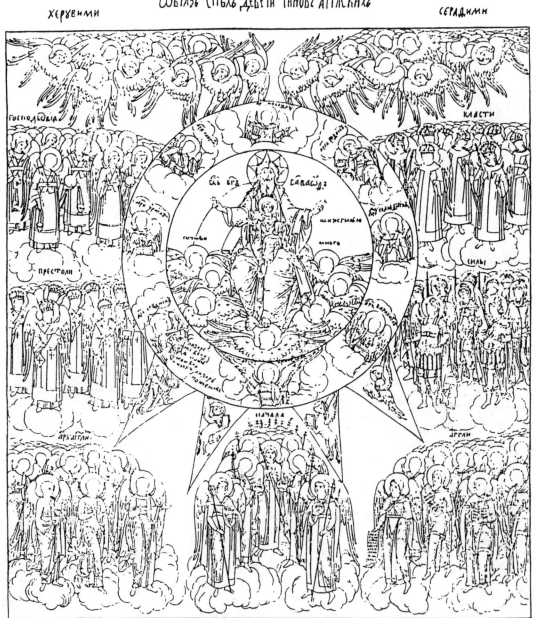

cf. p. 13

впервы день сотвори бгъ нбса горнАА иземнаА воᲂвторы тверть посреде
воды кнебеса невидимое втрети морА иреки источники иезера вчетверты
слнцъ ипцъ извезды кпАты великиА киты ирцы ивсАкую дшѫ живо-
тныхъ ради ивсАкъ птицу пернату породы вшести день сотвори .
чака. въседны день почи бгъ ѿвсехъ дѣлъ своихъ иблагослови егѡ.

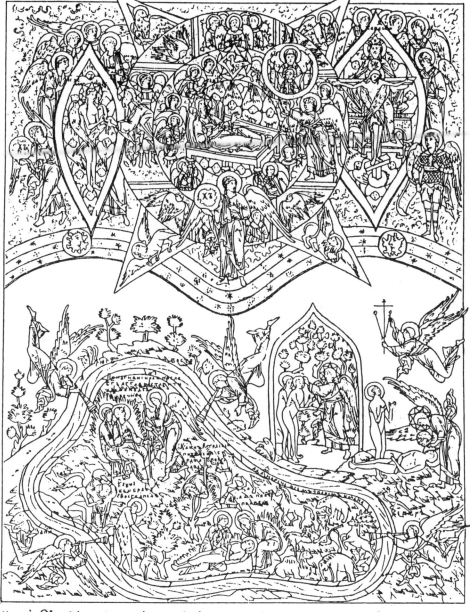

иречⷱ гдⷭ бгъ недобро быти единому взⷨ гдⷭ персть ѿземли исозда
чакꙋ сотворилъ емꙋ помощнⷩка. чака послⷪбⷬазꙋ своемꙋ ипоподобїю
иꙋложи бгъ сонъ вадама изъ ивⷣнꙋ внего дшꙋ живꙋ инарчⷱ
ꙗтъ единꙋ ѿребръ егѡ исозда имѧⷩ адамъ .

ебвꙋ , *cf. p. 13*

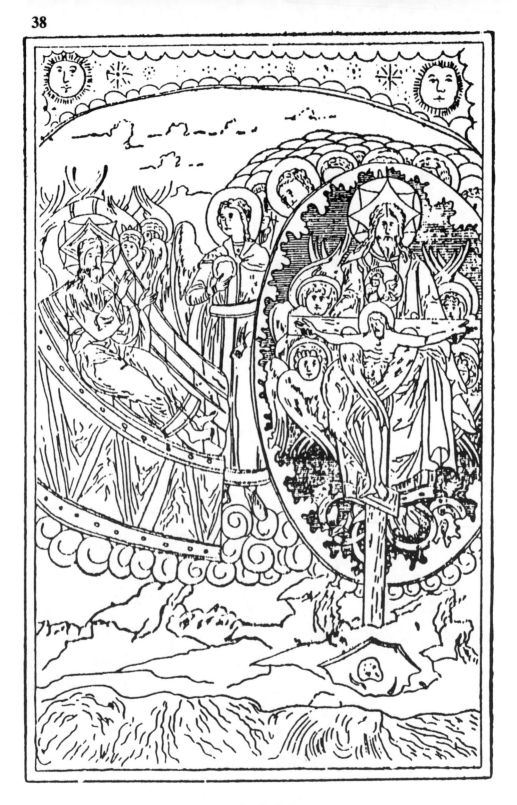

cf. p. 14

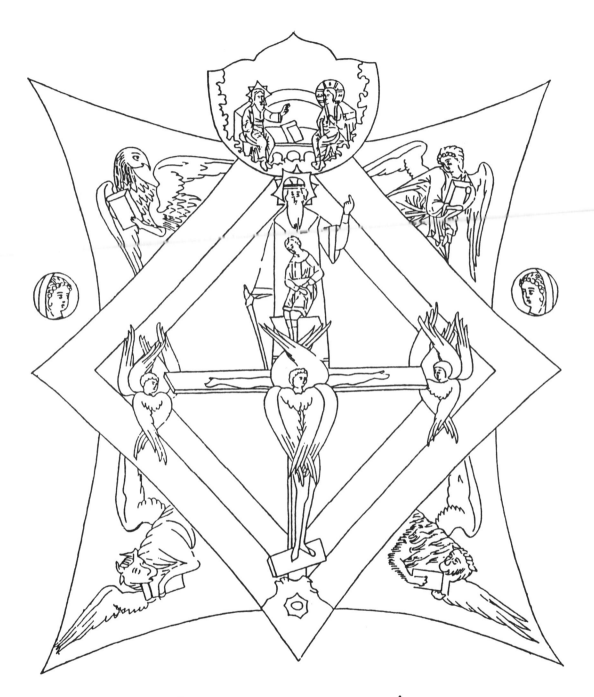

ТЫ ЕСИ ІЕРЕЙ ВО ВѢКЪ ПО ЧИНУ МЕЛХИСЕДЕКОВУ.

cf. p. 14

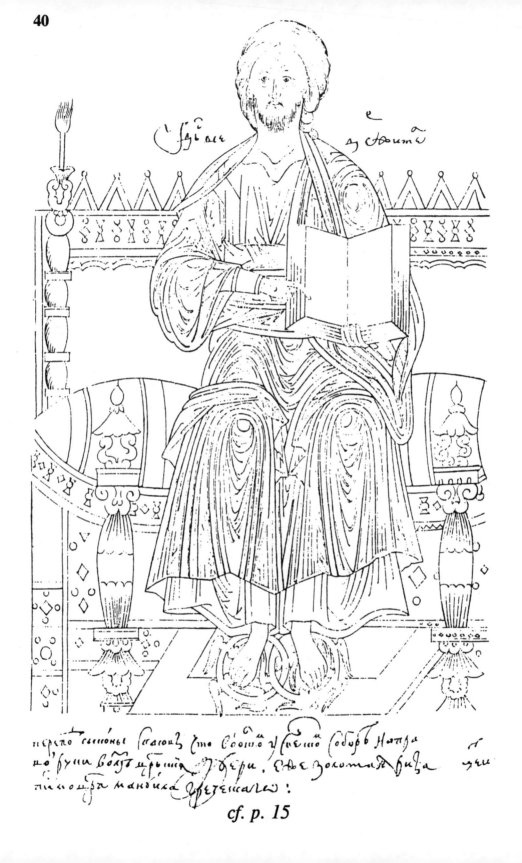

cf. p. 15

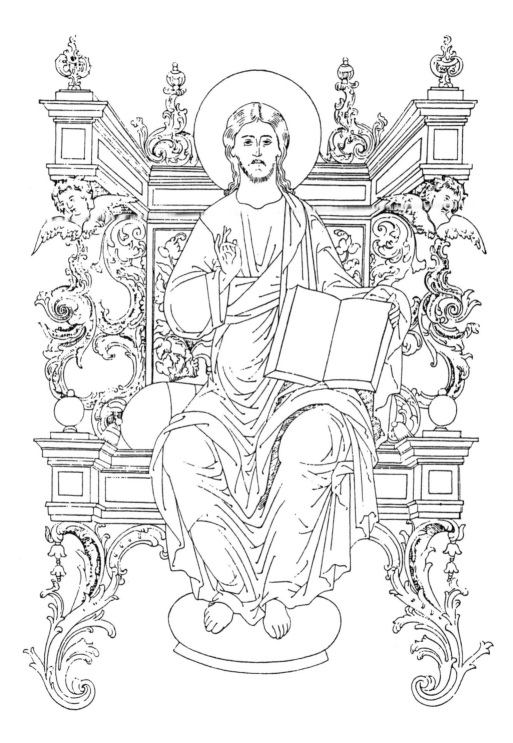

cf. p. 15

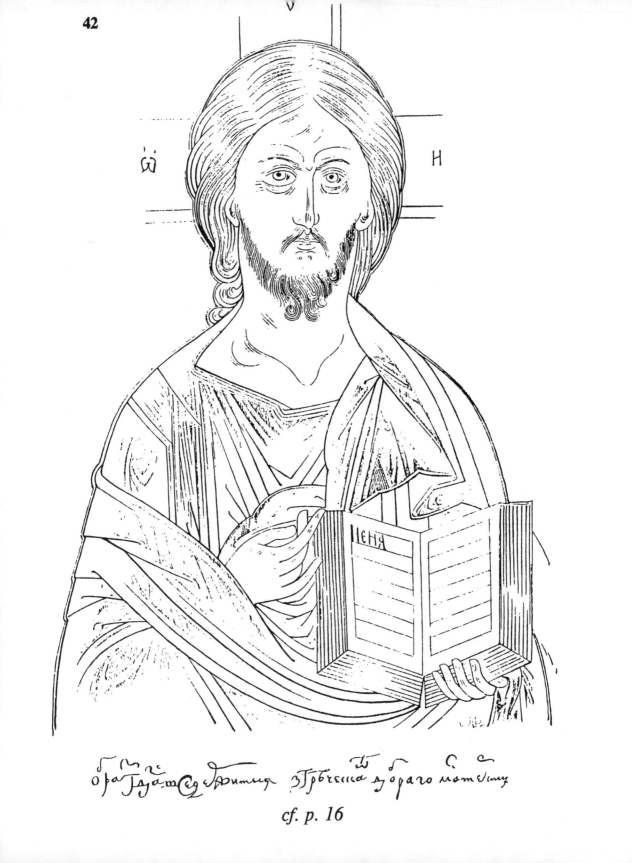

ѡбраꙁъ гадателѧдѣтища зъгрѣшша дѡбраго пастꙑрѧ

cf. p. 16

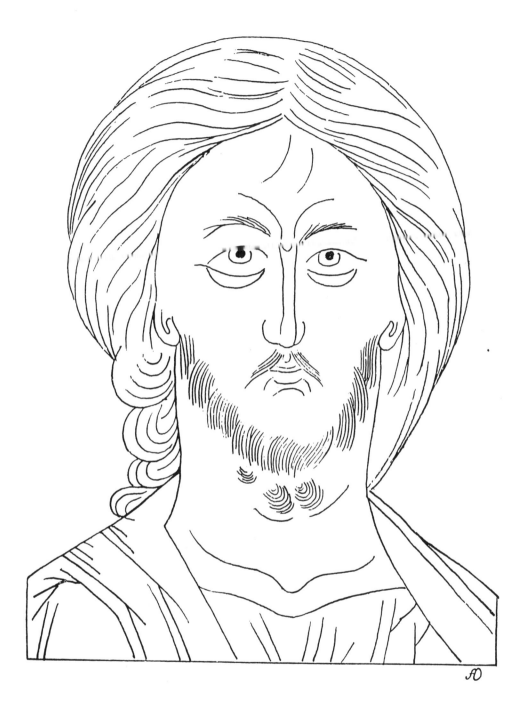

СПАСИТЕЛЬ

cf. p. 16

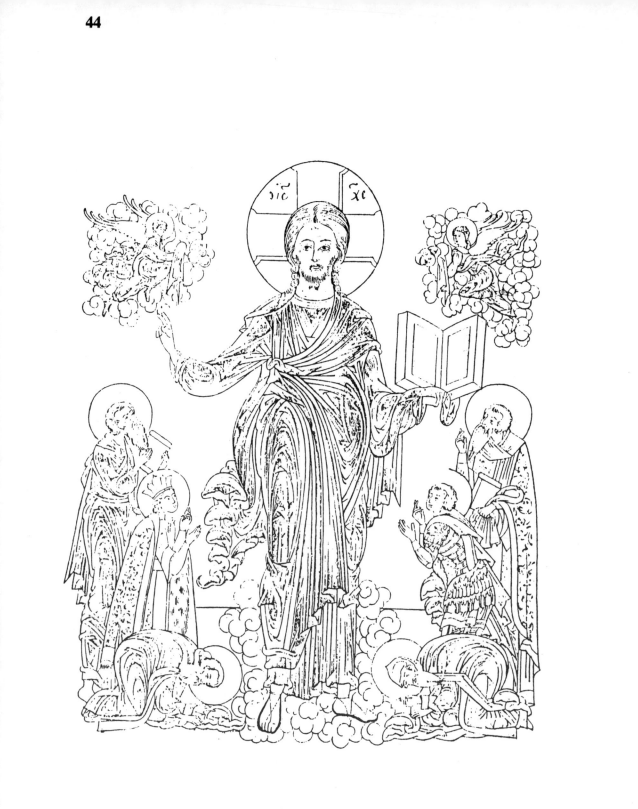

cf. p. 17

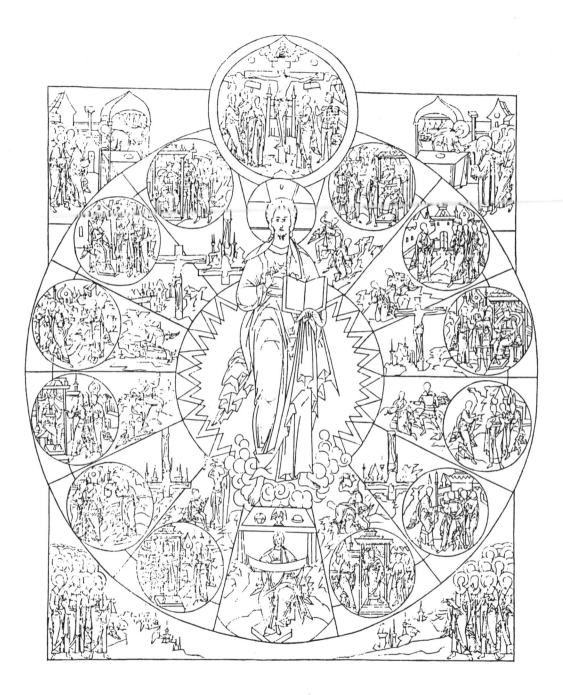

cf. p. 17

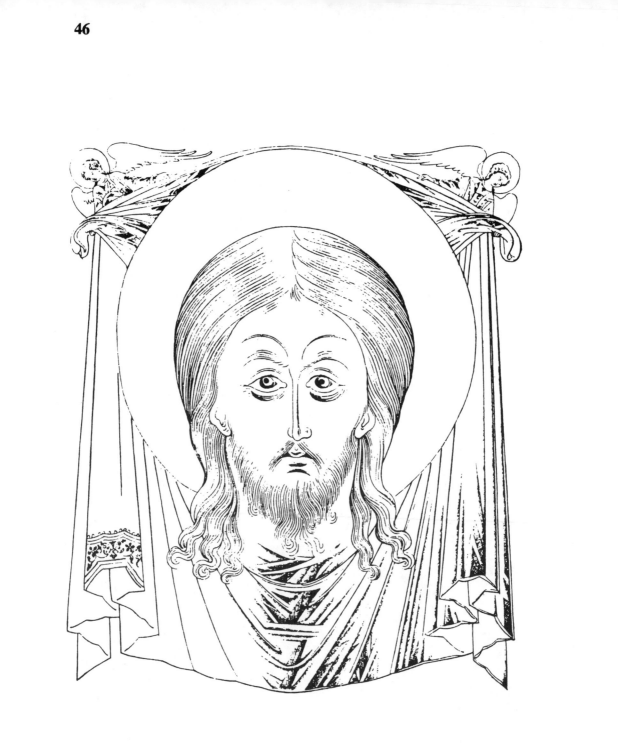

cf. p. 18

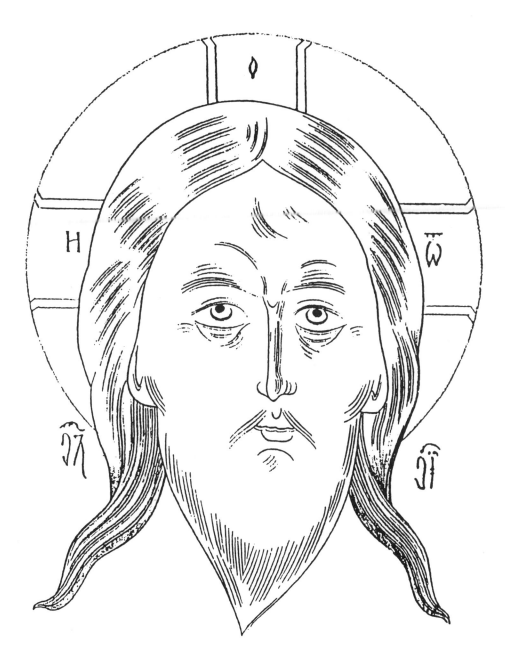

СПЭСЪ МОКРЭМ БОРОДЭ.

cf. p. 18

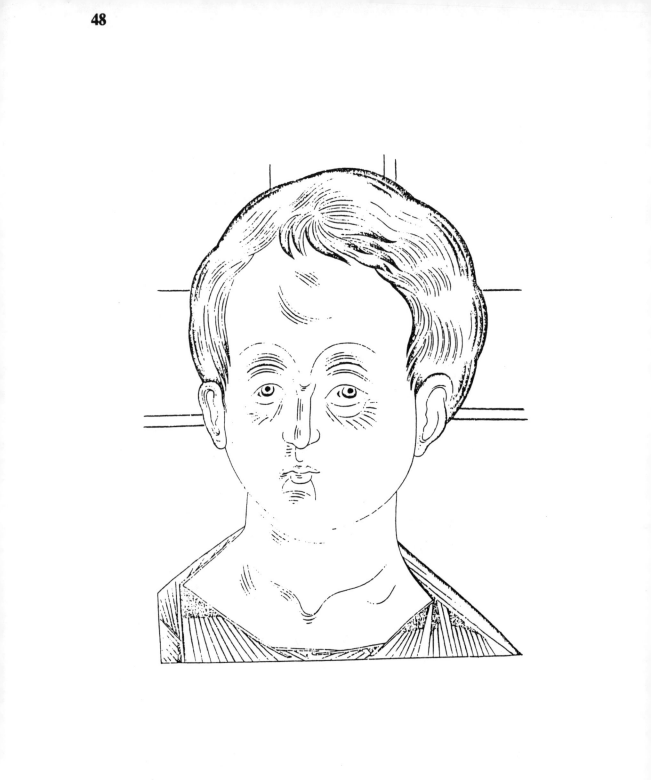

cf. p. 19

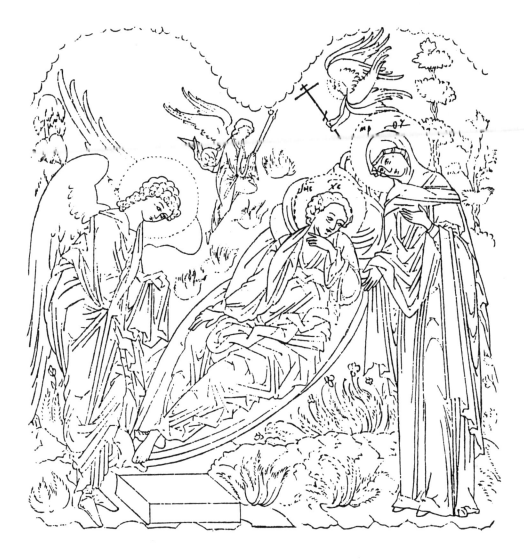

cf. p. 19

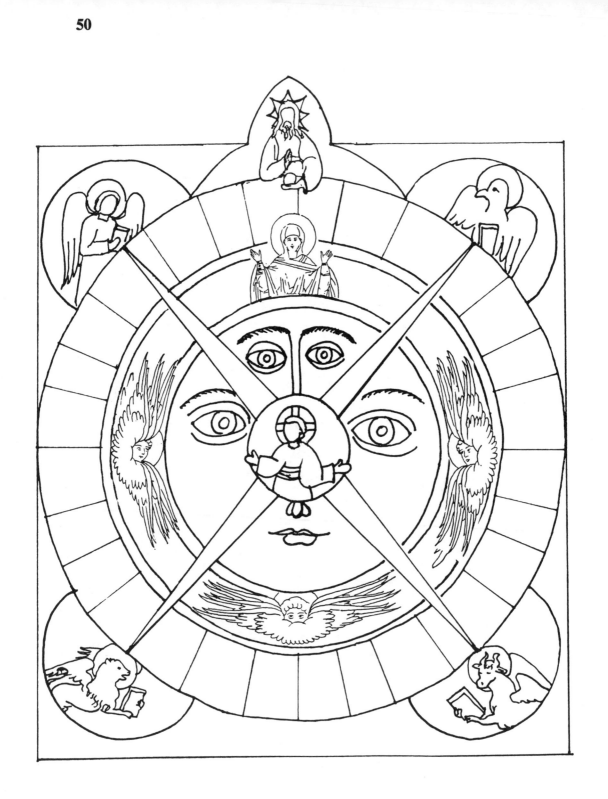

cf. p. 20

ОУНЫНІЕ. ГЛАНЯЩЕГО ІС ХС.

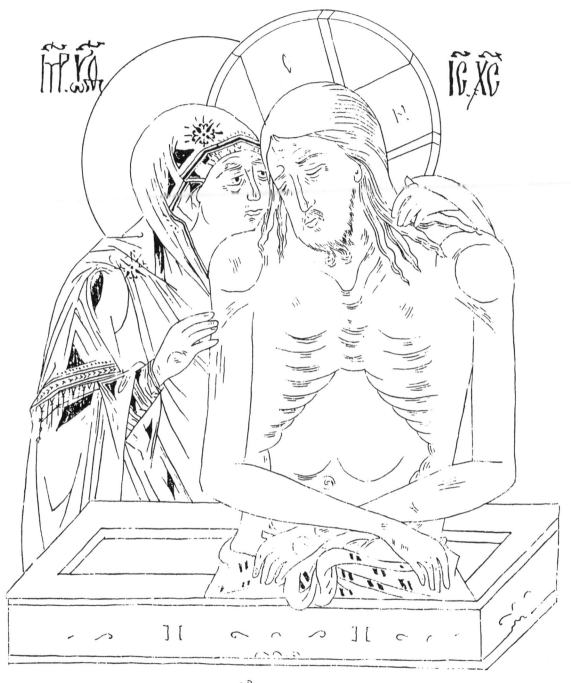

НЕ РЫДАЙ МЕНЕ МАТИ.

cf. p. 21

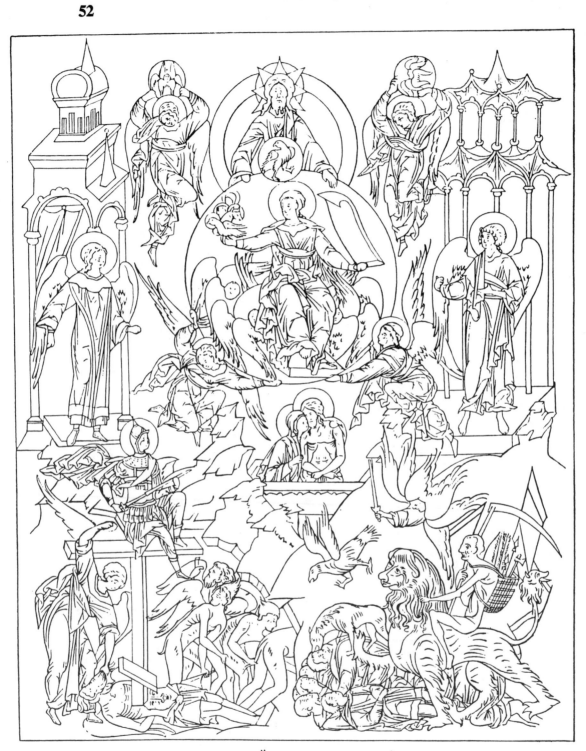

ЕДИНОРОДНЫЙ СЫНЪ-СЛОВО БОЖІЕ.

(рисун. XVII вѣка)

cf. p. 21

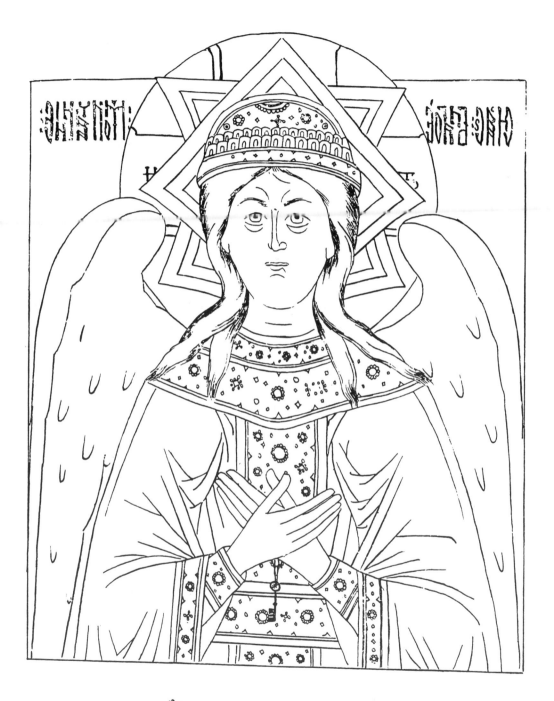

СПАСЪ БЛАГОЕ МОЛЧАНІЕ.

cf. p. 21

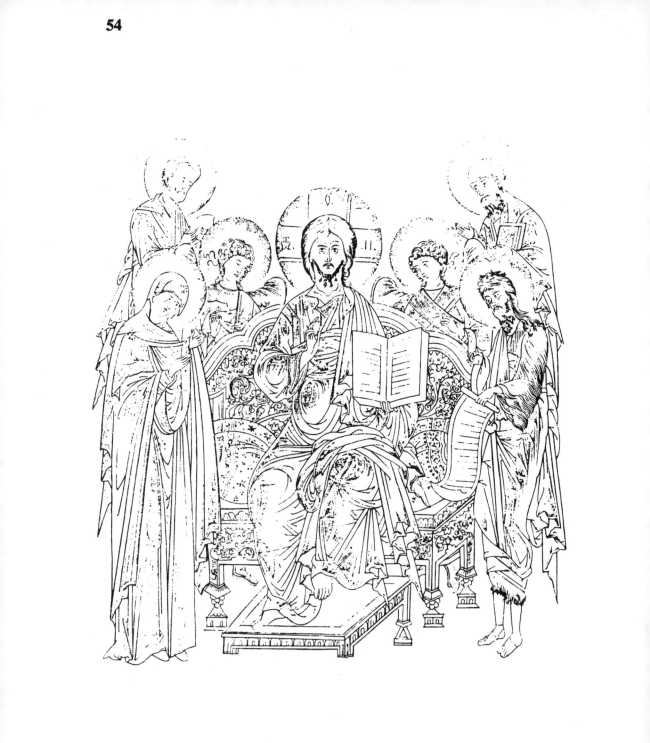

cf. p. 22

ДЕИСИСЪ

cf. p. 23

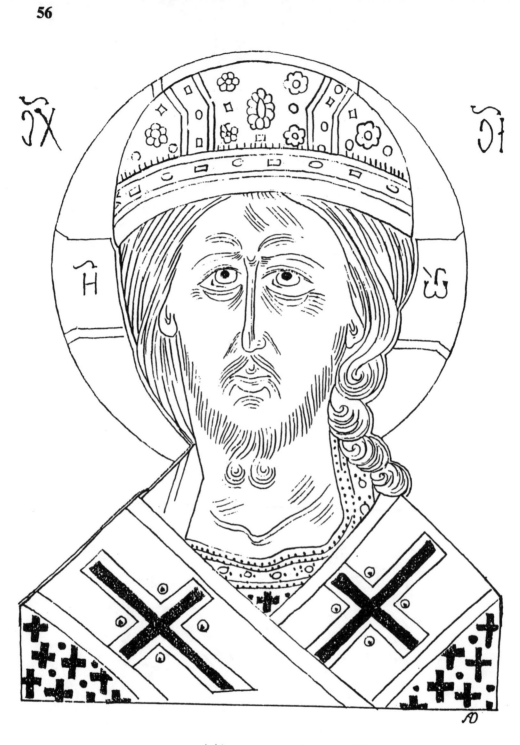

ВЕЛНКІЙ АРХІЕРЕЙ

cf. p. 23

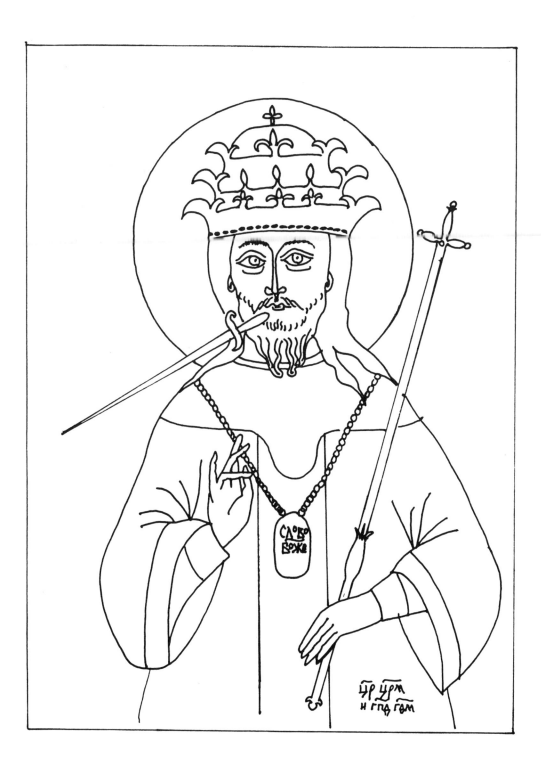

cf. p. 23

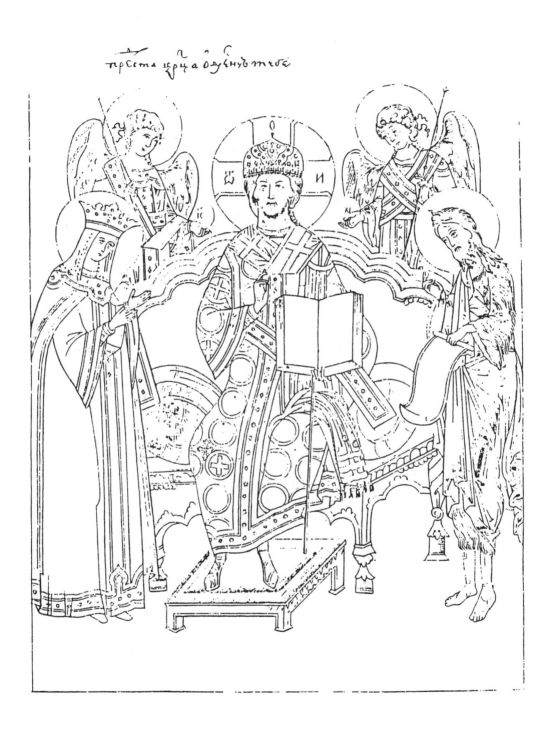

прѣста црца ѡдѣннѹ тебе

cf. p. 24

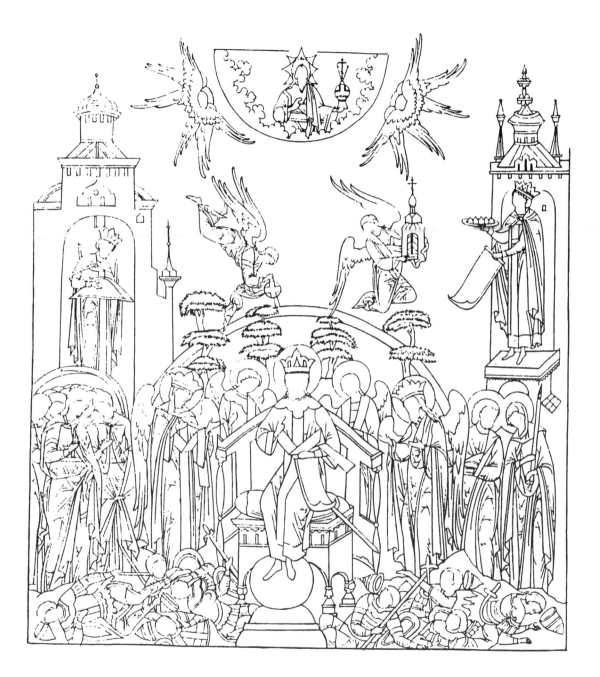

17. Переводъ образа „Предста Царица“,
изъ Филимон. собр. Общ. Др. Письм.

cf. p. 24

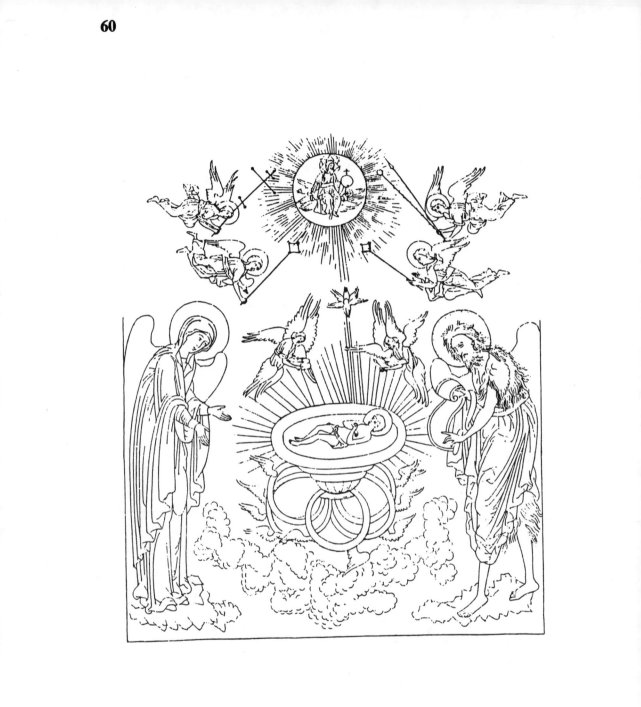

cf. p. 25

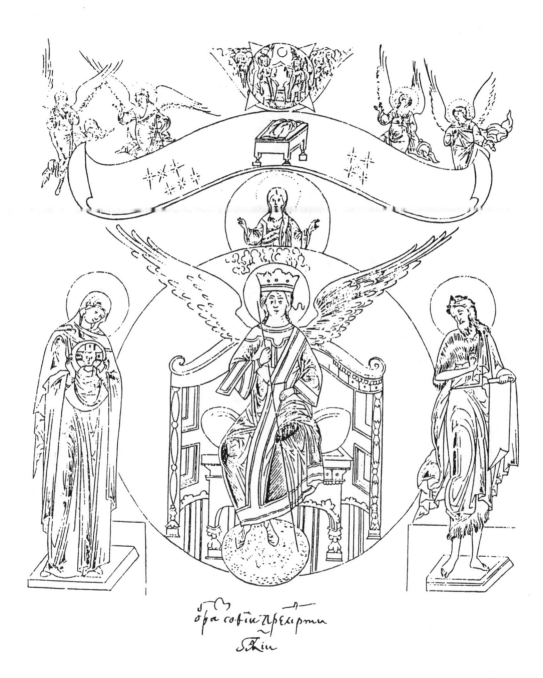

cf. p. 25

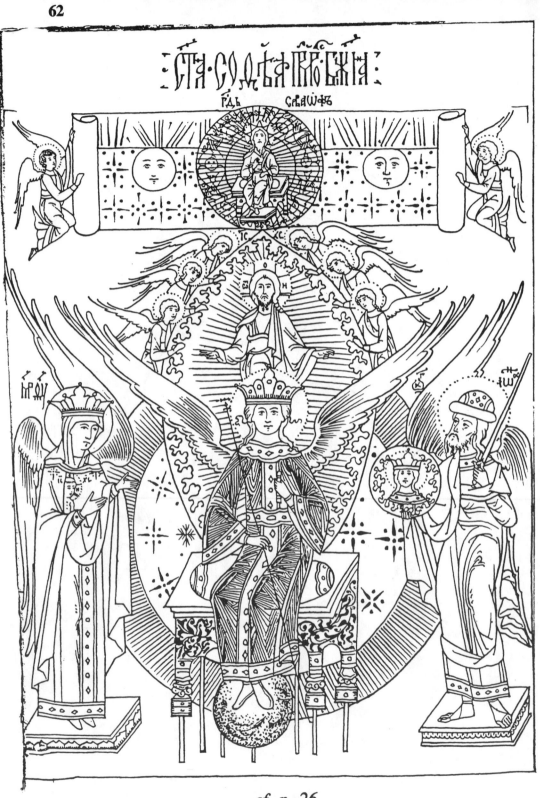

cf. p. 26

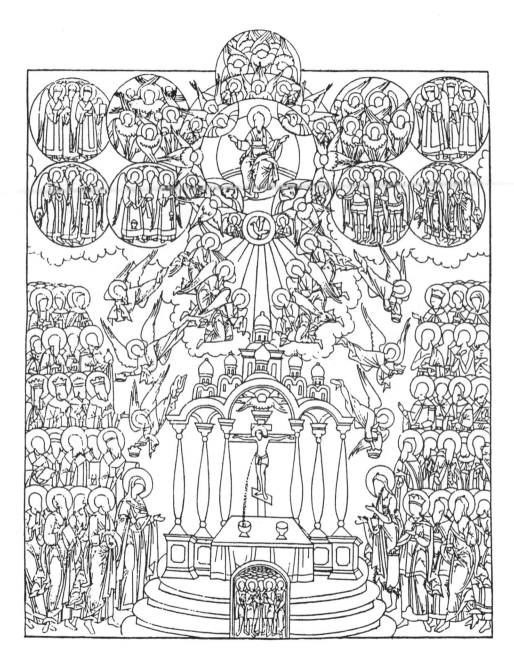

cf. p. 26

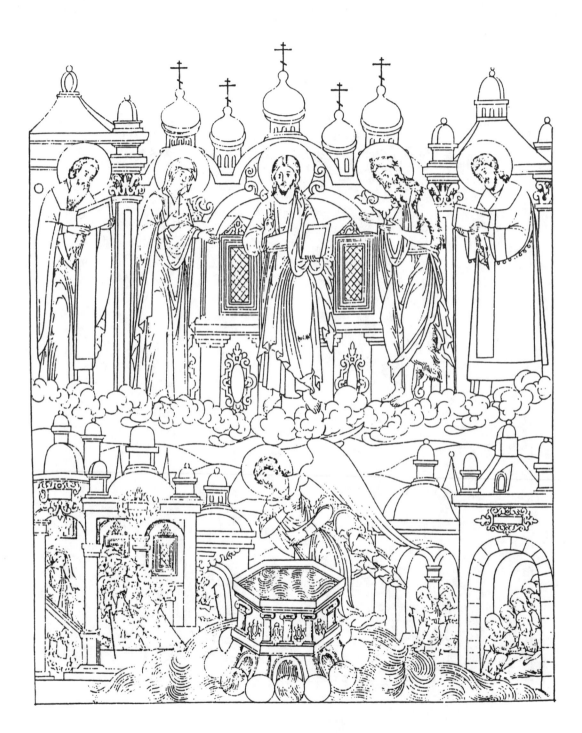

cf. p. 27

ВСѧКОЕ ДЫХАНІЕ ДАХВАЛИТ ГЅДА. ХВАЛИТЕ ЁГО СНБЅ ХВАЛИТЕ ЁГО
въвышнихъ.

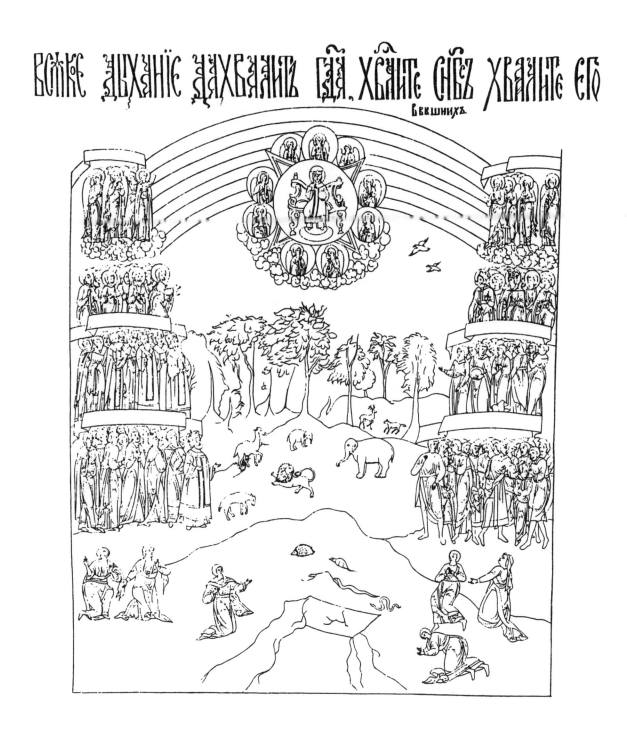

cf. p. 27

THE CIRCUMCISION *p. 90*

This depicts the Jewish ritual that took place eight days after Christ's birth. The type, called OBREZANIE in Slavonic, shows Joseph and Mary bringing their child to the Temple to be circumcised. They are met by the priest Zakharias (Zakhariya) and another.

The figure shown at the left of the example illustrated here is the Church Father Basil the Great (Vasiliy Velikiy). He is not a part of the "Circumcision" type, but was placed on the same pattern page because his day of commemoration, January 1, is also the day on which the Circumcision is celebrated.

Like many of the patterns illustrated in this book, this example is a mirror image. As a finished icon the image would be reversed.

Note the odd peaked cap worn by the priest Zakharias. It is often used in iconography to identify Jews.

Guidebooks:

Icon outline patterns were sometimes gathered together into painters' manuals called podlinniki. The most famous of such collections are the Stroganov Podlinnik (now available in reprints in the West) and the more complex Siyskiy Podlinnik (unfortunately not yet entirely available in Western reprint). Both of these were illustrated, but manuals are also found that have only written descriptions.

MID-PENTECOST *p. 91*

This type is commonly called PREPOLOVENIE, which literally means "The Middle." The middle of what? Of the period between Easter and the Day of Pentecost. That Wednesday of the fourth week after Easter became associated in the Church with Christ teaching in the Temple as an adult (John 7:14-30), or sitting among the learned doctors as a twelve-year-old boy (Luke 2:41-52), and also with Immanuel in the "Unsleeping Eye" type.

Here the boy Christ is surrounded by learned men in the Temple. They are astonished by the understanding and wisdom of the strange lad in their midst. At right are Joseph and Mary, who have just found their missing son in these peculiar circumstances.

Gold Leaf:

Gold leaf was applied to many icons after the outline had been scratched into the surface. It provided a gleaming background appropriately called the "light" (svyet) of the icon. Unfortunately it is an unstable surface for painting, and paint applied over it tends to flake off as time passes.

Not all icons had gold leaf backgrounds. Some had tinted varnish applied over inexpensive metal leaf to make it appear gold, a deception that is often very successful. Many icons had no gold, fake or real, just a solid background such as green or ochre.

Late 19th and early 20th century icons sometimes have a standardized painted background in tones graduated from blue to white.

THE SYMBOL OF FAITH *p. 92*

The "Symbol of Faith" (SIMBOLA VYERUI) is another term for the Nicene Creed, one of the major doctrinal affirmations of the Orthodox Church. It is recited in the standard Liturgy of St. John Chrysostom. It begins with the Creation and ends with the saints in Paradise, the "Age to Come."

In the center of this visual depiction of the Nicene Creed is the Council of Nicaea, with God enthroned on angels above. Among other scenes are the Creation of Adam and Eve, the Expulsion of Adam and Even from Paradise, the Annunciation to Mary, the Birth of Christ, Christ Suffering Under Pilate, the Crucifixion, the Placing in the Tomb, the Descent to Hades, the Ascension, the New Testament Trinity, and so on through the Preaching of the Apostles, the Resurrection of the Dead, and the Garden of Paradise in which Enoch, Abraham, and Isaac are seated.

Gold Highlights:

In many icons an underlying layer of gold leaf was exposed to create highlights on garments. It could also be done by a technique called inokop, in which highlights were painted on in a tacky substance such as garlic juice. When gold leaf was pressed to the surface it adhered to the sticky areas, creating gleaming details. Those less scrupulous simply used gold paint.

THE REMOVAL FROM THE CROSS *p. 93*

The SNYATIE (Removal) SO (From) KRESTA (the Cross) depicts the taking down of the body of Christ by Joseph of Arimathaea and by Nicodemus. The Mother of God (Mary) is often present, and, as here illustrated, other women as well.

The type varies in complexity and may include the darkened sun and the moon that has become as blood, as well as Lord Sabaoth and the Holy Spirit in the heavens above.

Some examples include angels on clouds, holding open books bearing the Trisvyatoe ("Thrice-Holy") prayer from the Liturgy of St. John Chrysostom: "Holy God, Holy Mighty, Holy Immortal, have mercy upon us" (SVATUIY BOZHE, SVYATUIY KREPKIY, SVATUIY BEZSMERTNUIY, POMILUI NAS). This prayer is said to have originated when, during fifth-century services to counteract an earthquake in Constantinople, a young boy heard angels singing the first three parts of the prayer; those to whom he recounted this miracle added the final "have mercy on us."

The title above the cross in this example is, in full, SNYATIE SO KRESTA GOSPODA BOGA I SPASA NASHEGO ISUSA KHRISTA — "The Removal From the Cross of the Lord God and Savior of Us Jesus Christ."

THE PLACING IN THE TOMB p. *94*

The POLOZHENIE (Placing) VO (In) GROB (the Tomb) shows the body of Christ with only the face visible, wrapped in grave clothes and being placed in a sarcophagus.

The illustration here combines it with the "Removal from the Cross" type.

The "Placing in the Tomb" varies, with some examples assimilating the Greek "Lamentation," showing the body of Christ clad in a loincloth, placed upon a sheet lying on the stone of anointing. The empty cross is in the background.

The Mother of God, Mary Magdalen, Joseph of Arimathaea, Nicodemus, John the Theologian (Evangelist) and others regard the body. Two angels, each bearing a ceremonial fan (ripida) may be included. Greek examples of this type tend toward emotionalism, but Russian painters generally gave the scene a transcendent peace.

Some icons of this type have a large inscription around the four borders — "THE NOBLE JOSEPH TOOK DOWN FROM THE CROSS YOUR PURE BODY, WRAPPED IT IN PURE LINEN, ANOINTING IT, HE PLACED IT IN A NEW TOMB" (from Matins for Holy Saturday, etc.). This inscription is also found on the Antimins, a cloth bearing the image of the "Placing in the Tomb" type, and kept on the altar. The Antimins has a saint's relic sewn into it, and is signed by a bishop, authorizing the place where it is used for celebration of the liturgy.

THE MYRRH-BEARING WOMEN *p. 95*

The ZHENUI (Women) MIRONOSITSUI (Myrrh-Bearing) type varies in the number of women depicted, as do the four Gospel accounts. The type shows the women who came to Christ's tomb and found the stone rolled away and the grave clothes lying empty. Either one or two angels may be shown beside the empty linens, again in keeping with the varying Gospel accounts. The apostles Peter and John are sometimes included, looking at the empty linens.

The Myrrh-Bearing women may also be found as a secondary scene in "combined representation" icons of the Resurrection of Christ.

Egg Tempera:

Tempera, the traditional paint for icons, consists of powdered colors, often natural minerals such as cinnabar, mixed with the yolk of an egg and a little rye beer for preservation. The precise composition of pigments varied from place to place according to what was available. Late icons painted in oils are sometimes encountered, but they are usually from the 19th or 20th centuries and Westernized in style, the product of the State Church rather than the more traditional Old Believers. Sometimes painters attempted to mix oils and tempera, often with unfortunate results.

THE EUCHARIST *p. 96*

Also called the "Communion of the Apostles" or "The Liturgy," this type represents the Last Supper transformed into the eucharistic ritual. Christ stands at a central table, the altar. Apostles approaching in a row on the left receive the eucharistic bread, and those on the right receive the wine (the illustrated two-part example is a mirror image). Two angels stand behind the altar table in some examples.

The two eucharistic elements and their reception may be shown on the same panel, in which Christ is generally pictured twice (at each side of the altar), or on separate panels.

The inscription appropriate to the reception of the bread reads PRIIMITE IADITE SIE EST TYELO MOE ("Take, eat, this is my body"). That for the reception of the wine is PIITE OT NEYA SIYA EST KROV MOYA ("Drink of it, this is my blood").

An icon of the Eucharist is sometimes found just above the Tsar Doors of the iconostasis.

The Eucharist is the chief sacrament of Russian Orthodoxy. It is held that believers who participate in it by receiving the bread and wine (administered together in a spoon) thereby become part of the mystical body of Christ. The Eucharist is also viewed as a holy mystery, a true sacrifice that unites each celebration of it with the sacrifice of Christ, thereby transcending time.

THE MYSTIC SUPPER *p. 97*

The TAINAYA (Mystic) VECHERA (Supper) is the Last Supper, the meal recorded in chapter 22 of the Gospel of Luke (and elsewhere).

Christ is seated in the center behind the table in some examples, and at the end of the table in others. The disciples are with him. Judas is generally easily recognized because he has no halo. In some versions he holds a small money bag and in others he reaches into a bowl on the table.

Assembly-line Painting:

By the nineteenth century large numbers of icons were still painted by individuals, but many workshops had adopted a system with division of labor. One man applied gesso, another gold leaf, another painted garments, another faces, and yet another added inscriptions and titles. This often made the work tedious and boring, and painters of the time were not always the saintly figures of romantic fancy. One who reads only "church" books might think that the artists were all pious monks, but by the 18th and 19th centuries that was no longer true. Icon painting had become a thriving business, and suffered from the abuses to which any form of commerce is subject.

THE RESURRECTION I *p. 98*

The VOSKRESENIE is the most important festival of the Eastern Orthodox Church. Early icons depicted it as Christ's descent into Hades to free the Old Testament righteous men and women held there in captivity. Only hinted at in the New Testament (see I Peter 3:19), the imagery comes largely from the apocryphal Gospel of Nicodemus.

The type shows Christ standing on the fallen gates of Hades. Sometimes locks, bolts, and hinges are seen scattered about. Jesus grasps the hand of Adam; Eve kneels at Christ's feet; other figures walk forth from bondage.

The example shown adds other elements to that very old scene. At bottom left the resurrected Christ climbs out of his tomb. On the right, angels bind Hades, shown as a bearded anthropomorphic figure.

Painting Order:

Backgrounds and garments were generally painted first, the hands and faces last. Hair and flesh were painted in a dark undertone (sankir), with successively lighter paint superimposed, resulting in figures that sometimes stand out noticeably above the level of the background. Lines of the hair and facial highlights were added last.

Finally the title of the icon was added in Church Slavonic, and a decorative border line about the edge completed the painting.

THE RESURRECTION II *p. 99*

This complex variant was extremely popular in the eighteenth and nineteenth centuries. It expands the old "Descent into Hades" form by adding many more righteous patriarchs, prophets, and holy women, among whom are usually Jacob, Isaac, Rebecca, Abraham, Noah, Moses, Kings Solomon and David, and John the Forerunner. They step out of the Jaws of Hell, the mouth of a great monster (borrowed from Western art). They wind upward to the Gates of Heaven at top right, where Rakh, the Righteous Thief, awaits entry to Paradise. Inside he is shown again meeting Enoch and Elijah. A six-winged Seraph guards the heavenly gates. Just above the Jaws of Hell angels descend and bind Hades, shown as a bearded devil.

In the center of the type is the Western version of the Resurrection, Christ above the empty tomb. Roman soldiers are terrified by his appearance. Originally Orthodox icons did not depict the actual Resurrection, using only the "Descent into Hades" to symbolize it. To the right of Christ an angel speaks to the "Myrrh-bearing women." At far left, Peter sees the linen grave clothes lying empty. Above is the "Doubting Thomas," the disciple putting his finger into Christ's wounded side. At lower right Christ appears at the Sea of Tiberias (John 21:4-8), and at the very top is the New Testament Trinity.

THE BIRTH OF THE MOTHER OF GOD *p. 100*

The Rozhdestvo (Birth) Presvyatoe (of the Most Holy) Bogoroditsui (Birth-Giver of God) type is derived entirely from apocryphal sources (the Protoevangelion of James, the Pseudoevangelium of Matthew). It depicts Anna, the Mother of Mary, reclining on a bed after giving birth. Servants prepare to bathe the newborn child. The father, Joakhim, looks on from the right.

This formulaic depiction is also followed in other "birth" icons such as the "Birth of Holy Nicholas the Wonderworker" and the "Birth of Holy John the Forerunner," and as there is little to distinguish one from another, attention must be paid to the titles. Some icons depict the four famous births (that of Mary, of Christ, of Nicholas, and of John the Forerunner) all on a single panel.

In the example shown, Anna, mother of Mary, is seen twice — once reclining on her bed and again seated with her child and her husband Joakhim. Two midwives prepare to wash the newborn child (lower right) and other servants attend the mother.

The "Birth of the Most Holy Mother of God" is one of the twelve great festivals of the Church year. It is celebrated on September 8 (Sept. 21 Western Calendar).

THE BIRTH OF THE MOST HOLY MOTHER OF GOD *p. 101*

This "combined representation" version details the events leading to the birth of Mary. It is a reversed image, so we begin at upper right with Joakhim and Anna in the Temple; note the anachronistic cross: to a Russian "temple" (khram) meant "church." Joakhim's gifts are refused by the priest because he and Anna have no offspring.

In the center, Joakhim, after praying in the mountains for a child, encounters the Archangel Gabriel, who assures him that Anna will give birth. Also shown is Anna, who encountered the Archangel Gabriel while walking in a garden. The angel tells Anna that she will have a child, and Anna promises to devote her promised offspring to God.

At upper left, Joakhim and Anna meet and embrace at the Gate called "Golden" (according to the Apocryphal Gospel of the Birth of Mary), rejoicing over the news each has separately received.

In the center Anna, attended by serving girls, reclines after giving birth. At lower right others wash the newborn child Mary.

At bottom, center, the nine-month-old child Mary stands precociously before her parents (according to the Protoevangelion she takes seven steps to reach her mother Anna).

In the final scene at lower left, Joakhim gives a feast for the Jewish religious officials and people in celebration of the miraculous birth of his daughter.

In the top circle is Gospod Savaof, "Lord Sabaoth."

THE ENTRANCE OF THE MOTHER OF GOD INTO THE TEMPLE *p. 102*

The VVEDENIE (Entrance) VO (Into) KHRAM (the Temple) is again derived from the Protoevangelion of James. It shows the presentation of the three-year-old Mary by her parents Joakhim and Anna to the Temple priest Zakharias (Zakhariya), father of John the Forerunner.

Mary often holds a candle, as do the virgins (sometimes represented by only one girl) in the background, an element said to be a late borrowing from the Western celebration of Candlemas.

This is one of the twelve great festivals, and is celebrated on November 21 (December 4, Western Calendar). The figure at right is the apostle Filimon (Philemon), on November 22.

The Varnish:

The surface of a completed icon was covered with a layer of a thick, protective linseed oil-resin mixture called olifa. This initially made the colors very brilliant, but over time the varnish darkened and absorbed soot and dust, obscuring the painting and eventually turning the surface virtually black. Darkened icons were often repainted over the olifa layer, sometimes in tones almost as somber as those beneath, because so much time had passed that no one remembered how bright the colors beneath had been. Some icons were repainted several times, usually with the same image, but sometimes with a completely different type. In modern times many old icons have been restored by removing the successive layers of olifa and paint, revealing the brilliant and fresh colors of the original painting.

THE ANNUNCIATION *p. 103*

The BLAGOVYESHCHENIE (Annunciation of Good News) depicts the Archangel Gabriel announcing the coming birth of Christ to Mary. In this example Gabriel stands before Mary, who sometimes (as here) holds a spindle of purple thread, an element taken from the Protoevangelion of James, in which she is said to have won by lot the right to spin the royal color purple for the veil of the Temple.

This detailed version by the noted iconographer Simon Ushakov presents buildings in bewildering detail, far removed from the simplicity of older patterns. Ushakov was noted for keeping the substance of earlier iconographic forms while altering and enriching them with techniques (such as chiaroscuro) borrowed from the West.

This is one of the twelve great festivals, and takes place on March 25 (April 7, Western calendar).

Icons in the Church:

In major churches icons were painted on walls and pillars and were set in the great icon screen separating congregation and altar, symbolizing the dividing line between

heaven and earth. They were also kept on special stands (the analoy) and were carried in procession. Some were specially made with long handles for holding them aloft. Such icons were often painted on both sides with two different images.

Some icons used in funerals were inscribed with name and date of death and were given to a church in commemoration.

THE ANNUNCIATION AND PRE-ANNUNCIATION *p. 104*

In addition to the usual "Annunciation," a variant of which is shown here, there is another related type called the "Pre-Annunciation." It is based the Protoevangelion of James story that Mary went out with a pot to draw water, and as she did so she heard the words of the Archangel's greeting but saw no one; so she returned to her spinning in the house; then Gabriel appeared to her and repeated his greeting. The type shows her startled by the unseen voice as she stands with her pot at the well. In this example God is represented by a triangle in the clouds (a Western borrowing), from which the Holy Spirit flies down in the form of a dove.

Icons and children:

An Orthodox child was taken to the church to be given a name by the priest on the eighth day after birth. The name was that of a saint. The child might be given an icon of his or her patron saint. Such an icon was called a "name day" or "angel day" icon, because the name saint was like a guardian angel to the child. Children were often not baptized until forty days after birth.

There is a particular type of icon called a razmernaya ("measured") icon, which is painted on a wooden panel cut to the length of the newborn child.

THE NATIVITY OF OUR LORD JESUS CHRIST *p. 105*

The ROZHDESTVO (Birth) GOSPODA (of the Lord) NASHEGO (of Us) ISUSA KHRISTA (Jesus Christ) depicts the Mother of God lying before a cave in a hill. The newborn Christ lies in a manger within the cave (sometimes outside), watched by an ox and an ass. The type may include angels, shepherds (at least one usually has a horn), and the approaching three Magi.

Many examples depict Joseph, Mary's husband, listening gloomily to an old shepherd who is traditionally seen as the Devil in disguise. The Evil One is tempting Joseph to doubt the truth of the incarnation and virgin birth.

A midwife named Zelomi, preparing to wash the newborn child, is often included. With her is another named Salome (Baba Solomiya), who, though a first cousin of Christ's mother, questioned her virginity. She touched Mary to test her physically, and as punishment Salome's hand withered. It was healed when she repented. This story is related in the apocryphal Protoevangelion of James.

The traditional Orthodox Nativity disappoints Westerners used to the innocent joy of Italian and German Nativity scenes. When Western depictions began to strongly influence Russian iconography (particularly in the 17th century), the Birth of Christ took on a more cheerful and intimate aspect.

The Nativity is one of the twelve major festivals, but is of less importance than Easter, the Baptism of Christ (Epiphany) and Pentecost. It is celebrated on December 25 in the Old Calendar, January 7 in the New Calendar.

THE ASSEMBLY OF THE MOST HOLY MOTHER OF GOD *p. 106*

This SOBOR PRESVYATUIYA BOGORODITSUI type, which should not be confused with the Nativity, is also sometimes called "What Shall We Bring You?" The latter title is taken from the Christmas Vespers, which asks, "What shall we bring you, O Christ, who for our sake appeared as man on earth?". Then it describes how the angels offer a hymn, the heavens a star, the Magi bring gifts, the shepherds offer their amazement, the earth gives its cave, the wilderness gives a manger, and mankind offers Christ his virgin Mother.

Mary is seated in a central circle with the Christ Child. Above her, angels give their song. To the left, Magi approach with gifts. At right are the amazed shepherds. A woman on one side symbolizes the earth offering the cave where Christ was born, and another woman on the opposite side offers the manger. A crowd of singers stand in the lower center. On one side of them is St. John of Damascus with a scroll reading "In you rejoices...", and on the other side stands Euthemius (Evfimiy) the Great. This is not one of the major festival types.

The saint on the right, Stephen the First-martyred, is included on this podlinnik page because his day of celebration is on December 27, immediately following the celebration of the Assembly (Russian Sobor, Greek Synaxis) of the Mother of God on December 26.

THE THEOPHANY OF OUR LORD JESUS CHRIST *p. 107*

The BOGOYAVLENIE (Theophany) depicts the baptism of Christ (kreshchenie Khristovo) in the Jordan River by John the Forerunner (the Baptist). The Holy Spirit descends from Heaven as a dove in an eight-pointed aureole of light, or as here, in a circle radiating three beams of light.

Three angels are usually included in this type, their hands covered with cloths as a sign of veneration. Some examples also include the figures of a man and woman in the waters of the Jordan. The man represents the River Jordan, divided by the Old Testament prophet Elijah, and the woman represents the (Red) Sea, divided by Moses. The two events were considered prefigurations of the Baptism of Christ. The anthropomorphic river and sea may also be seen as survivals of the pagan personification of nature.

The abbreviated inscription at top reads OBRAz BGOYAVLNIYA GA NSHGO ISHA KHA — in full, OBRAZ (the Image) BOGOYAVLENIYA (of the Theophany) GOSPODA NASHEGO (of Our Lord) ISUSA KHRISTA (Jesus Christ).

This is one of the major festivals, and is celebrated on January 6 "Old Style" and January 19 "New Style."

Some modern conservative Orthodox hold that the Holy Spirit may only be depicted as a dove in icons showing the Baptism of Christ, but that was not the common practice.

THE TRANSFIGURATION OF THE LORD *p. 108*

The PREOBRAZHENIE GOSPODNE (Transfiguration of the Lord) depicts Jesus surrounded by light, with Moses on one side and Elijah on the other. The disciples Peter, John, and James fall to earth in awe at the sight. The incident took place on Mount Tabor, and is mentioned in the Gospels (Matthew 17:1-9 and elsewhere). This is one of the twelve major festivals, and is celebrated on August 6th of the old calendar, August 19th of the new.

Transfiguration is an important concept in Russian spirituality, which experienced a great revival in the 18th and 19th centuries under such teachers as Paisiy Velichkovskiy and Seraphim of Sarov. It was believed that a highly-developed individual might see the Light of the Transfiguration, and that at the end of time the cosmos would return to a transfigured state.

The meditative practice leading to witnessing the Light of Tabor is called Hesychasm, from the Greek word for stillness. It is a method of prayer similar in some respects to the Hindu repetition of a mantra or the Buddhist practice of reciting the Buddha's name. The Russian "mantra" was GOSPODI IISUSE KHRISTE SUINE BOZHIY POMILUI MYA GRYESHNAGO — "Lord Jesus Christ, Son of God, Have Mercy on Me, a Sinner." The best introduction to the subject is *The Way of a Pilgrim*, which recounts the experiences of a humble Russian man who learned the method of ceaseless prayer from an elder (staretz). The book is titled in Russian *Otkrovennie rasskazui strannika dukhovnomu svoemu otsu* — "Sincere Tales of a Pilgrim to his Spiritual Father."

THE DORMITION OF THE MOTHER OF GOD *p. 109*

The USPENIE (Dormition) depicts the death of Mary. Tradition relates that when her death drew nigh, angels brought the Apostles from different parts of the world to be present at her side (Thomas, who arrived later, should correctly be omitted but often is not). In the example illustrated, the Apostles are seen arriving in clouds pushed by angels.

Christ stands behind the recumbent Mother of God and receives her soul, represented as an infant. The Apostles stand around her. A fanatical Jewish priest (sometimes named Iefoniya or Athonios) often stands before the bier on which Mary lies. Attempting to

push it over, he had his hands cut off by a sword-wielding angel (he later repented and was healed).

In the circle at upper center is Mary enthroned and ascending heavenward, an element not part of early iconography of the festival.

The story of the Dormition (i.e. "Falling Asleep") is based largely on a fourth or fifth-century apocryphal work called *The Discourse of Holy John the Theologian Regarding the Dormition of the Mother of God.*

One sometimes sees images of the Coronation of Mary, her crowning as Queen of Heaven. Such depictions, found in late icons, are a borrowing from the West and were not part of early Russian iconography.

The "Dormition" is one of the twelve major festivals, and is celebrated on August 15 Old Style, August 28 New Style.

THE APPEARANCE OF THE MOTHER OF GOD ON THE THIRD DAY AFTER HER DORMITION *p. 110*

Tradition says the Apostle Thomas was not present at the Dormition of the Mother of God, but was so distraught that the other Apostles took him to her tomb. When opened, the tomb was found to be empty, with only a fragrance from the empty burial garments remaining. On the evening of that day the Apostles gathered together and, as was their custom, left one place at table vacant in remembrance of Christ, placing a piece of bread there as his portion. After eating, they held aloft Christ's piece of bread, beseeching him for help, and then ate it as a blessing. On that night Peter had just raised the piece of bread when the Apostles heard the singing of angels and saw above them the Mother of God surrounded by angels and light. She told them that she would be with them "all the days," and the Apostles responded, "Most holy Mother of God, help us." This is said to be the origin of the piece of bread representing the Mother of God that is set aside in the Eucharist; it is named (in Greek) the Panagia after her, meaning "All-Holy."

At top: Christ; below him Holy Wisdom, John the Forerunner, John the Evangelist (crowned and winged, holding the sun and moon); center: The Mother of God; base: The Apostles, Peter in the middle; Old Testament prophets on outer edges: Daniel, Isaiah, Zechariah, Solomon, Jonah, Jeremiah, Moses, Zephaniah, Ezekiel, David, Aaron, Habbakuk.

THE ELEVATION OF THE CROSS *p. 111*

The **VSEMIRNOE VOZDVIZHENIE CHESTNAGO I ZHIVOTVORYASH-CHAGO KRESTA** (The Universal Elevation of the Honorable and Life-giving Cross)

is based on a ceremony that is believed to have originated in Jerusalem after the dedication of the Basilica of the Resurrection, built by the Emperor Constantine, whose Edict of Milan legalized Christianity in the Roman Empire.

Tradition relates that Constantine's mother Helena discovered the true cross of Christ. Bishop Makarius had pointed out to her the site where the Holy Sepulchre was said to be, and there she found three crosses, one of which was recognized as the cross of Christ after a dying man was healed by it.

The type depicts the cross being raised up before the people. In some examples it is held only by Bishop Makarius of Jerusalem, in others by both Makarius and Bishop Sylvester. The Empress Helena and the Emperor Constantine look on. In the pattern shown, Bishop Makariy holds his hands aloft, but they are empty; the painter would have added the cross to the finished icon.

The date above the main image is September (SENTYABR) 14. The secondary image for September 15 is the great Martyr Nikita. The Elevation of the Cross is a major festival held on September 14, New Style September 27.

THE DESCENT OF THE HOLY SPIRIT *p. 112*

The SOSHESTVIE SVYATAGO DUKHA depicts the descent of the Holy Spirit upon the Apostles on the Day of Pentecost (Acts 2). Twelve apostles are inside a room. The Mother of God is sometimes among them. The flames of the Holy Spirit descend on each of them.

Another variant (seen here) shows the twelve seated in a semicircle. They hold books or scrolls. Below is a crowned man holding a cloth between his outstretched hands. He symbolizes the world (cosmos), which once was pure but is now tainted by sin. His crown symbolizes the rule of sin, and he is in a dark place, the world without faith. He is old, aged by the sin of Adam. On his cloth are twelve scrolls, the teaching of the Twelve Apostles. A gap between Peter and Paul, who sit at the top of the semicircle, is the place invisibly occupied by Christ as head of the Church.

The "Descent of the Holy Spirit" is a major moveable feast.

Unit of measurement:

Russian icons were measured in vershka (one vershok = .7 inches).

THE ENTRANCE INTO JERUSALEM *p. 113*

The VKHOD VO IEROUSALIM type varies from example to example in the number of persons included. It shows Christ riding upon an ass, entering Jerusalem in the company of his disciples as the palm-waving crowds (sometimes represented by only one man!) look on.

The reversed pattern shown here was created by someone who had obviously never

seen a palm tree, but who did his best with the kind of tree familiar to him.

The "Entry into Jerusalem" is a major moveable feast.

Metal ornamentation:

Famous early icons were often decorated with gold and gems as a sign of veneration. By the 16th century many were decorated with tooled or embossed sheets and strips of silver. These were nailed directly onto the painted surface of the icon, leaving the face, hands, and often the body visible. In the 17th century ornate metal halos affixed to the heads of saints were particularly popular, along with a metal crescent (tsata) suspended at the saint's neck.

THE ASCENSION OF THE LORD *p. 114*

The VOZNESENIE GOSPODNE is recorded in the Gospels of Mark and Luke and in the Book of Acts. The type depicts Christ rising to heaven in a circle of light, often supported by angels. Two angels on the hill below gesture toward him while his disciples look on in wonder. The Mother of God is frequently placed in the center with onlooking disciples.

It is interesting to note how the "Appearance of the Mother of God after her Dormition on the Third Day" type is based on the resurrection and ascension of Christ. In both the tomb was found empty, and in both the transference to heaven is visibly seen. This apocryphal patterning after the Gospel events related of Christ shows the increasing importance accorded Mary in the Church.

The "Ascension" is a major moveable feast.

Writing an Icon?

In Russian the word for both writing and painting is pisat. *Consequently some contemporary icon enthusiasts and painters in English-speaking countries speak of "writing" an icon. This is good Russian but bad English, and though theological excuses are often made for use of the term, it is best avoided as an affectation.*

THE MEETING OF THE LORD *p. 115*

The SRETENIE GOSPODNE depicts the infant Christ in the arms of the aged Simeon BOGOPRIYMETS (the "God-Receiver" — see Luke 2:25-38), who met him in the Temple at Jerusalem when he was brought there by Joseph and Mary to be presented to the Lord.

The elaborate variant example shown here illustrates Kontakion seven of the Akathist of the Annunciation. Simeon holds Christ, Mary stands before him, and behind Mary are the Prophetess Anna and Joseph, who holds the doves for sacrifice. Behind Joseph is a crowd of others, usually not found in simple versions.

The scene takes place in front of very elaborate background buildings. Notice the curtain on the right, which swirls around a column. It is a late form of the old symbolic cloth placed between two supports to show that a scene takes place in an interior.

The figures at the center of the base visually depict Simeon's prophecy concerning the Christ Child — "Behold, this child is set for the fall and rising of many in Israel."

The "Meeting of the Lord" is a major festival celebrated on February 2 Old Style, February 15 New Style.

SIMEON THE GOD-RECEIVER *p. 116*

This type eliminates the Temple background of the "Meeting of the Lord" festival type, showing only the aged Simeon holding the Christ Child.

The reader may have noticed by now that even icons showing Biblical scenes represent them as formalized parts of the intricate structure of the calendar and liturgy of the Church. There are days on which certain events are commemorated and days on which certain saints are commemorated. Each has its place and position in the calendar and liturgy, and all are fitted into the vast ritual structure, just as icons within a church are fitted into an organized pattern within the elaborate framework of the icon screen or ikonostas.

The one-piece metal cover:

By the eighteenth century the taste for metal ornament led to the introduction of a one-piece icon cover of brass or silver (or silvered brass or gilded silver). It frequently covered all the surface except the saint's face and hands. Costumes and backgrounds were reproduced on the metal covering by engraving or repoussé work. Such a cover is called a riza (sometimes also oklad).

THE RAISING OF LAZARUS *p. 117*

The VOSKRESENIE LAZAREVO illustrates John 11:43-44. Lazarus, rising from the dead and still wrapped in grave clothes, is seen emerging from the tomb. Christ gestures toward him.

This scene is found on some "Resurrection and Major Festivals" icons, those that expand the twelve feasts around the central image to fourteen or sixteen festivals. In the latter case the festivals shown are: The Birth of the Mother of God, the Presentation of the Mother of God in the Temple, the Holy Trinity, The Annunciation, the Birth of Christ, the Baptism of Christ, the Transfiguration of Christ, the Dormition of the Mother of God, the Pokrov (Protection) of the Mother of God, the Fiery Ascension of Elijah, the Elevation of the Cross, the Cutting Off of the Head of John the Forerunner, the Resurrection of Lazarus, the Ascension of Christ, the Entry of Christ into Jerusalem, and the Presentation of Christ in the Temple.

Dating Rizi:

Rizi were often very elaborate, reflecting the taste of the period in which they were made. From the time of Tsar Peter the Great, silverwork had to be stamped with the town hallmark, date of manufacture, and percentage of silver contained. The maker's initials were frequently added as well, making dating an easy matter. New covers were often added to old icons, though, so the date of the riza is not always a reliable indication of the date of the icon.

THE PROTECTION OF THE MOST HOLY MOTHER OF GOD *p. 118*

The POKROV PRESVYATUIYA BOGORODITSUI commemorates an event said to have occurred in 911 A.D. when the people of Constantinople were threatened by Saracen invasion. They fled to the Church of the Vlakhernae (Blachernae) and implored the aid of the Mother of God. The Holy Fool for Christ's Sake Andrew (Andrey) and his disciple Epiphanius (Epifaniy) saw Mary appear in the air over the assembled people. She held a veil in her hands and spread it over the crowd as a sign of protection.

In the example shown, Mary stands on a cloud within the church, accompanied by saints such as John the Forerunner and the Apostles Peter, Paul, and John. At lower right Andrew points out the vision to Epiphanius. Below the Mother of God stands Romanos the Melodist, a famous hymnographer of the 6th century. He is included because his feast day is on October 1, the same day the "Protection of the Most Holy Mother of God" is celebrated (October 14 New Style) — and also because he composed the most famous of all Orthodox hymns to Mary, the Akathistos (Russian Akafist), meaning "Not Seated," so called because it was sung while standing. To the left of Romanos is Tarasios, Patriarch of Constantinople, and the Emperor Leo and Empress Zoe. In a small scene near center, left, Romanos the Melodist, deacon of the Church of Holy Wisdom in Byzantium, lies on a bed as the Mother of God gives him a scroll to eat, after which he was able to sing well.

THE CUTTING OFF OF THE HEAD OF THE HOLY PROPHET JOHN THE FORERUNNER *p. 119*

The USEKNOVENIE GLAVUI SVYATAGO PROROKA IOANNA shows the execution of John as described in Matthew 14:1-12. In the illustrated example, He is seen in prison at far left, and again at bottom left, being led to execution. In the center is the execution, which overlaps the next episode, John's body lying on the ground as his head is presented to Salome upon a salver. At upper right Salome returns to court with John's head. At the top is Lord Sabaoth in clouds. An angel descends to comfort John in prison.

In spite of the gruesomeness of the event, Russian painters generally gave the faces

of John and his executioner a completely unemotional and detached appearance.

This type is often included in "Resurrection and Major Festivals" icons having more than twelve festivals.

All is not gold that glitters:

Many rizi are superb examples of craftsmanship, decorated with intricate cloisonné enamel and set with precious or semiprecious stones. Some metal covers, however, are more show than substance. "Gold" rizi often have only a thin gold wash over silver. Some "silver" rizi have only a thin layer over brass, and impressive gems and nets of pearls may be only glass.

THE FIERY ASCENSION OF ELIJAH THE PROPHET *p. 120*

The OGNENNOE VOSKHOZDENIE ILIY PROROKA shows the Old Testament prophet Elijah ascending to Heaven in a fiery chariot as described in 2 Kings 2:11-13. As he departs he drops his mantle to his successor, Elisha. The example shown has related scenes — Elijah dividing the Jordan River by striking it with his mantle (center), Elijah fed in the wilderness by an angel (I Kings 19:5-8), and Elijah fed by a raven beside the Brook of Cherith (I Kings 17:4-6).

Elijah was very important to Russian peasants because he was believed to control storms and lightning. Thunder was caused by the wheels of his fiery chariot as it rolled across the cloudy skies.

This type may be included in "Resurrection and Major Festivals" icons showing more than twelve scenes.

SIX-DAY ICON *p. 121*

This SHESTODNEV ("Six-Day") type shows the days of the week represented as festival types. It is a mirror image, so it actually begins at upper left with the "Resurrection" ("Descent into Hades"):

Sunday: Resurrection
Monday: Assembly of the Archangels
Tuesday: Beheading of John the Forerunner
Wednesday: Annunciation
Thursday: Footwashing
Friday: Crucifixion

The decline of Icon painting:

Icon painting declined near the end of the 19th century and by the 1920s it was almost gone in Russia. There were two reasons for this: First, a flood of cheap icons printed on paper and tin came on the market in the late 1800s. Ordinary painters could hardly

compete, and some workshops even began to buy printed icons, selling them after adding a cheap riza to increase the appeal; second, the fall of the Russian monarchy and the rise of the Communists to power severely affected icon painting and all religious activity. Old churches were torn down or turned into warehouses, and countless icons were destroyed by action or by neglect.

THE WEEK *p. 122*

We have seen that the "Six Day" type represents all the days of the week except Saturday as festival types. This SEDMITSUI ("Of the Week") type adds that missing day.

At upper left is the "Resurrection" (Sunday); opposite it is the "Assembly of the Archangels" (Monday); then the sequence continues through the "Beheading of John the Forerunner" (Tuesday), the "Annunciation" (Wednesday), the "Footwashing" (Thursday) and the "Crucifixion" (Friday).

Saturday is added as a gathering of "All Saints," and occupies most of the lower part of such icons.

Also shown in the illustrated example are, top center, the "Seven Days of Creation"; below that, Lord Sabaoth "Among the Powers"; below that is the Deisis.

In the center of the bottom portion is the Tree of Paradise, with the serpent (holding the apple) twined about it, and Adam on the left and Eve on the right. Below are saints clothed in white (Revelation 3:5). Sometimes the Hetimasia or "Preparation of the Throne" is found (see Psalm 9:7-8).

THE "OUR FATHER" *p. 123*

The "Our Father" (Otche Nash) type visually depicts the Lord's Prayer (Matthew 6:9-13) as a sequence of scenes illustrating the lines of the prayer. The scenes depicted vary from example to example. Here is the Lord's Prayer in Church Slavonic:

OTCHE NASH, IZHE ESI NA NEBESYEKH, DA SVYATITSYA IMYA TVOE: DA PRIIDET TSARSTVIE TVOE; DA BUDET VOLYA TVOYA, IAKO NA NEBESI, I NA ZEMLI. KHLYEB NASH NASUSHCHNUI DAZHD NAM DNES: I OSTAVI NAM DOLGI NASHA, IAKO I MUI OSTAVLYAEM DOLZHNIKOM NASHUIM: I NE VVEDI NAS V NAPAST, NO IZBABI NAS OT LUKAVAGO. IAKO TVOE EST TSARTSVIE I SILA I SLAVA VO VYEKI, AMIN.

Icon ornaments: Drawbacks and deception:

Decorative metal ornaments and covers often detract from the painting itself. In some cases the riza is of higher quality than the painting.

The addition of silver ornaments and covers explains the countless icons one encounters with rough nail holes defacing the painted surfaces from which such objects have been removed.

In the late 19th century one-piece covers were often added by workshops to disguise the fact that only the faces and hands of the saints depicted had been painted. The rest of the panel was often not even covered with gesso, just left as raw wood. Such icons were usually cheap, Westernized, and often quite small.

THE TERRIBLE JUDGMENT *p. 124*

The STRASHNUIY SUD type is complex and variable, illustrating the events of chapter twenty in the Apocalypse, the Revelation of St. John.

In the center is a modified "Deisis" with Adam and Eve kneeling before Christ. At each side the Twelve Apostles join Christ in judging humanity (Matthew 19:28)

Below is the altar "throne" (prestol) covered with the mantle of Christ, on which is opened the Book of Life containing the deeds of all people. Two angels support the cross or bear scrolls inscribed with Matthew 25:34 and 25:41 (sometimes Revelation 20:12 and 20:15), or they hold the book of Life open. This altar representation is the "Preparation of the Throne" (Greek Hetimasia) — the altar is the "throne" of Christ, readied for judgment.

Multitudes come to the throne. Below it a naked human awaits the weighing of his good and bad deeds in the Scales of Judgment, a motif as old as the Egyptian *Book of the Dead*. Scrolls with good deeds are loaded on one side (the "right hand" of Christ), and those with evil deeds are placed on the left. A demon tries to weight the scales against the soul being judged.

Angels blow trumpets calling all to judgment; the earth and sea give up their dead (Revelation 20:13), and animals and fish expel humans they have eaten.

On the right of many examples four circles are often found containing the four strange beasts mentioned in the seventh chapter of Daniel. They are variously interpreted; one source gives the bear as Babylon, the leopard as the King of Macedonia, the lion as Rome, and the horned beast as the Antichrist.

At left, below the scales, the blessed enter Paradise. St. Peter unlocks the door to admit them. Inside are seated Abraham, Isaac and Jacob, with the souls of the righteous depicted as little children. Behind them stands RAKH RAZBOINIK, "Rakh the [Repentant] Thief."

At right the wicked, driven by demons, enter the Jaws of Hell. There Satan is seated holding the soul of Judas, or sometimes that of the rich man who would not help Lazarus (Luke 16:19-31).

A great serpent with rings along its length winds up from Hell toward the heel of Adam (see Genesis 3:14-15). Each ring represents a type of sin. Together the rings comprise the so-called "tollhouses" through which the departed soul passes, being examined at each for the sin it represents.

At the base of the type are chambers in which humans suffer the various "tortures of Hades" (Muki Ada). At upper left, in contrast, the blessed find peace in different

rooms symbolizing the "many mansions" of John 14:2.

At far right, rebellious angels driven from Heaven by St. Michael fall headlong as demons into Hell. On the far left, holy monks ascend to Heaven on wings, like angels.

CHRIST AND THE GADARENE SWINE *p. 125*

Some icons are essentially illustrations of episodes in the Old or New Testaments. They are usually easily identified by anyone with a general knowledge of the Bible.

The illustrated example shows such a type — Christ casting out demons from the possessed men who lived among the Gergesene or Gadarene tombs (Matthew 8:28-33, also Mark 5:1-20). Christ gives the expelled demons permission to enter a herd of swine. The unfortunate animals rush down a hill into the water and are drowned. This pattern shows how demons were often visualized and painted in Orthodox Russia. Note that the hair on their heads stands up straight. There are many accounts of early Russian monks encountering demons, even within monasteries.

The origin of Icons:

Icons originated in the art of the pagan world as exemplified by the mummy portraits and religious art of Greco-Roman Egypt. Mummy portraits in the Faiyum district bear striking, often beautiful wide-eyed portraits of the deceased "painted" with hot wax on wood (a technique called "encaustic"). Icons of Mary nursing her child are reminiscent of representations of the Goddess Isis nursing her divine son Horus, and even the title "Mother of God" (in Egyptian Mut Netjer) was earlier applied to Isis. Icons of George and the Dragon are paralleled in Egypt by the God Horus, mounted on a horse and dressed in Roman armor, striking with his lance at the evil Set, shown as a crocodile.

THE ARCHANGEL MICHAEL *p. 126*

The angels, also called "Bodiless Powers," are frequently found in icons as secondary figures, but some have their own types. Michael (Mikhail) is the great heavenly soldier, the chief captain of the hosts of Heaven who fights against the powers of evil. He may bear a trident or lance, a staff, or a sword.

In this mirror-image pattern he is ornately robed, bearing in his right hand a circle containing the type "The Assembly of the Archangel Michael." Just above it is a smaller circle with "Lord Sabaoth." The ruffled interior edges of these circles and of the oval in which Michael stands represent clouds.

On Michael's right (his left in a finished icon) the fallen angels are being cast out of Heaven, plunging headlong into the Jaws of Hades. In the lower corner opposite is the monk Arkhipp, whose church was saved from a flood when St. Michael struck the earth with his lance and opened a gap into which the waters plunged. This "Miracle of Holy Michael at Khonae" is also found as a separate icon type.

MICHAEL ARKHISTRATEGOS *p. 127*

This popular type is based on the Book of Revelation. It depicts Michael as the chief captain (Greek Arkhistrategos, Russian Voevoda) of the heavenly armies, crowned and riding upon a winged horse. A rainbow extends over his head, a lance is in one hand and a censer and book in the other. A long horn (trumpet) extends from his mouth (this image is reversed).

Michael is shown defeating Satan, who has fallen at the base beside tumbled buildings; often the buildings are in a flaming abyss (the Archangel Michael is associated both with the Old Testament destruction of Sodom and Gomorrah and with the visionary destruction of Sodom in the Apocalypse). At upper left is Christ Immanuel before the Hetimasia, the prepared altar which is also the symbolic throne of Christ.

Some examples have inscriptions reading "From the Gospel goes forth the Word of God to all the world"; "From the censer goes forth a sweet fragrance to all the world"; "From the trumpet goes forth a great voice to all the world." Beside the Hetimasia may be found the words "Thy throne, O God, is forever and ever."

THE ARCHANGEL MICHAEL *p. 128*

Here Michael is shown with the Heavenly Powers, the ranks of angels. He holds a sword and stands on the defeated Devil. At the top of the image is a circle with the "New Testament Trinity."

Michael wears the garments of a soldier. Similar clothing is used for soldier-saints like St. George and St. Demetrius.

Metal Icons:

Cast metal icons were very popular in the 18th and 19th centuries. They had three virtues: Cheapness, durability, and portability. They were generally from the conservative workshops of the Old Believers, who gave the faces of Christ and the saints a primitive charm that is sometimes quite barbaric. Most were cast in brass, and may be gilded or silvered, and some have colored enamel baked onto the surface. Often diptychs, triptychs, or polyptychs are found, their panels joined together by hinges. Such a skladen or "folding" icon was very popular, as were cast brass crucifixes.

Metal icons were easily cared for. Tarnish was removed by rubbing the surface with powdered chalk. Unfortunately icons that were frequently polished often have the features of the saints worn away.

THE ASSEMBLY OF THE ARCHANGEL MICHAEL *p. 129*

The Archangel is shown in the center of a gathering of angels. A disk is held before him on which Christ Immanuel is seen. "Assembly" is Sobor in Slavonic and Synaxis

in Greek.

The inscription is SOBOR STAGO ARKHISTRATIGA MIKHAILA I PROCHI NBNUI SIL; with missing letters added it reads "The Assembly of the Holy General Michael and the Other Heavenly Powers."

Icons — A medieval survival:

Icons are essentially a medieval art form that has survived into the 20th century. Even the materials used — a wooden panel to which cloth is affixed, gesso, gold leaf, powdered colors mixed with the yolk of an egg — are basically those of the medieval artist in Western Europe. But the West abandoned tempera paints and wooden panels centuries ago for oil paints and canvas.

Western Renaissance painters of religious scenes often used relatives, friends, or people from the streets as models for the saints. In Russia this was considered blasphemous. Orthodox saints were generic, abstract figures painted according to traditional rules that set forth the shape of hair or beard, the type of garment worn, and the colors of the garments. To distinguish similar-appearing saints, the name was inscribed beside the figure or inside the halo. Such abstraction was intended to show the spiritual nature rather than the actual physical form.

THE MIRACLE OF THE ARCHANGEL MICHAEL AT KHONAE *p. 130*

According to legend, in early Christian times there was a Church at a place called Khonae. It was faithfully watched over by the priest Arkhippus.

Pagans in the area did not like the church being there, so they conceived a plan to eliminate it. They decided to divert two streams so that they would flood and overwhelm the building. Arkhippus, seeing the great flood of water rushing against his church, prayed to God to protect it. In response the Archangel Michael appeared in a burst of light, and struck the ground at the church with his lance. A great cavern opened up in the rock, swallowing the onrushing flood into its depths. Thus the church was saved.

This example shows clearly the men at work in the mountains diverting the streams. Two of them are being swept away in the flood.

Archippus bows humbly before his church as the Archangel Michael disperses the waters.

THE ARCHANGEL GABRIEL *p. 131*

Gabriel (Gavriil) is depicted much like Michael, though usually without a sword. He is the angel of the "Annunciation," and revealed to Mary that she was to give birth to Jesus. In the example shown here he is shoulder-length, his head tilted slightly as it would be if he were part of a "Deisis." Gabriel is also found in an "Assembly" type much like the "Assembly of the Archangel Michael."

Gabriel and Michael are often represented bearing transparent disks that may be inscribed with the IC XC abbreviation for Jesus Christ, or sometimes only cloud-like designs. Some sources interpret the disk as a globe, but that is misleading for two reasons: First, readers may inaccurately assume that the sphere of the earth is meant. Second, in Russian iconography the object is more commonly shown as a flat, transparent disk representing a zertsalo or mirror, rather than as a sphere. The object originated in pagan times as a spherical orb symbolizing the sovereignty of the bearer. In early Byzantine art it is held by rulers, and this usage was transferred to the Archangels as heavenly powers. Very old depictions of Michael show him holding a spherical orb surmounted by a cross. It represents the kosmos (universe) under the rule of Christ. In Russian iconography it often becomes, as we have noted, a transparent disk of varying size which often acts as a sigil or seal of Christ, bearing the abbreviation of his name.

THE ASSEMBLY OF THE ARCHANGELS *p. 132*

This SOBOR depicts Michael and Gabriel together, and between them is a disk on which is the image of Christ Immanuel. A crowd of angels is grouped behind them. The roughly-written title at upper right, with missing letters added, reads ARKHAN-GELSKIY SOBOR — "The Archangelic Assembly."

Increased Western influence:

Western influence on Russian art strongly increased in the middle of the 16th century. Icon painters impressed by the religious engravings in Western works such as Piscator's Bible began introducing more realism into icons. Such influence was generally avoided by the conservativeOld Believers, who kept alive the old abstract forms into the 20th century.

As time went by, the State Church became so heavily influenced by Western art that some 19th century icons look much like Italian Roman Catholic religious paintings.

This change did not happen without controversy. In the 17th century Patriarch Nikon had the eyes of Westernized icons put out with hot irons.

THE GUARDIAN ANGEL *p. 154*

The Guardian Angel (Angel Khranitel) is the spiritual being who watches over each human. He is found as a secondary figure on many icons, and is also frequently found as a "border saint" outside the main image.

In this reversed image the Guardian Angel is set amid scenes showing the life and death of a pious man (left). He spends his time in moderation, and listens to spiritual reading, as shown at lower left. When he dies (upper left), his soul is received by an angel and is carried as an infant to Christ. (text continues on p. 133)

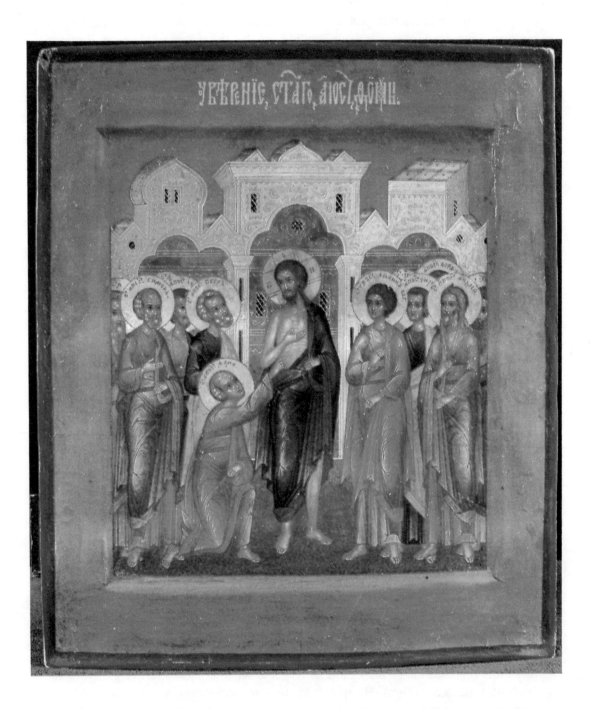

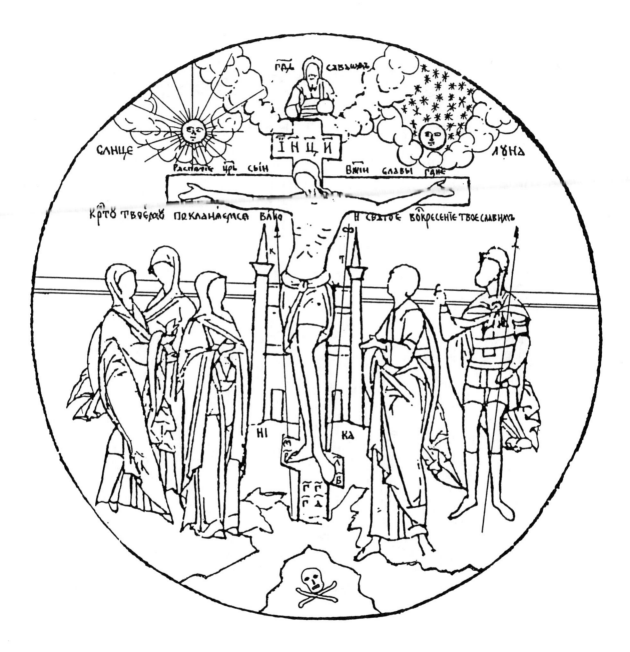

cf. p. 28

ОБРѢЗАНІЄ ГОСПОДНЄ И ВАСИЛІЙ ВЕЛИКІЙ.

cf. p. 66

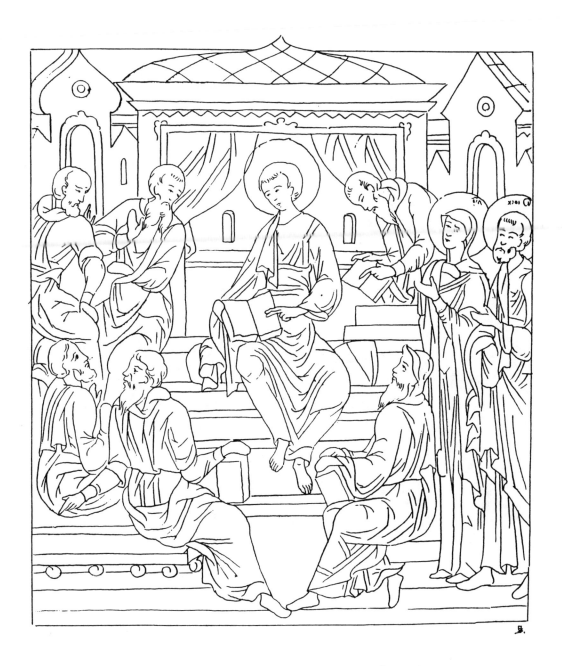

ПРЕПОЛОВЕНІЕ ИЛИ 12ᵀᴴ ЛѢТНІЙ ЇC. ХР҃. ВО ХРАМѢ

cf. p. 66

cf. p. 67

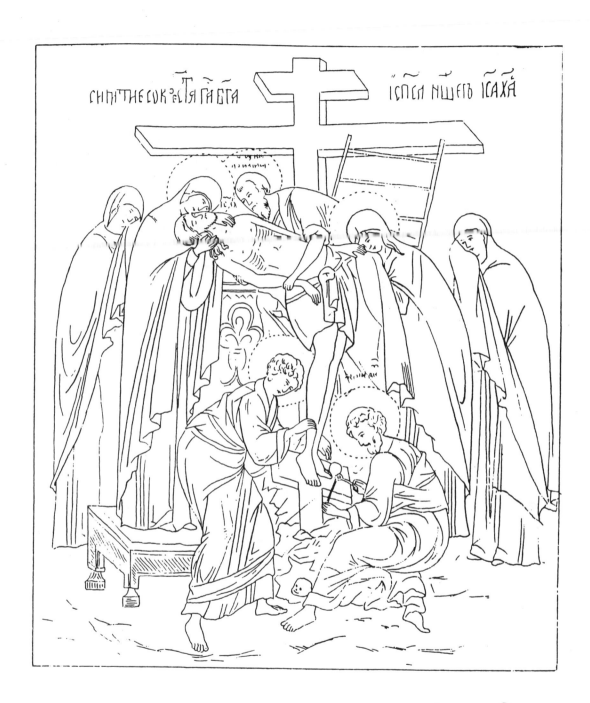

СНѦТІЕ СО КРЕСТѦ. ГОСПОДѦ·НАШЕГО ІЙСѦ ХРТѦ.

cf. p. 67

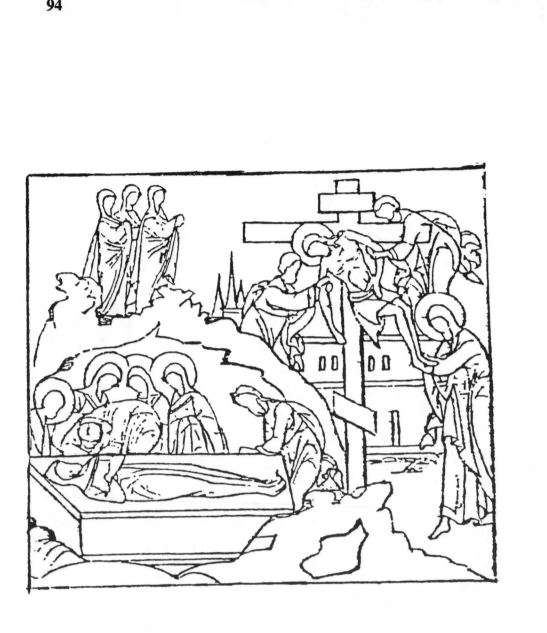

cf. p. 68

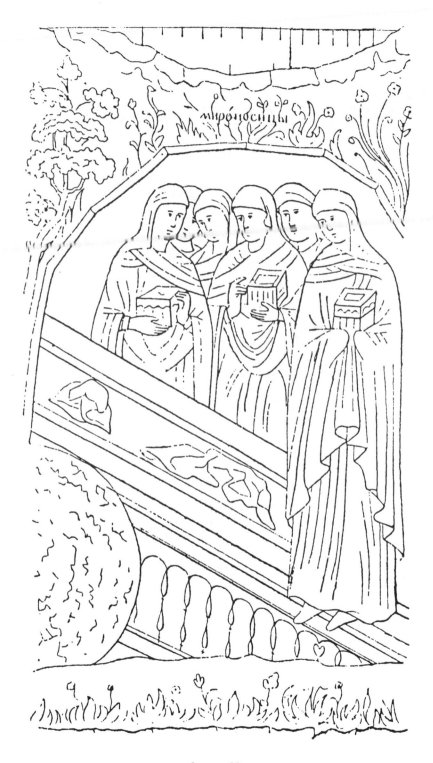

cf. p. 68

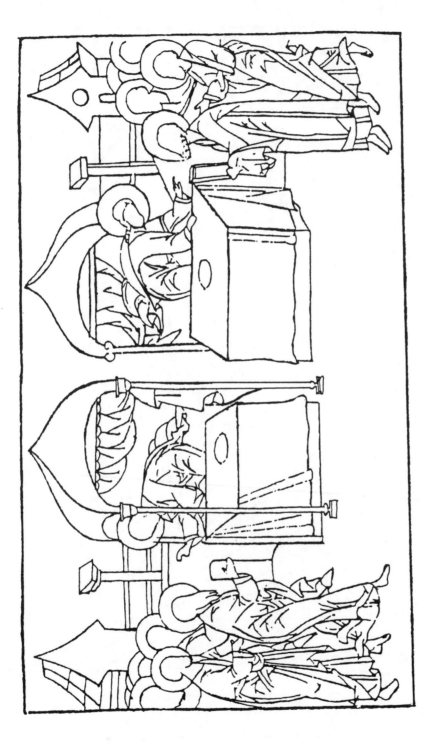

cf. p. 69

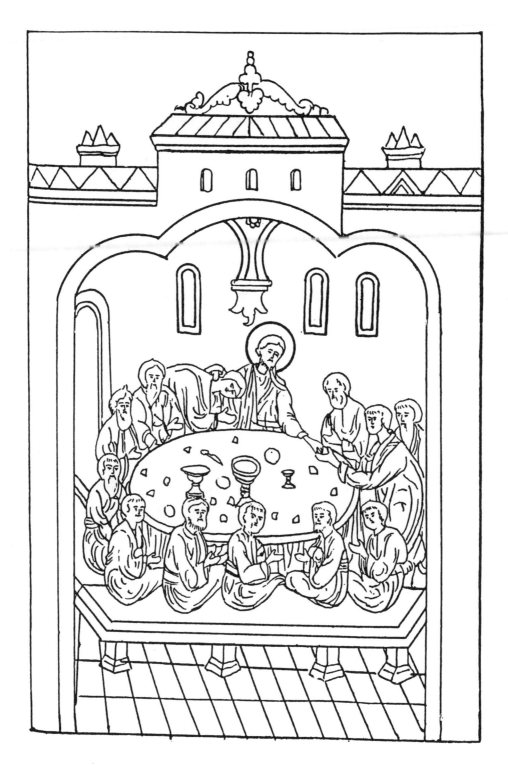

cf. p. 69

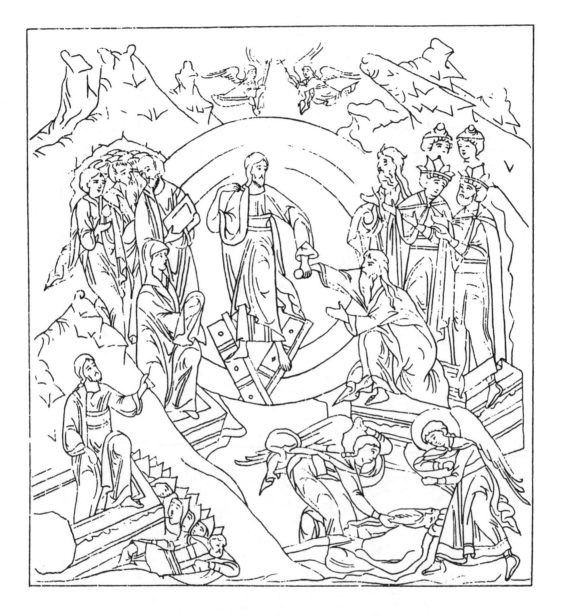

ВОСКРЕСЕНІЕ ХРИСТОВО.

cf. p. 70

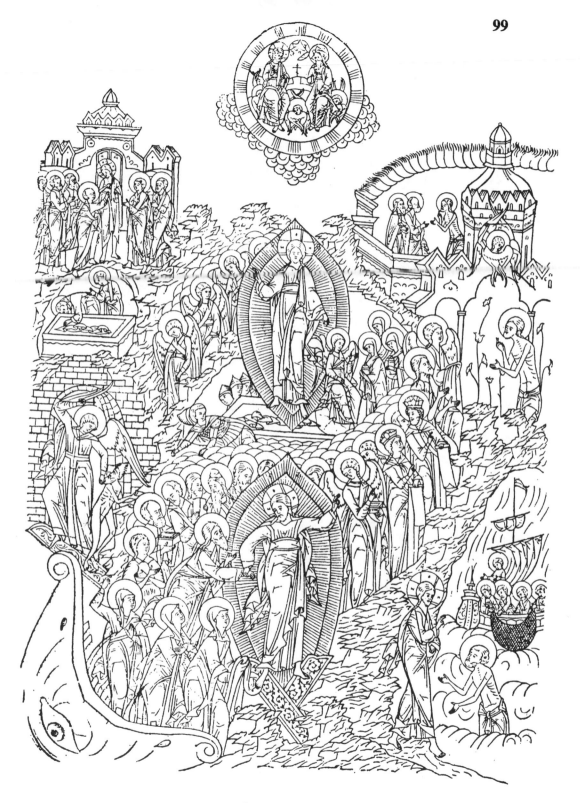

cf. p. 70

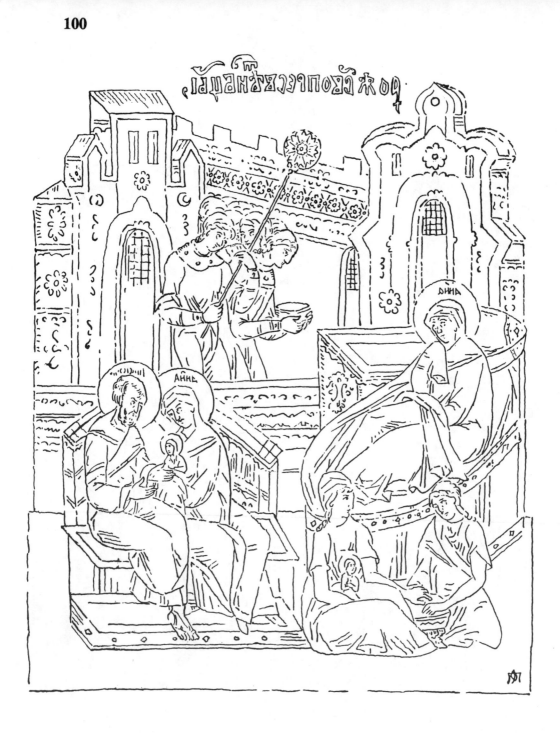

РОЖДЕСТВО Б. М.

cf. p. 71

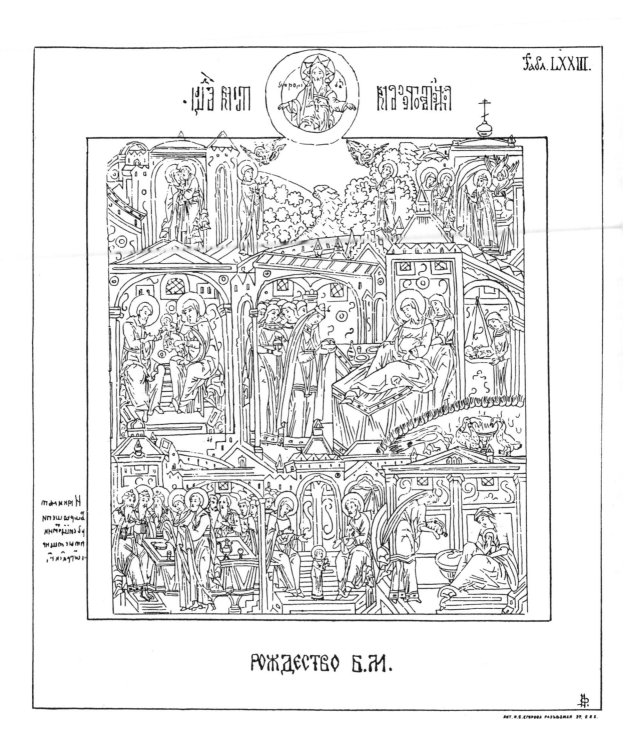

РОЖДЕСТВО Б.М.

cf. p. 71

НО̑ꙗбрⷤ

КА КВ

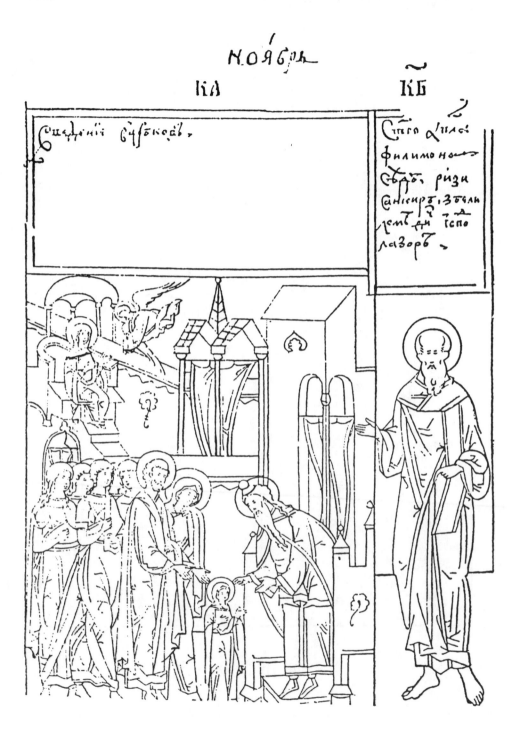

Сщ҃ение ҆ цр҃ковⷤ.

Ст҃го а҆пⷧ҇а
филимонѡ
С а҆рⷯѣ. рꙗзⷤⷩ
С а҆гꙑрⷮ. з болⷣ
хотⷮ ди і спо
лазорⷮ.

cf. p. 72

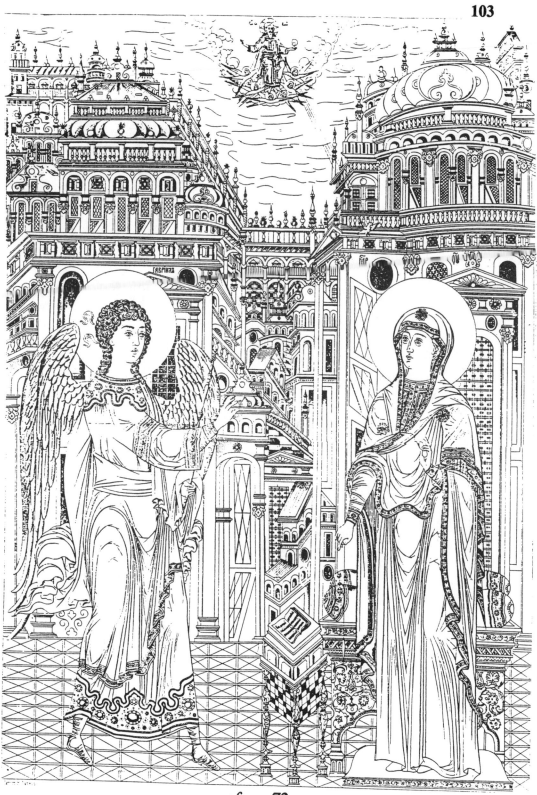

cf. p. 72

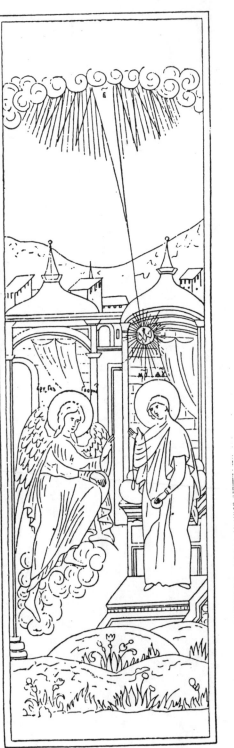

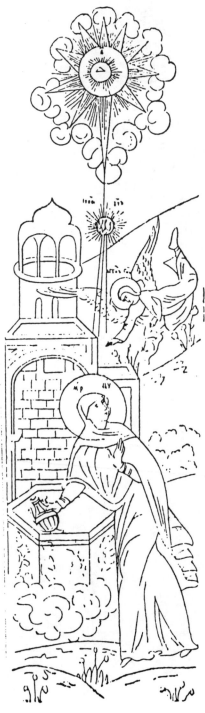

cf. p. 73

мⷰць

КЕ҃

Иⷤ стⷡ о. Га нⷲⷲго І҃с. Х҃а

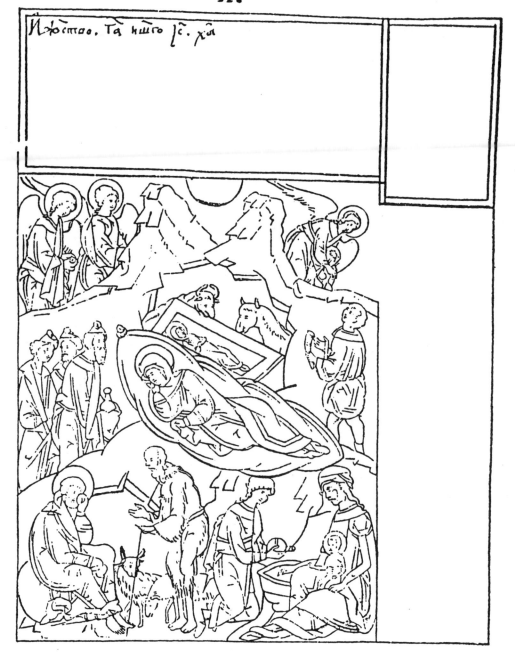

cf. p. 73

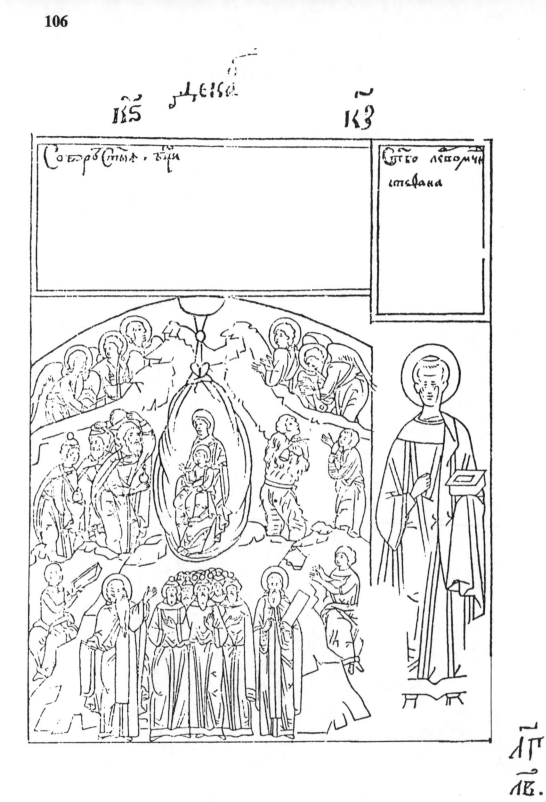

cf. p. 74

ⲰⲂⲢⲀ ⲂⲄ҃ⲞⲒⲀⲂⲖⲈⲚⲒⲀ ⲄⲤⲚⲄⲞ ⲒⲤⲤⲬⲀ

ст ⷪ Іѡа агглⷮ гдни

іс хс

cf. p. 74

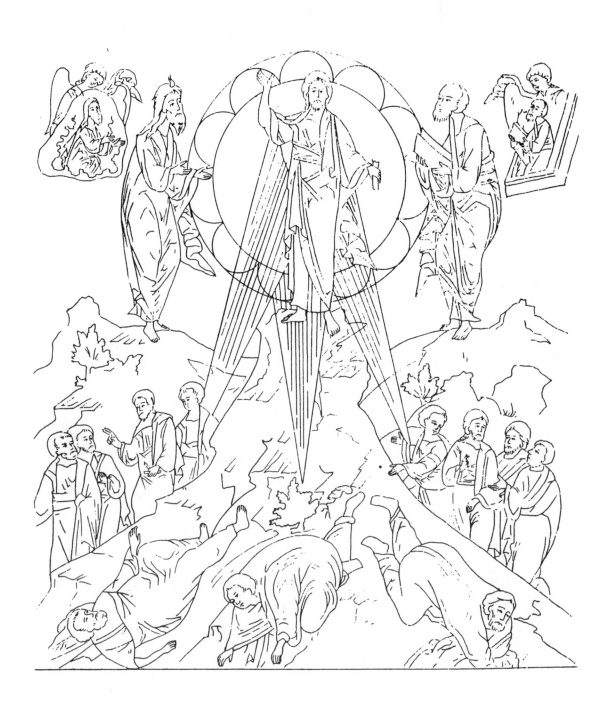

cf. p. 75

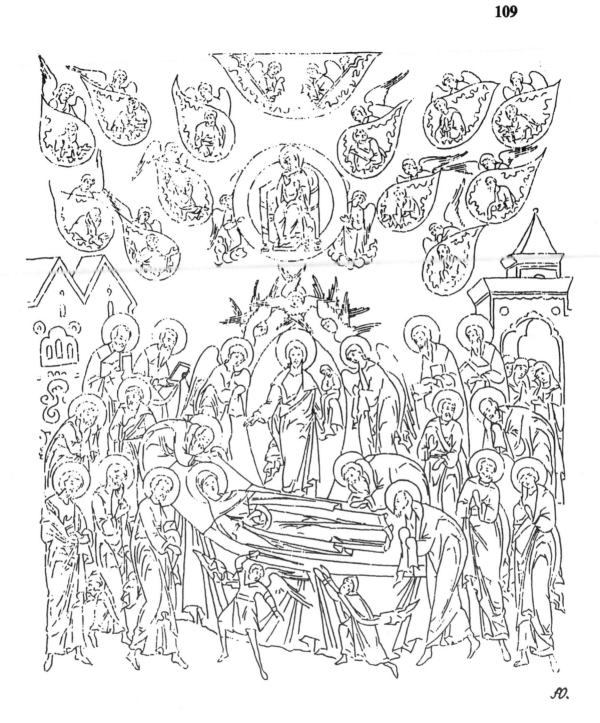

УСПЕНІЕ ПРЕСВ. БОГОРОДИЦЫ.

cf. p. 75

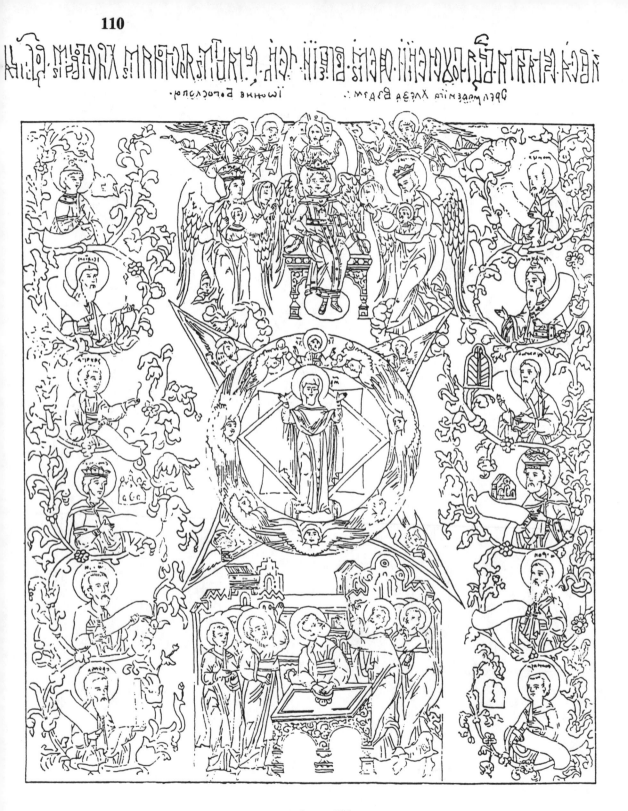

cf. p. 76

СЕНТАБРЬ

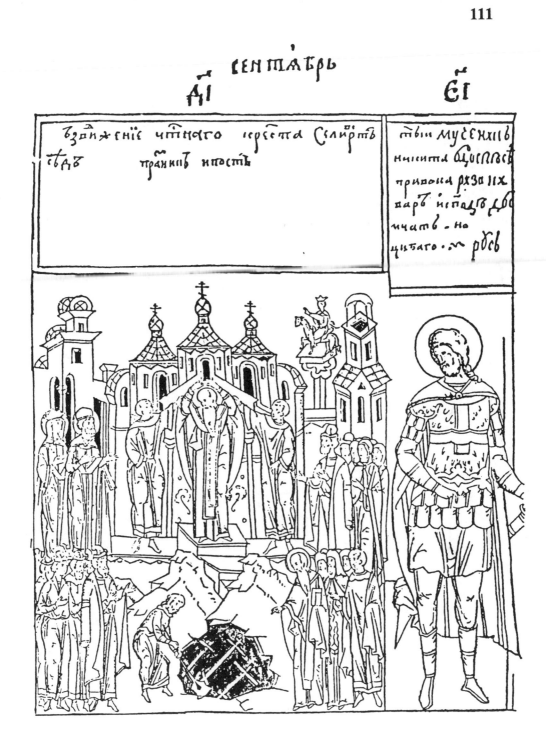

въздвиженїе чтнаго крста Селиѡрть
свдъ праникъ ипостъ

тꙑ мусенхиъ
нъчнѡта ѳцꙋспꙋвсъ
приводна рхзоних
пар‍ иподъвдѡ
нчать но
цитаго ѡ рꙋсв

cf. p. 76

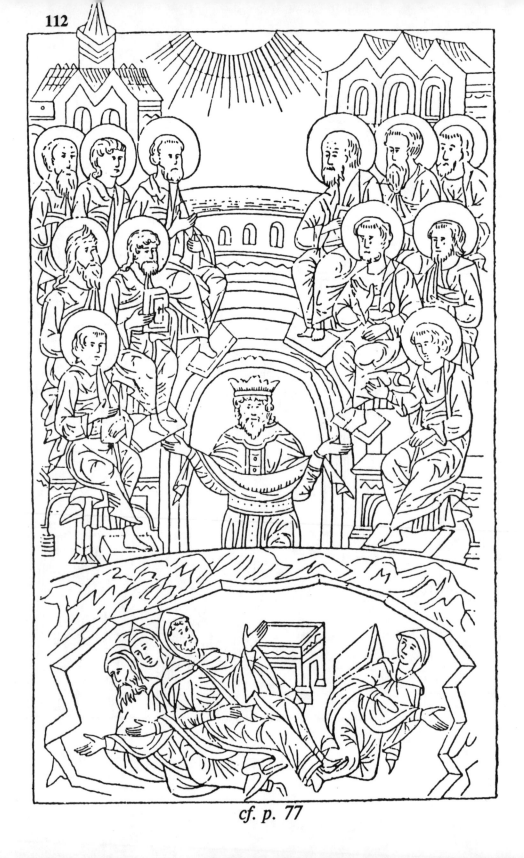

cf. p. 77

ВХОДЪ ГОСПОДЕНЬ ВО ІЕРУСАЛИМЪ.

cf. p. 77

cf. p. 78

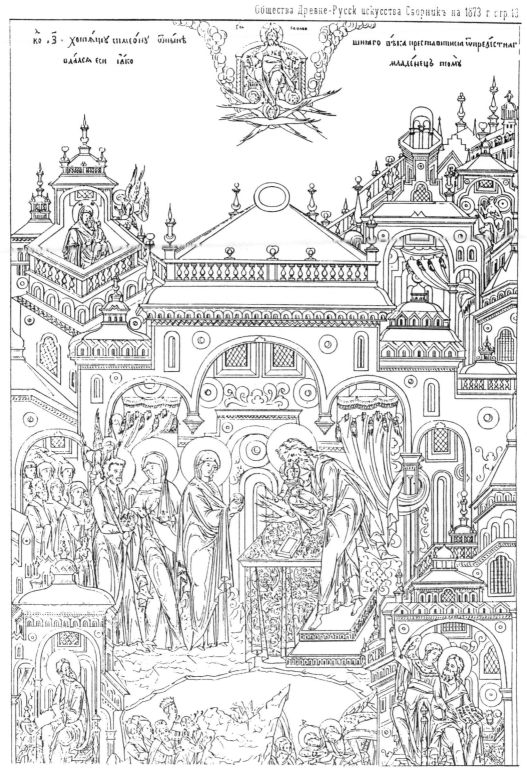

cf. p. 78

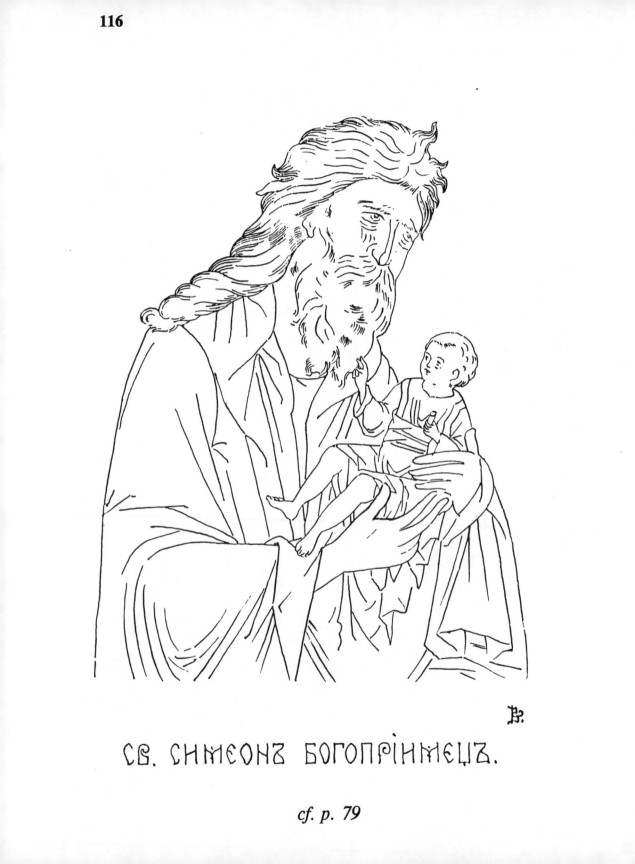

СВ. СΗΜΕΟΝ БОГОПРІΗΜЕЦЪ.

cf. p. 79

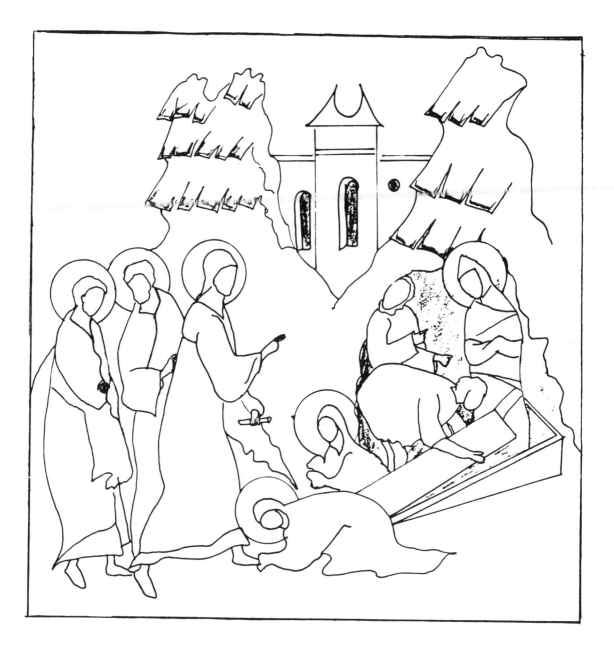

cf. p. 79

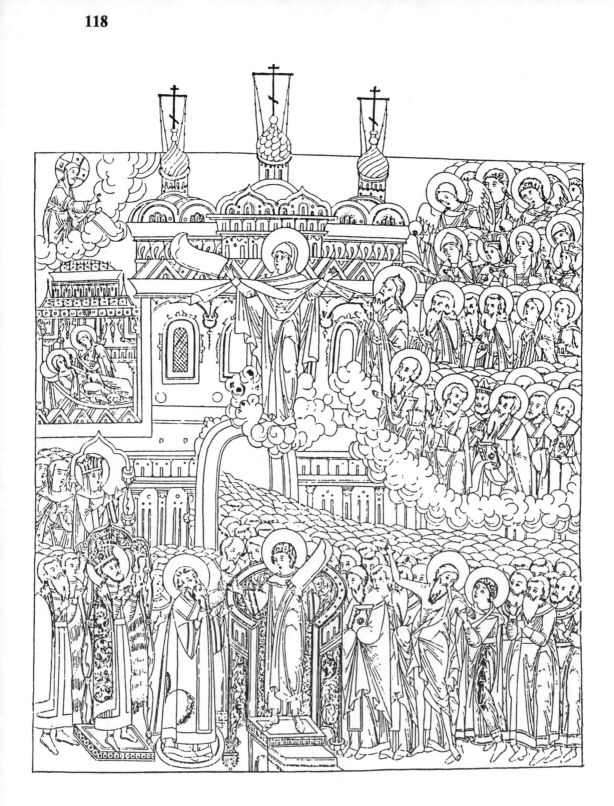

cf. p. 80

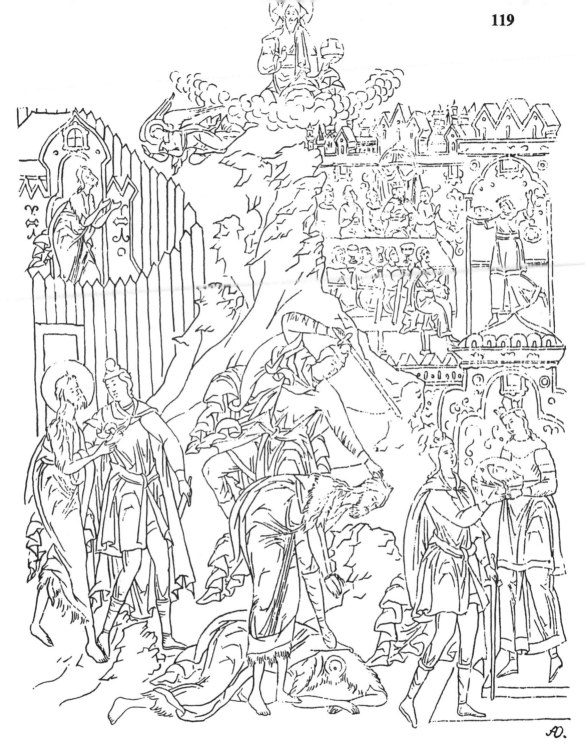

УСѢКНОВЕНІЕ ГЛАВЫ ІОАННА ПРЕДТЕЧИ.

cf. p. 80

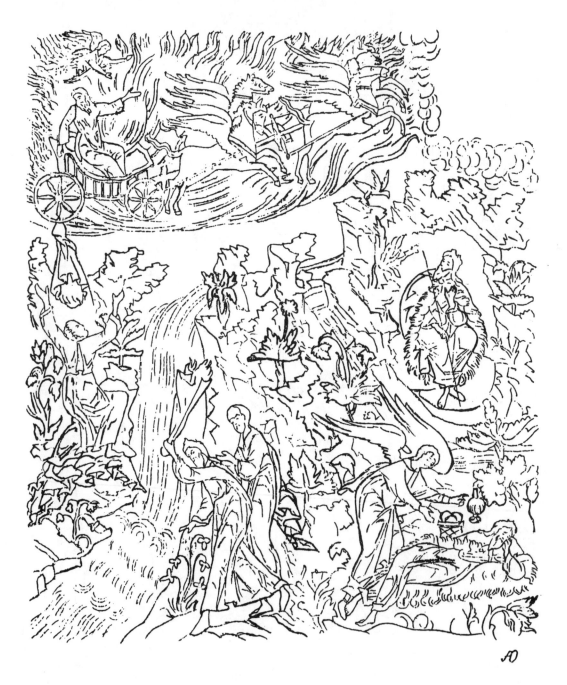

СВ. ПРОРОКЪ ИЛІА.

cf. p. 81

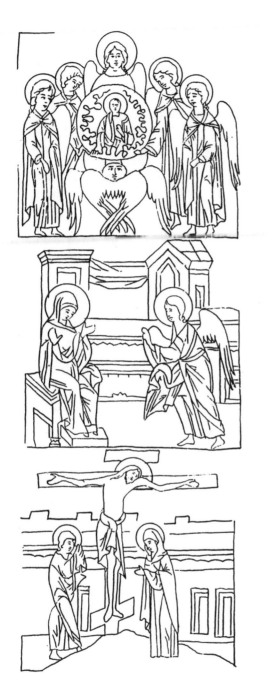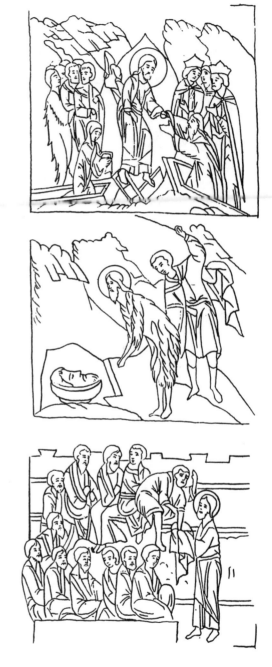

НЕДѢЛѦ ИЛИ ШЕСТОДНЕВЪ.

cf. p. 81

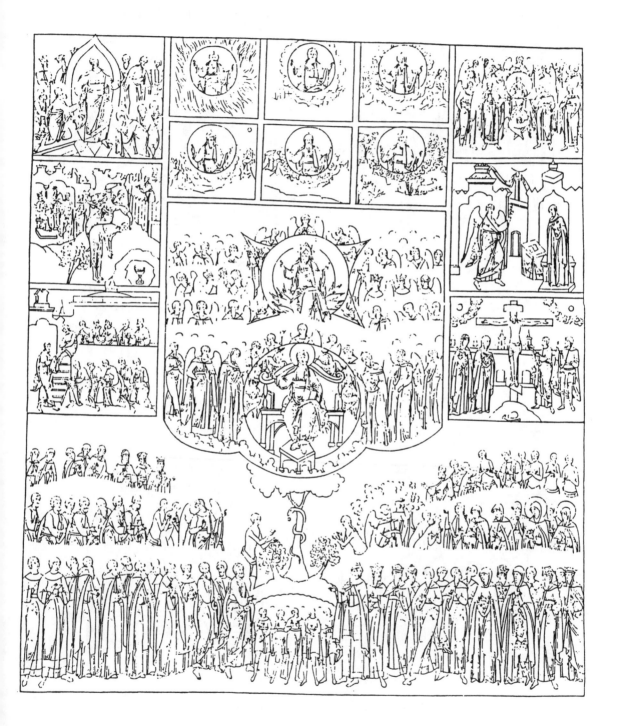

cf. p. 82

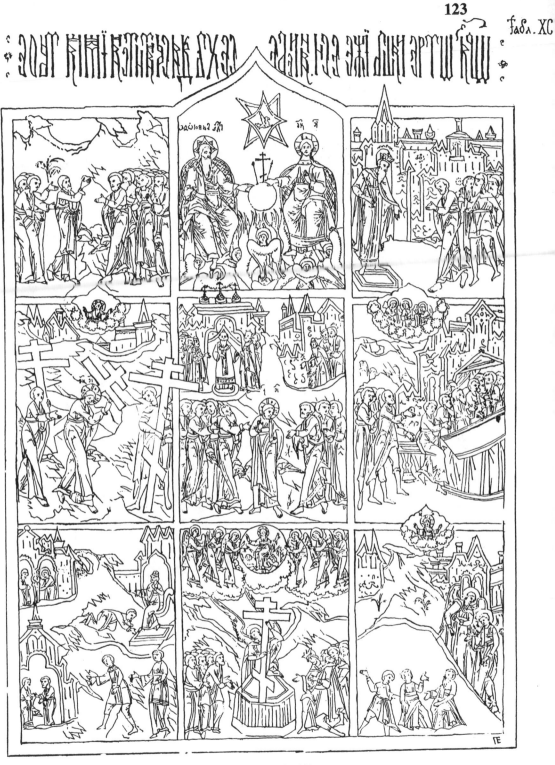

ОТЧЕ НАШЪ.

cf. p. 82

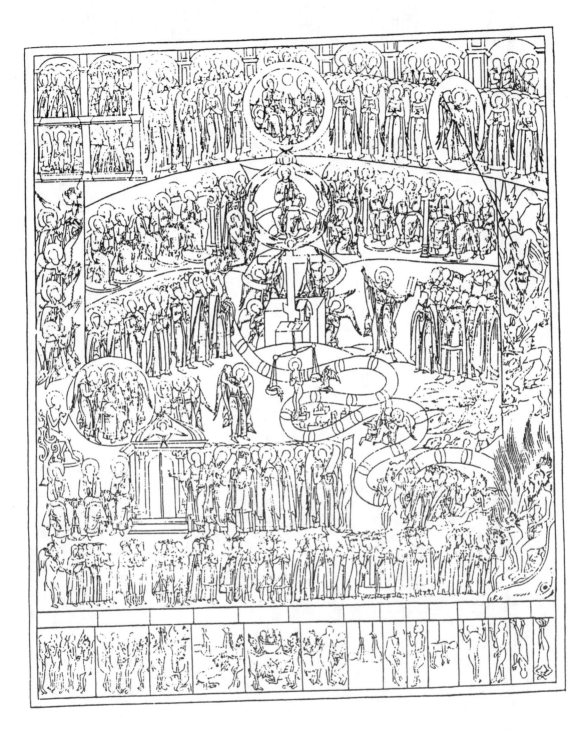

cf. p. 83

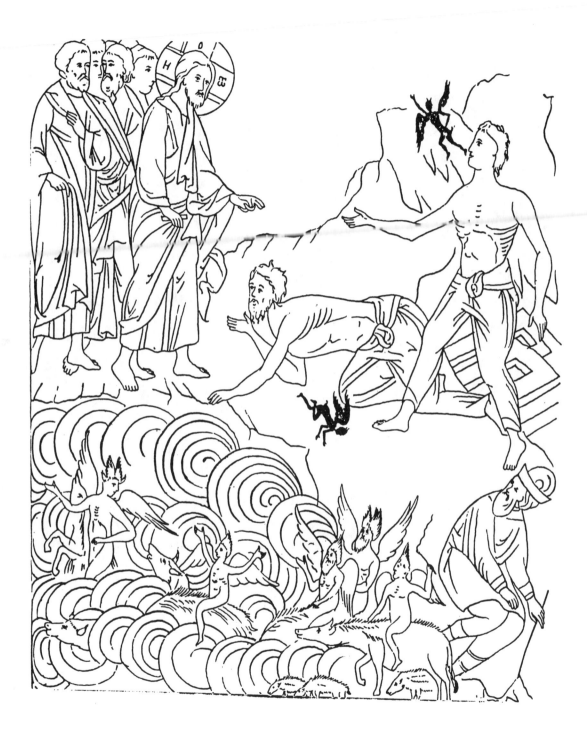

cf. p. 84

МИХАИЛЪ АРХАНГЕЛЪ.

cf. p. 84

Св. Михаилъ Архангелъ.

cf. p. 85

cf. p. 85

76. Соборъ Архистратига Михаила.

Изъ частнаго собранія переводовъ.

cf. p. 85

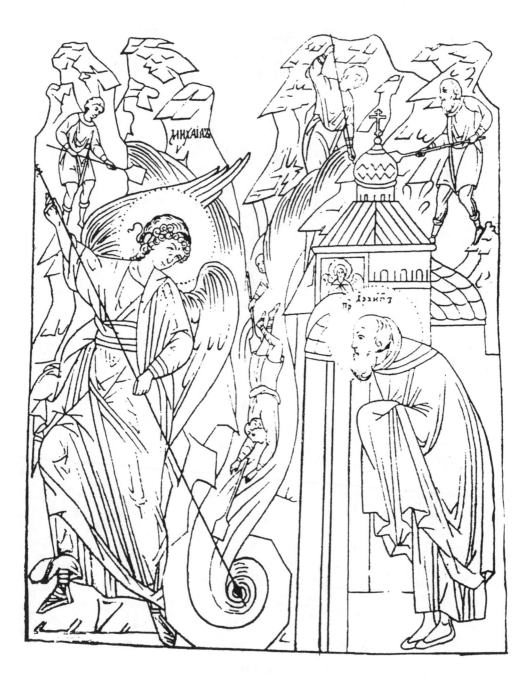

cf. p. 86

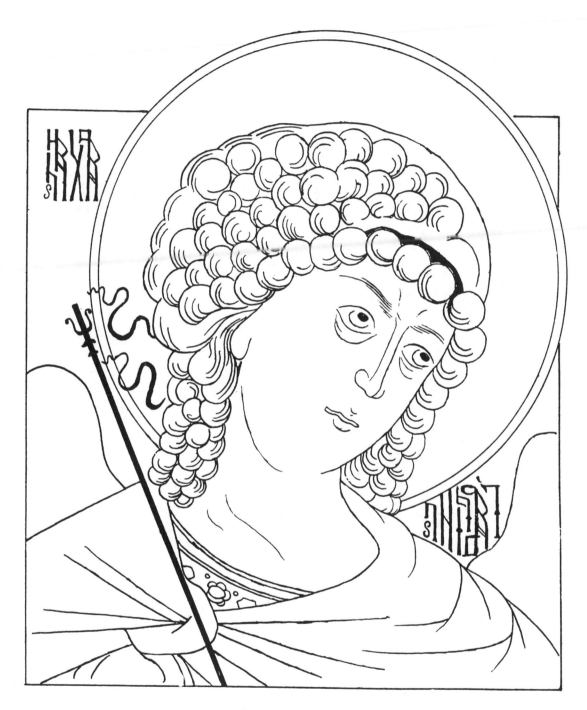

Св. Арханг. Гавріилъ.

cf. p. 86

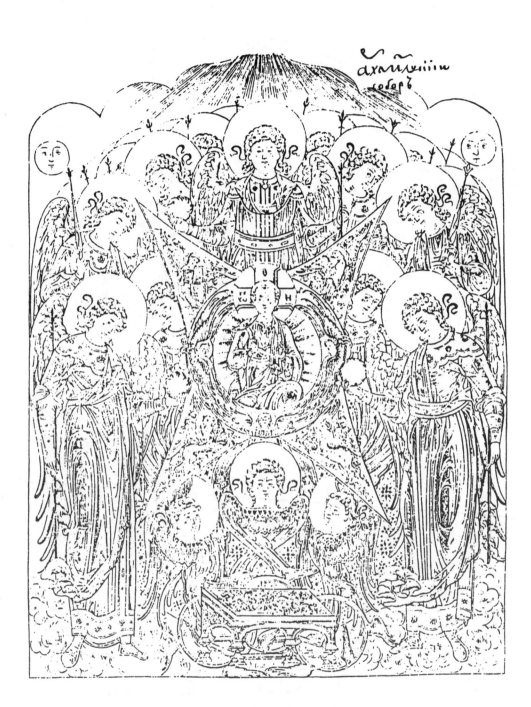

cf. p. 87

At right is a dissolute man. At lower right he is seen drinking and making merry, urged on by a demon. At upper right he dies, and the angel carries the record of his evil deeds to Christ.

A common cross inscription:

Brass crucifixes often bear the matins exapostilarion, tone 2, from the Feast of the Exaltation of the Cross. It is generally written thus, on the reverse of the cross:

"The Cross is the guardian of the whole earth; the Cross is the beauty of the Church; the Cross is the strength of kings; the Cross is the support of the faithful; the Cross is the glory of angels: the Cross is the plague of demons" (KREST KHRANITEL VSEI VSELLENNEI / KREST KRASOTA TSERKOVNAE / KREST TSAREM DERSHAVA / KREST VERNUIM OUTVERZHENIE / KREST ANGGELOM SLAVA / KREST BESOM IAZBA).

"HE SLUMBERS NOT NOR SLEEPS" *p. 155*

This type, here titled "The Guardian Angel of the Soul of Man," is also sometimes called "The Sleep of the Righteous."

Here a pious man is shown in the center. He is seen praying before an icon of Christ by day, and sleeping soundly and peacefully at night, watched over by his Guardian Angel. A demon who would trouble the man is driven away at the sight of the angel with his sword and trident.

At left (the image is reversed) the angel records the man's deeds.

This type often bears the title or inscription "He Slumbers Not Nor Sleeps Who Guards Israel," so it should not be confused with the icon of Christ Emmanuel that bears the same title.

Baptismal crosses:

Each Orthodox believer receives a metal cross at baptism which is worn for life (it is only removed for such things as intimate relations, etc.). It is a four-pointed cross bearing on the face an eight-pointed cross, and often on the reverse is the inscription DA VOSKRESENET BOG I RAZUIDUTSYA VRAZI EGO I DA BYEZHAT OT LITSA EGO NENAVIDYASHCHIY EGO. IAKO ISCHEZAET DUIM DA ISCHEZNUT. IAKO TAET VOSK OT LITSA OGNYA TAKO DA POGIBNUT BYESI OT LITSA LI-UBYASCHIKH BOGA I Z[NAMENAIUSHCHIKHSYA KRESTNUIM ZNAMENIEM]....
— *"Let God arise and let his enemies be scattered, and let them that hate him flee from before his face. As smoke vanishes, so let them vanish; as wax melts before the fire, so let the demons perish at the presence of them that love God, and [who sign themselves with the sign of the cross]....*

HOLY JOHN THE FORERUNNER *p. 156*

Known in Western Christianity as John the Baptist, he is commonly called John the Forerunner (Slavonic Predtecha, Greek Prodromos) in Eastern Orthodoxy. In the New Testament he was the forerunner of Christ's earthly ministry, and in the apocryphal Gospel of Nicodemus he was also the precursor of Christ's descent into Hades.

Here he is shown as "Angel of the Wilderness," holding a scroll on which is written "Behold the Lamb of God who takes away the sins of the world." The title inscription on the pattern is SVYATUIY IOANN PREDTECHA "Holy John the Forerunner."

This "combined representation" example also shows other related scenes. It is a reversed image, so we begin at lower right with the ZACHATIE SVYATAGO IOANN PREDTECHA — "The Conception of John the Forerunner," showing his parents, Zakharias and Elizabeth, together. Beside that is the ROZHESTVO SVYATAGO IOANN PREDTECHA — "The Birth of Holy John the Forerunner."

On the left (bottom) we see the SOBOR SVYATAGO IOANN PREDTECHA — "The Assembly of Holy John the Forerunner." (The crowds assembled at the Jordan for baptism). Above that is the Obretenie, The "Finding" of the honorable head of Holy John the Forerunner, in this case the third of three such discoveries.

JOHN THE FORERUNNER *p. 157*

Here John holds a diskos (eucharistic footed dish) containing the nude infant Christ, symbolizing the Lamb of God of the Eucharist. In many examples a zvezditsa ("little star," a liturgical implement that supports a cloth cover) is placed above the diskos, just as is done in the Eucharist, in which a portion of bread is called the "Lamb." A chalice may replace the diskos.

Sometimes John holds a scroll with a text adapted from John 1:29 — AZ VIDEKH I SVIDETELSTVO VA ONEN: CE AGNETS BOZHIY VZEMLYAI GRYEKHI MIRA ("I saw and witnessed concerning him, behold the Lamb of God, which takes away the sins of the world."). Or the text may be POKAITESYA, PRIBLIZHIBOSYA TSARSTVIE NEBESNOE ("Repent ye: for the Kingdom of Heaven is at hand" — Matthew 3:2). Sometimes the two are combined on one scroll.

John wears a hair shirt (vlasyanitsa) and may be depicted with wings, but must not be mistaken for an angel. The wings derive from the double meaning of the Greek word used to describe him in Mark 1:2 — angelos means both messenger and angel. John is often called a "heavenly man and earthly angel" in Orthodoxy.

Complex icons of John "with the life," that is, with additional scenes of his birth, youth, preaching, etc. are based on both the Gospels and the Protoevangelion of James.

This pattern is by the iconographer Simon Ushakov.

THE PRAYER OF JOHN THE FORERUNNER IN
THE WILDERNESS *p. 158*

In this example John is shown twice — first as the large figure at right, second as a smaller figure in the forested background. He is also seen a third time in a scene from his early life; at left an angel leads the child John into the wilderness "there to remain until he comes of age."

It is usual for John's wilderness to be represented as a forest in Russian icons. Northern painters were not familiar with deserted areas of Judea, and to them a wilderness was a vast, uninhabited expanse of trees, not a dry place barren of vegetation.

Pointers in Icon dating:

Icons with a uniform flat surface are generally 18th century or later. Prior to that time the central "ark" (kovcheg), the square or rectangle in which the main image is painted, was carved lower than the surrounding border. From about the second half of the 18th century the recessed ark began to go out of fashion.

The one-piece metal riza became popular in the 18th century, and probably partly accounted for the fall of recessed ark from favor. A one-piece riza may generally be dated as 18th-century or later, but the icon it covers may be older than the riza in some cases.

JOHN THE FORERUNNER AS ANGEL OF
THE WILDERNESS *p. 159*

John holds a salver containing his head, and in his hand is a scroll reading "I saw and witnessed concerning him, behold the Lamb of God, which takes away the sins of the world," etc.

Beside him is a tree with an axe cutting into it, illustrating Luke 3:9: "And now also the axe is laid unto the root of the tree: every tree therefore which bringeth not forth good fruit is hewn down, and cast into the fire." The inscription at the top reads "The Holy Forerunner and Baptizer of the Lord John." There is a separate icon pattern (not shown) that depicts only the decapitated head of John on the salver. It usually bears a title such as GLAVA SVYATAGO IOANN PREDTECHA "The Head of Holy John the Forerunner."

Pointers in Icon dating:

Many icons of the late 19th and early 20th century have the image painted in an area shaped like an arch. The outer border and the area above the arch are often tooled and painted in colors imitating cloisonné. The images on such icons are generally very Westernized and realistic.

THE BIRTH OF HOLY JOHN THE FORERUNNER *p. 160*

This pattern is very like those of other famous "birth" icons, so care must be taken in identification. Here his mother Elizabeth reclines. Beside her is her husband, the priest Zakharias, who holds a scroll reading "He shall be called John" (IOANN DA BUDET). At lower left attendants wash the newborn child. Others at top wait on Elizabeth.

The birth of John is celebrated, as noted by the date at top, on June 24. The unrelated figure on the right of the manual page is the martyr Fevronia, celebrated on June 25.

The "Little Red Icons":

There is a very interesting style of icon that is easy to recognize. They generally have bright, cinnabar-colored borders and simply-painted images of the Mother of God, John the Forerunner, and other saints robed in incised foliage-ornamented cinnabar-red and silver garments. The "light" (background) of these icons is silver or gold-tinted silver. They are often very appealing.

These icons were painted by the so-called "Serbian Wandering Painters" who immigrated into Russia to escape Turkish depredations. They date from the end of the 18th century into the nineteenth century, and are quite distinctive.

THE FINDING OF THE HEAD OF JOHN THE FORERUNNER *p. 161*

Icons of John may include scenes of three later discoveries of his miraculously-preserved head. In the first, two monks unearth the relic preserved in a container found in a cave (tomb). The event is celebrated on February 24, Old Style.

The second finding took place in a cave where the head was discovered by a priest and monk. It is also celebrated on February 24.

The third finding of the head occurred in a church, and is celebrated on May 25. That is the finding shown in this example, though the Stroganov Icon Painters' Manual from which it is taken does not carefully distinguish the three findings iconographically.

The secondary image on this manual page, dated May 24, is Simeon STOLPNIK ("of the Pillar"), who spent much of his life as an ascetic dwelling atop a column. He is the younger of two "pillar" Simeons, and is called Simeon of Wonderful Mountain.

JOHN THE THEOLOGIAN *p. 162*

John the Theologian (IOANN BOGOSLOV), is John the Evangelist, to whom the fourth gospel of the New Testament is attributed, and also notably the Apocalypse. He is usually bearded and balding. Often he holds his gospel, opened to John 1:1: "In the beginning was the Word, and the Word was with God, and the Word was God" (V NACHALYE BYE SLOVO, I SLOVO BYE K BOGU, I BOG BYE SLOVO). The

Holy Spirit as a small angel with an eight-pointed slava whispers divine inspiration into his ear. Often John's symbol is shown as well, either the lion (traditional Eastern form) or the eagle (borrowed from the West). Depicted in this manner, with his hand held meditatively to his lips, he is generally called "John the Theologian in Silence," recalling the type of Christ as angel known as the "Good Silence." The odd object held in the crook of his arm is a pen and ink set, with two quill pens in the holes on top.

JOHN AND PROKHORUS *p. 163*

John is often shown with his scribe Prokhorus (PROKHOR), traditionally considered one of the seven deacons in Acts 6:5 and a nephew of St. Stephen. John, divinely inspired, is standing or seated, and is turned away from Prokhorus, who is seated taking dictation at the entrance to a cave. The inscription above John in this example reads, with missing letters added, [H]AGIOS IOANN BOGOSLOV — "Holy John (the) Theologian." The writer has used the Greek [H]Agios instead of the Slavonic Svatuiy. At the top is the old symbol for John, the lion.

Because John the Theologian wrote the gospel in which Christ took on material form and became visibly present on earth, John was adopted as the patron saint of iconographers, the so-called "God-painters" through whose efforts the Orthodox deity and saints took material form in paint on wood and gesso. When a boy apprentice in an icon workshop progressed to the point where he was allowed to begin learning to paint, he was first given an icon of John the Theologian to copy.

SAINT LUKE *p. 164*

Luke, the author of the third gospel, is usually seated in an interior, a book in his hand and another book or scroll on a table or stand in front of him. The text on his book is the beginning of his gospel: "Forasmuch as many have taken in hand to set forth in order a declaration of those things..." (PONEZHE OUBO MNOZI NACHASHA CHINITI POVYEST O IZVYESTVOVANNUIKH K NAS VESHCHEKH...).

At top is his symbol, the winged ox. Some icons show him painting the Mother of God, which according to tradition he did during her lifetime. Several miracle-working icons of Mary are ascribed to him by tradition. The half-Greek inscription on this example reads (with missing letters added) [H]AGIOS LUKA — "Holy Luke."

THE HOLY APOSTLE AND EVANGELIST LUKE *p. 165*

The reversed inscription reads AGIOS APOSTOL I EVANGELIST LUKA — "The Holy Apostle and Evangelist Luke." The first word, AGIOS, is Greek, the rest Slavonic. This version shows Luke painting an icon of Mary. The icon shows her with Christ

as a child, and the fact that he is painting them from life is an odd anachronism.

It is said that Luke showed Mary two icons he had painted of her, and she gave them her approval, expressing her desire that the grace of Christ would be in the images.

Many famous icons of Mary are attributed to the Apostle and Evangelist Luke, contrary to all historical evidence.

SAINT MATTHEW *p. 166*

Matthew is shown much like St. Luke, except with a longer beard. He sits in a room and writes his gospel, the first in the New Testament. The text on his book or scroll reads "The book of the generation of Jesus Christ, the son of David, the son of Abraham" (KNIGA RODSTVA ISUSA KHRISTA, SUINA DAVIDOVA, SUINA AVRAAM-LYA). The inscription reads, half Greek, half Slavonic, [H]AGIOS MATFEY — "Holy Matthew." At the top is his symbol, a winged man.

SAINT MARK *p. 167*

Mark is shown much like Matthew and Luke, sitting at a table and writing his gospel, the second in the New Testament. The text he writes is "The beginning of the Gospel of Jesus Christ, the Son of God" (ZACHALO EVANGELIA ISUSA KHRISTA, SUINA BOZHIYA). At the top is his symbol, the eagle. His half-Greek inscription reads [H]AGIOS MARK — "Holy [or "Saint"] Mark."

The Four Evangelists:

Oddly-shaped icons of the Four Evangelists are frequently found. They are usually from a set of the Four on the Royal Doors (the "Tsar Doors") of the iconostasis, which gave entry to the altar. They may be oval or round, or even triangular, as well as in the standard form. The complete set of four seldom stays together once they have been removed from the doors. The Four Evangelists are also found on the metal cover of the Gospels.

SAINTS PETER AND PAUL *p. 168*

In this reversed Pattern Peter is shown on the right. He holds the key to heaven (see Matthew 16:19). His inscription would generally read, SVYATUIY [or HAGIOS] APOSTOL PETR — "The Holy Apostle Peter."

At left is St. Paul, holding the Gospels. His inscription generally reads SVYATUIY [or HAGIOS] APOSTOL PAVEL — "The Holy Apostle Paul." Christ Immanuel is shown above.

In this example Peter holds a scroll reading TUI ESI PETR, I NA SEM KAMENI

SOZIZHDOU TSERKOV MOIU — "You are Peter, and upon this rock I will build my church." These were Christ's words to Peter in Matthew 16:18.

SAINT NICHOLAS THE WONDERWORKER *p. 169*

This is a typical portrait of Nicholas, showing the key characteristics ascribed to him by tradition. He wears a bishop's stole (omofor, Greek omophorion) about his neck.

The inscription on this reversed image, with missing letters added, is AGIOS NIKOLAE CHUDOTVORETS — "Holy Nicholas the Wonderworker." Other forms of his name are Nikola and Nikolai.

Nicholas was immensely popular. Peasants said that when God grew too old and died, Nicholas would take over in his place.

Historically little is known about him. Tradition makes him Archbishop of Myra in Asia Minor. He is said to have fought against the anti-Trinitarian teachings of Arius at the Council of Nicaea. He is the patron saint of Russia, and of travellers and seafarers.

When he carries the Gospels, the text they reveal is a variant of Luke 6:17: "At that time Jesus stood on the plain, and a multitude of his disciples..." (VO VREMA ONO STA IISUS NA MYESTYE RAVNYE, I NAROD OUCHENIK EGO....

Nicholas is often shown with the Mother of God in a small circle on one side, holding the bishop's stole which she is said to have given him when he was imprisoned. Christ, on the other side, holds the Gospels, which he gave to St. Nicholas.

NICHOLAS OF MOZHAISK *p. 170*

This type originated in a miracle that is said to have occurred when Tartars attacked the city of Mozhaisk. St. Nicholas appeared in the air above the attackers, sword in hand, and saved the city. The type shows him full-length, a sword in his outstretched right hand and a church (sometimes interpreted as a city) in his left. Though carved three-dimensional icons are uncommon in Orthodoxy, this type is among the few sometimes found in sculptural form.

There are other well-known types of Nicholas. "Nicholas of Zaraisk" shows him standing with arms outstretched, but instead of having a sword in his right hand, he blesses — and in place of a church in the left, he holds the Gospels. The type is named after the city of Zaraisk, to which the icon is said to have been brought from Korsun via Novgorod in the first half of the 13th century.

The other well-known type, Nicholas of Velikoretsk (Velikorechye) is simply the half length form of Nicholas holding the Gospels and blessing, but in "boxes" about the outer edge are eight standard scenes from his life.

NICHOLAS OF ZARAISK *p. 171*

This is the image that was said to have been brought to the city of Zaraisk in the year 1225. He holds the Gospels, and blesses with his right (this is a reversed image) hand. The omophorion of a bishop is about his neck (the long cross-decorated scarf), and at his waist is the epigonation (Russian palitsa), the square of stiff cloth hanging point-down.

Nicholas is noted for many miracles, and these often appear as border scenes in his icons. Among them are: The birth of Nicholas, his baptism, his learning letters, the healing of a blind woman, his consecration as bishop, his finding of a spring of water, his exorcism of a devil from a monastery, his consecration as deacon, his appearance to three wrongly-imprisoned men, his appearance to Emperor Constantine in a dream (to free the imprisoned men), His appearance to the eparch Evlavius, the rescue of the three condemned to execution, the healing of a blind man, the healing of a possessed man, the driving of a devil out of a tree beside a well, the saving of the drowning boy Demetrius, the saving of the Kievan infant fallen into the Dniepr, Nicholas saving a poor merchant by buying his rug and giving it back, the return of the boy Agricola (abducted by Saracens) to his parents, the death of Nicholas, and the transfer of the relics of Nicholas from Myra to Bari in Italy.

The icon inscription reads "Holy Nicholas the Wonderworker."

SAINT GEORGE *p. 172*

The Great Martyr George (VELIKOMUCHENIK GEORGIY), also known as Georgiy pobyedonosets ("George the Victorious") is a mounted soldier who strikes with a lance at a dragon beneath his horse. The type is very old, and can be traced to Roman Egypt, where the mounted warrior in Roman armor is the God Horus, and the dragon a crocodile, symbolizing the evil god Set.

In the Russian type an angel descends from heaven and places a crown of victory on George's head. On the right (this pattern is reversed) is a stylized city with a king and queen watching from the battlements. According to tradition, George came to Silene in the province of Libya, where a ravaging dragon demanded daily sacrifice. Fate chose the king's daughter, but George subdued the beast and told the princess, whose name was Elisaba, to fasten her sash about the neck of the dragon so that it might be led through the town for conversion of the people before it was finally killed.

George is a young smooth-faced man. In some icons he may be shown as a solitary standing warrior wearing a diadem, his lance in one hand and his sword in the other, or he may hold the cross of martyrdom. Icons that show a small boy on the horse behind George (a Christian lad rescued by him from Saracen slavery) are Greek or Balkan rather than Russian.

HOLY DEMETRIUS OF THESSALONIKA *p. 173*

DMITRIY SOLUNSKI is shown much like St. George. He is dressed as a warrior and rides a charger, but in place of the dragon, Dmitriy strikes down the King of the Infidels, who is crowned and seated on a fallen horse. An angel descends from Heaven with a crown of victory for the Saint, as in icons of George. Dmitriy may also be shown as a solitary figure in military garb, standing or seated.

Warrior saints such as George and Demetrius are usually recognizable by their Roman military clothing. When included in the "Deisis" on an iconostasis, they are depicted without the armor and weapons of their earthly life, and may then be recognized by inscription.

Some icons show a small clerical figure seated on the horse behind Demetrius. This is Cyprian, Bishop of Carthage, who Demetrius is said to have saved from pirates. Icons with Cyprian seated behind Demetrius are Greek or Balkan rather than Russian.

This is a reversed image.

SAINT NIKITA WITH JOHN CHRYSOSTOM AND JOHN THE BAPTIST *p. 174*

Niketas, called NIKITA in Russia, was a Goth martyred in the 4th century. Here he is shown standing in armor, his lance in one hand and the cross symbolizing his martyrdom in the other. Other icons may depict him seated on a throne, grasping the devil in one hand and beating him with a chain held in the other. One prays to Nikita for avoidance of birth defects.

Beside Nikita in this example is John Chrysostom ("The Golden-Mouthed") in the garments of a bishop, holding the Gospels to show that he is a teacher of the Church.

John the Forerunner holds a salver containing his own head and a scroll with the "Repent ye..." text.

The three inscriptions in this reversed pattern are: AGIOS MUCHENIK NIKITA — "The Holy Martyr Nikita"; AGIOS IOANN ZLATOUST "Holy John the Golden-Mouthed"; and AGIOS IOANN PREDTECHA — "Holy John the Forerunner."

THEODORE TIRON *p. 175*

Theodor (Feodor) is commonly shown together with Theodor Stratilates, but he is also found separately. Theodore Stratilates ("The General") and Theodore Tiron ("The Soldier") are distinguished from George and Demetrius by their dark beards.

Theodore was a soldier of the Roman legions who was converted to Christianity at the beginning of the 4th century. He burned a pagan temple and was martyred for his deed by being burned to death. His iconographic companion, Theodore Stratilates, was martyred in the 4th century after he broke up sacred golden images belonging to the

Emperor, and gave the pieces to the poor.

Prayer is made to Theodore Tiron to ward off Robbery.

CHRISTOPHER "DOG-HEAD" *p. 176*

This is perhaps the most remarkable of all the warrior saints, and indeed of all saints celebrated in the Orthodox Church.

Some Orthodox saints are quite simply fictitious, and Christopher "Dog-Head" is one of these. There are many versions of his origin, none definitive. Some think he originated in tales of a race of dog-headed men. Others think that his head was intended to be that of the ass that carried Christ to Jerusalem, thus the saint's name Christopher, meaning "Bearer of Christ." Still others say that Christopher was originally a very handsome young man whose good looks were an obstacle to his piety, so he prayed to be changed and awoke one morning with the head of a dog.

The most fascinating possibility, though not proven and in dispute, is that he is a development of the ancient Egyptian god Anubis, who had the head of a jackal. Statues of Anubis from Roman Egypt look remarkably like the Orthodox warrior saint Christopher "Dog-Head."

In Russian podlinniks (painting manuals), it is specified that he is to be painted with a horse's head, and that is how he is shown here. In Greek icons his head usually looks more like that of a dog.

In any case, Christopher is a warning not to take all the traditions of Orthodoxy too literally. He belongs with such saints as Barlaam and Ioasaph, whose origins are found in the story of the Buddha's early life as garbled by admixture with Western fantasy.

The inscription reads "The Martyr of Christ Christopher."

THE THREE HIERARCHS *p. 177*

These are the saints Basil the Great of Caesarea, Gregory the Theologian of Nazianzus, and John Chrysostom, "The Golden-mouthed." They are often shown together, dressed in bishops' robes, each holding a copy of the Gospels to show that he is a teacher of the Church.

Basil has a balding head and a long sharp beard. Gregory is balding, with a shorter, rounder and straight-bottomed beard. John is balding, and has a very short dark beard. Basil is considered the father of Orthodox communal monasticism, Gregory was an orator and poet, and John was known for his eloquence. The usual Orthodox Sunday liturgy is the Liturgy of John Chrysostom.

The Three Hierarchs exemplify the correct garments for a bishop. The ornate outer robe on John and Gregory is called the sakkos; the wide stole decorated with crosses, which passes around the shoulders and hangs in front, is called the omophorion. Also often seen is the flat, diamond-shaped epigonation (Russian palitsa), hanging just below

the waist (not seen here). The three are shown without bishop's mitres. Basil wears a phelonion instead of a sakkos.

THE NINE MARTYRS OF KIZYKOS *p. 178*

These died for their faith in the Fourth Century. They are seen before the church at Kizykos, each carrying an object related to his martyrdom. Their names are Magnos (bones broken), Theognis (whipped and nails pulled out), Rufus (blows and fire), Antipatros (tortured with thorns), Theostikhos (fingers cut off, etc.), Theodotos (scalded), Thaumasios (knife and lance), Artemas (pushed off a mountain while in a chariot); and Philemon (buried alive). In Slavonic their names are Magn, Feognid, Ruf, Antipatr, Feostikh, Feodot, Favmasiy, Artema, and Filimon.
 Christ is in the clouds above, bestowing the nine crowns of martyrdom.
 The Nine Martyrs of Kizykos are commemorated on April 29.

THE FORTY MARTYRS OF SEBASTE *p. 179*

They suffered under the Emperor Licinius in 320 A.D., being made to stand all night in an icy lake near Sebaste, in Armenia, before their execution.
 Here they are seen in the lake. One figure, his face hidden by the doorway, is entering the warm bathhouse, abandoning his suffering companions. But another figure has just removed his upper garment and is joining the martyrs. He was a guard, sometimes called Candidus, who found faith. Christ is shown above with the forty crowns of martyrdom.

THE SEVEN YOUTHS OF EPHESUS *p. 180*

These "Seven Sleepers" were early Christians who sought refuge in a cave from the persecutions of the Emperor Decius in the 3rd century. They were walled up alive, and went into a miraculous sleep. Two hundred years passed. Then the sleepers awoke, and were found by the citizens of Ephesus, which in the passage of two centuries had become Christian. The Seven Youths died not long after. Their names are Iamvlikh, Ioann, Dionisiy, Eksakustodian (Konstantin), Antonin, Martinian and Maximilian.
 The "Seven Youths of Ephesus are usually depicted lying together within a cave in a hill, all sound asleep.

THE UNMERCENARY PHYSICIANS KOSMAS AND DAMIAN *p. 181*

The "Unmercenary Physicians Kosmas (Kozma, Kosma) and Damian (Domian) are twin brothers usually shown together. Caution is advised, however, because in the

Orthodox calendar there are three sets of unmercenary physicians named Kosmas and Damian.

The first pair died at Rome in 284, are commemorated on July 1, and look like Demetrius of Thessalonika and George the martyr (no beards); the second pair lived in Arabia, were martyred in the early 4th Century, are commemorated on October 17, and look like Florus (bearded) and Lavrus (no beard); the third pair lived in Asia, died in the 3rd Century, are commemorated on November 1, and have beards. All three pairs are called "unmercenary," *anargyroi* in Greece and *bezsrebrennik* in Russia, meaning literally "without silver," because they accepted no money in payment for their services.

Because the pair illustrated here both have beards, we know that they are Kosmas and Damian of Asia (November 1). Both are generally shown with a medicine container in one hand a spoon in the other, and are invoked for aid in studies.

In this example Kosmas and Damian are seen with Saint Christopher "Dog-Head" and St. George the Victorious.

Another famous unmercenary phyisician is Panteleimon, depicted as a beardless youth holding a medicine box in one hand and a spoon in the other. He was born in Asia minor in 275, and was martyred for his faith. His name is Greek for "All-merciful."

SAMON, GURIY, AND AVIV *p. 182*

These three are often found on attractive icons popular with married couples, because they were believed to watch over faithfulness in marriage. Samon, on the left, has short hair and a short beard. Guriy, in the middle, is an older man with a long pointed beard. Aviv, on the right (the image shown is reversed) is dressed like a deacon and carries a censer. Samon and Guriy were martyred first, at Edessa in Syria. Later Aviv, deacon at Edessa, was also martyred and was buried with Samon and Guriy (early 4th Century).

FLORUS AND LAURUS *p. 183*

Flor and Lavr were twins, stonemasons working on a pagan temple. They turned the temple over to Christians and were drowned as punishment by the Emperor Licinius.

The two are the patron saints of horsekeepers. In the standard icon type, the Archangel Michael stands on a hill in the center, holding the reins of two horses, one light and one dark (sometimes the horses are omitted). Florus stands to Michael's right, and Laurus on the Archangel's left. Below are three riders chasing a herd of horses. Their names are Spevsipp, Elevsipp, and Melevsipp, (originally Speusippus, Eleusippus, and Meleusippus, meaning "Horsebreaker," "Horse-scout," and "Black horse"). They are said to have been converts from paganism martyred in the 2nd Century.

In this example the central angel is called simply "The Angel of the Lord," and the inscriptions says he is entrusting the herd of horses to Florus and Lavrus.

One can see from examples such as this how short the step was from protective

nature deities to Christian saints.

KIRIK AND OULITTA *p. 184*

This mother and son pair of martyrs are frequently depicted. They may be shown standing together looking toward Christ in the clouds, or scenes of their martyrdom may be shown. Oulitta (Iulitta) refused to renounce her faith before the magistrate of Tarsus (c. 304 C.E.) and was forced to watch her son killed after he scratched the official's face. Then she was also martyred.

EMPEROR CONSTANTINE AND EMPRESS HELENA *p. 185*

The Emperor Constantine legalized the Christian religion in the 4th-century Roman Empire. His very pious mother Helena, tradition relates, discovered the true Cross in Jerusalem. Both are thus associated with the beginnings of Christianity as a State religion, and the Church gives them the title "Equal to the Apostles."

History relates a somewhat less glowing view of Constantine, but what is important in icons is not factual history but the traditions through which the images were seen by the faithful.

In this example Constantine and Helena are standing before an image of the Mother of God of Vladimir, an image of Mary said to have been painted by St. Luke from life.

The background scene shows Helena in Jerusalem at the discovery of the true Cross of Christ.

Icons are often found showing simply Constantine and his mother with a cross between them.

PRINCESS OLGA OF KIEV *p. 186*

Olga, a crafty person, took fierce revenge on her enemies. She once besieged the city of Izkorosten for a year, but could not take it. Finally she demanded a symbolic tribute from the townspeople. Three pigeons and three sparrows were requested from each house. Olga had incendiary sulphur tied to the legs of the birds, and ordered them released. They flew home to their nests in the city and set it ablaze. She captured or killed the fleeing inhabitants, enslaving some and leaving others to pay tribute. Then she returned in triumph to Kiev with her young son Sviatoslav.

In the middle of the tenth century Olga, a pagan, went to Constantinople (Tsargrad), where the Greek Emperor Constantine was so taken with her beauty and intellect that he proposed marriage. Olga replied that she would be baptized into Christianity if Constantine would perform the ceremony. He agreed, and after baptism asked her to marry him. She replied that marriage would be contrary to Christian law, because the

Emperor had baptized her and called her his daughter. Thus Olga outwitted the Emperor, and was sent home with gifts to Russia. She promised him rich gifts in return, including slaves and soldiers, but when an emissary arrived to claim them Olga sent him away empty-handed. She was eventually canonized and given the title "Holy Equal-to-the Apostles (RAVNOAPOSTOLNAYA) Olga. She was called "first of Rus to enter the Kingdom of God."

THE HOLY GREAT PRINCES VLADIMIR, BORIS, AND GLYEB *p. 187*

Vladimir, the central figure in this pattern, is shown crowned and holding a sword and cross. He is celebrated on July 15. Saint Olga had no luck converting her son Svyatoslav, and her grandson Vladimir also began life as a pagan. Eventually, according to *The Tale of Bygone Years*, Vladimir began to inquire into various religions of the medieval world. He first was attracted to Islam, liking the idea of a sensuous paradise after death. He was fond of women, keeping some eight hundred concubines in addition to his lawful wife and other women, and also going after married women and young girls. But he did not like circumcision or the ban on drinking, one of his favorite pastimes. He then looked into Judaism, but was disenchanted after he found that its people were scattered and without a country, which he saw as a mark of divine disfavor.

He enquired into Latin Christianity, but thought it rather dull after emissaries reported back that they "found no glory there." But emissaries returning from Constantinople told of being entranced by the glory of the liturgy there in the Church of Holy Wisdom. So Vladimir chose Greek Orthodoxy for himself and (without asking) for his people. Kievan Russia was converted to Orthodoxy by edict in 988 C.E. Vladimir often holds a scroll reading "God, maker of heaven and earth, protect your newly-enlightened people."

THE HOLY GOOD-BELIEVING PRINCES BORIS AND GLYEB *p. 188*

The first official Russian saints were not Olga and Vladimir. That honor went to Boris and Glyeb, two sons of Vladimir by a Bulgarian woman.

When Vladimir died in 1015, Svyatopolk, another son of his by a Greek woman, did not want to share the inheritance and decided to kill his brothers. He sent conspirators to murder Boris, who did not resist, but sang Psalms, prayed before an icon of Christ, and then lay down to be murdered. Glyeb's assassins arrived while he was praying aboard a boat.

The two brothers accepted their deaths as Christ accepted his. Consequently they are called "Holy-Passion-Bearers" (Strastoterptsui). They were canonized in 1071.

Boris and Glyeb are usually shown together in their princely robes, with crowns upon their heads. They stand full length, hands on swords, or else, as shown here, they ride side by side, sometimes bearing lances from which pennants wave. Here both carry

sceptres. Boris has a short, dark beard; Glyeb is beardless.

PASSERS-BY HEAR THE ANGELS' SONG *p. 189*

Glyeb is said to have been slain by his own cook, who was intimidated into the act by the fierceness of Sviatopolk's emissaries, when they came aboard with drawn swords. Glyeb's body was cast down in a thick wilderness between two fallen trees. Travellers and dwellers near that lonely place reported seeing strange lights and hearing the singing of angels. When Yaroslav the wise, another son of Vladimir, heard of these happenings in the wood near Smolensk, he replied, "There is the body of my brother, Holy Glyeb." Thus Glyeb's body was recovered.

The pattern shows the incorrupt body of Glyeb lying in heavenly radiance, watched over by two angels. Passers-by are amazed by the light and the beautiful singing.

ALIPY, THE FIRST RUSSIAN ICON PAINTER *p. 190*

In the days of Vsevolod, son of Yaroslav, a Russian boy named Alipy was apprenticed to Greek iconographers working at the Monastery of the Caves (Pecherskaya Lavra). The boy became a monk and continued to paint icons. He did not charge for his works, but if someone paid, he spent one third on painting materials, one third went to the monastery, and the remaining third was given to the poor.

Alipy was a saintly monk who is said to have healed a man of a terrible skin disease by applying icon paints to the sores and having the man wash in the same water used by the priests after communion.

Once unscrupulous monks took orders for seven icons and prepayment in silver in Alipy's name. Alipy knew nothing of this, but when the works were due, seven empty boards were found to have miraculously become beautifully-painted icons, saving and enhancing Alipy's reputation. Other miraculous tales are told of this man whose life seems to have been a fitting beginning for the Russian tradition of icon painting. Alipy is said to have painted the prototype of the famous Svyenskaya Mother of God, copies of which are still being painted.

In the illustration shown, Alipy is painting an icon of the Mother of God (top). Below, he heals a man with his paints (left), is seen in his youth (center) and sleeps while an angel paints a commissioned icon for him (right).

THE TSAREVICH DIMITRIY *p. 191*

Dimitriy, born in 1582, was the son of Ivan "The Terrible" and Maria Nagaya. After Ivan's death, Dimitriy inherited Uglich. He is said to have been murdered in 1591 at the order of Boris Gudunov, so that Boris might become Tsar. The ruler at that time

was another son of Ivan, Feodor Ivanovich, who was mentally retarded, and whose death in 1598 ended the old imperial House of Rurik. He was succeeded by Boris Gudunov.

Icons of Dimitriy often show scenes related to his assassination — Dimitriy taken by assassins while with his nursemaid Vasilissa Volkhova, the murder of Dimitriy, the mother and nursemaid weeping over Dimitriy's body, and the churchward ringing a tower bell in alarm while the evildoers batter in the door.

ANTONIY RIMLYANIN *p. 192*

Antoniy "The Roman" was born, according to tradition, in 11th-century Rome. Though surrounded by worldliness, he decided to become a monk. After the death of his parents he gave part of his possessions to the poor, and put the rest into a barrel and tossed it into the sea.

Antoniy fasted and prayed on a large rock in a deserted spot by the ocean. A year later a great storm arose and washed him and his rock out to sea. He did not stop praying, and he and his rock were both carried on the water to Volkovskoya, a town near Novgorod. There Antoniy learned Russian, and with the money received from selling the valuables in the barrel he had tossed into the sea (which Russian fishermen miraculously found), he built a church and monastery. He is believed to have died in 1147.

His icons often depict him, as here, floating upriver on his rock with a wall-enclosed monastery in the background. In this reversed pattern Mary and the Child Christ are seen in clouds in the sky.

THE APPEARANCE OF THE MOTHER OF GOD
TO VENERABLE SERGIY *p. 193*

Russian monks are easily recognized by the garment they wear, called the *skhima,* shown here on the popular saint Sergiy (Sergei, Sergius) of Radonezh and his companion, Venerable Micah. The term "venerable" is an English substitute for the Russian *prepodobnuiy,* , used as a title of monks.

Sergiy was born to a pious Rostov family. He seemed quite dull in his youth until he met a mysterious monk who gave him something sweet to eat, from which time the boy was able to read and write. Then called Bartholomew, he later decided to become a monk, taking the name Sergiy.

This icon shows him later in life, when the Mother of God, together with the Apostles Peter and John, appeared to him and Micah.

It is easy to confuse Sergiy with other famous Russian monks, so one must be careful to read inscriptions. Among those others are Antoniy and Feodosiy, considered founders of the famous Monastery of the Caves (*Pecherskaya Lavra*) in Kiev; Kirill Byelozerskiy

("Of White Lake"), who founded a monastery at that place; Antoniy Siyskiy ("Of Siya [River]"), who founded a monastery in a remote area on Lake Mikhailov; and Varlaam Khutuinski ("Of Khutuin"), another northern monastery founder.

NIL STOLBENSKIY *p. 194*

Nil Stolbenskiy, who died in 1554, takes the second part of his name from Stolbensk Island in Lake Soliger, where he lived piously. One sometimes finds little statues of Nil on crutches, carved by the monks of his cloister in later years to sell to pilgrims visiting the site.

In this example Nil is seen standing before his island monastery. Inside, below an icon of Christ Immanuel, is shown the "repose" (death) of Nil. Christ is at upper right in this reversed image.

ALEXANDER SVIRSKIY *p. 195*

This prominent saint of the northern wilds was born to a pious couple in the village of Mandera, on the edge of Great Novgorod. He was a pious youth whose dullness was conquered with a sincere prayer to the Mother of God. After seeing travelling monks, Alexander conceived a great desire to take up that life. He left home and found himself alone in the wilderness at night. Christ spoke to him, directing him to the Monastery of Valaam.

On the long way to the monastery, Alexander met a stranger who accompanied him, disappearing when they reached their goal in remarkable time. Alexander then realized that his companion had been an angel sent to guide him.

Later in life he had a vision of the Holy Trinity, which appeared to him as three bright men who commissioned him to build a church.

Alexander takes his name from the monastery he built on the Svir River. In this reversed example he gazes toward heaven, where the Holy Trinity appears among clouds. The inscription above him, with missing letters added, reads "SVATUIY PREPODOBNUIY ALEKSANDR SVIRSKIY" — "Holy Venerable Alexander of Svir."

PROKOPIY USTIUZHSKY AND IOANN USTIUZHSKY *p. 196*

Ascetics and holy fools were depicted either with simple clothing, like Alexei, Man of God (Aleksey Chelovek Bozhiy), who was a wandering beggar in Edessa and Italy, or without any clothing at all, like Macarius (Makariy) of Egypt, who lived in the Fourth Century and is painted with a great beard that hangs nearly to his ankles.

The holy fools of Russia abandoned possessions, even the appearance of intelligence,

for Christ. They are often depicted totally nude. The textual basis for their lives is I Corinthians 3:18: "Let no man deceive himself. If any among you seems to be wise in this world, let him become a fool, that he may be wise."

Prokopiy of Ustiuzh, the bearded figure shown here, died in 1303. He was originally a Hanseatic League merchant from the West who converted to Orthodoxy. He became first a monk, then a severe ascetic. He can often be recognized by the fire pokers he carried. If he held them with heads up, it foretold a plenteous year. If the heads were down there would be want in the land.

The second figure in this pattern is the Holy Fool for Christ's Sake (Khrista radi iurodivuiy) Ioann of Ustiuzh, who died in 1494.

The inscription between Prokopiy and Ioann reads Blazhen[n]uie Prokopi i Ioann Oustiuzhskiya chiudotvor[tsui] — "Blessed Prokopiy and Ioann, Ustiuzh Wonderworkers." Holy fools are generally given the title "Blessed." At the top is the Old Testament Trinity.

THE METROPOLITAN ALEXEI p. 197

Before the creation of the Russian Patriarchate in 1589, the highest office in the land was that of metropolitan. Metropolitans are robed like bishops, but wear a distinctive white cowl that falls on each side of the face. Usually the Gospels are in the left hand and the right is raised in blessing, as is appropriate for a teacher of the Church.

Alexei entered a monastery at a young age and advanced in the Church until selection as metropolitan. He was consecrated in Moscow in 1354.

Among other famous metropolitans were Peter, Jonah (Iona), Job (Iov) and Philipp (Filipp).

The Patriarchate was abolished by Peter the Great, who instituted a State-controlled governing body called the Holy Synod in its place in 1721. The Patriarchate was re-established in 1917, with Tikhon as Patriarch.

ARTEMIY VERKOLSKIY p. 198

Tradition relates that he was born in the village of Verkola, near Arkhangelsk, in 1552. The devout son of a peasant family, on June 23, 1545, he was tilling a field and was suddenly struck by lightning. An angel took his soul to heaven, but the villagers viewed his death as a divine judgment, and left the body unburied in the forest.

In 1577 his remains were found still incorrupt, a sign of sanctity in Orthodoxy. His relics were taken to the church at Verkola. From that time miracles attributed to Artemiy began. He was officially canonized in 1640.

Icons depict him standing devoutly, sometimes with a branch in his right hand. They often include scenes of his life and death — his tilling, the angel receiving his soul, and the finding of his relics.

In this example Artemiy is seen lying on the ground in death as well as standing prayerfully beside an image of the USPENIE SVYATUI ANNUI — "The Dormition of Holy Anna."

ZOSIM AND SAVVATIY *p. 199*

They are considered the founders of the Solovetsky Monastery on the White Sea.

Savvatiy's origin is unknown, other than that he was in the White Lake Monastery of Kirill Byelozerskiy sometime between 1408 and 1431. He next went to the Valaam Monastery on Lake Ladoga. Uncomfortable at being praised there for his piety, he left for the uninhabited Solovetsk Island in the White Sea, where he settled with the Monk German (of Solovetsk). Savvatiy died in 1435.

One year later, German returned to Solovetsk with Zosim, who founded a monastery there which grew and flourished. Zosim died in 1478.

Zosim and Savvatiy are commonly shown standing in front of their monastery. They are the patron saints of beekeepers.

MARY OF EGYPT *p. 200*

Mary Egipetskaya was an actress and prostitute of Alexandria. Repenting of her worldly life, she went to live in the desert as an ascetic. There she remained for years, and in about 430 was found by the monk Zosimus, who gave her communion. He saw her again at Lent a year later, but when he next returned she had died, so he buried her and spread the story of her pious life. She is generally seen as a partially-clothed ascetic with long hair.

Three other famous female saints not illustrated in this book are St. Catherine, St. Barbara, and Paraskeva.

Catherine was born in Alexandria to a wealthy family, and was converted by a vision. Emperor Maximian tried but failed to get her to abandon her faith. Finally he had her martyred on a spiked wheel, which became her symbol. The wheel broke and she was beheaded.

The Great Martyr Barbara is said to have converted against the will of her pagan father. For this she was condemned to death. She is appealed to in cases of toothache and for unrepentant death.

Paraskeva was the patron saint of women's affairs and of market day. Her name means "Friday," the day on which markets were held. She is generally shown with a white cloth on her head surmounted by a simple diadem. She holds a cross in one hand, and in the other a scroll with the first words of the Nicene Creed, "I believe in one God the Father Almighty...".

Menological Icons

A menological icon is a visual calendar depicting the saints and festivals honored on each day of each month of the year. Consequently a complete set of such icons would comprise twelve panels, one for each month. These icons are easily recognized by their many rows of saints. They are quite often colorful and interesting.

Some menological icons in the Novgorod area were painted as tabletki, stiff panels made not of wood, but of linen gessoed on both sides. They were consequently very fragile.

So-called "year" icons are remarkable. On one panel, often quite large, they depict saints and festivals for each day of all twelve months of the year. Added to these are sometimes over one hundred depictions of miracle-working types of Mother of God icons celebrated during the Church year.

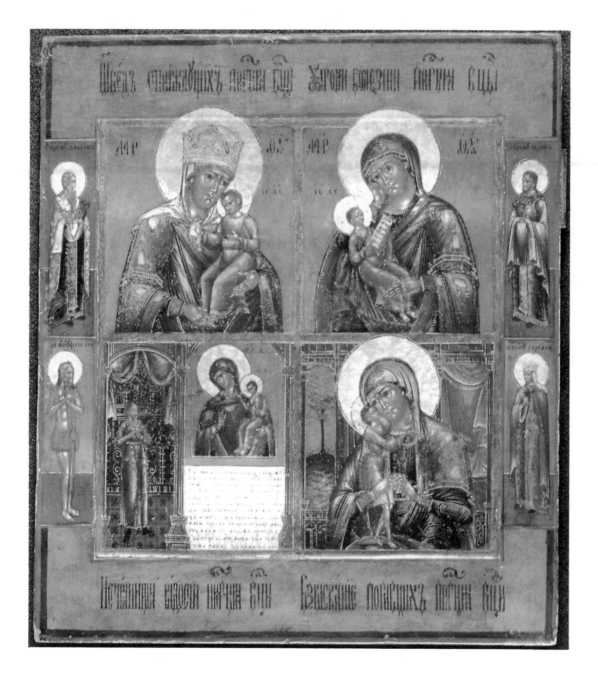

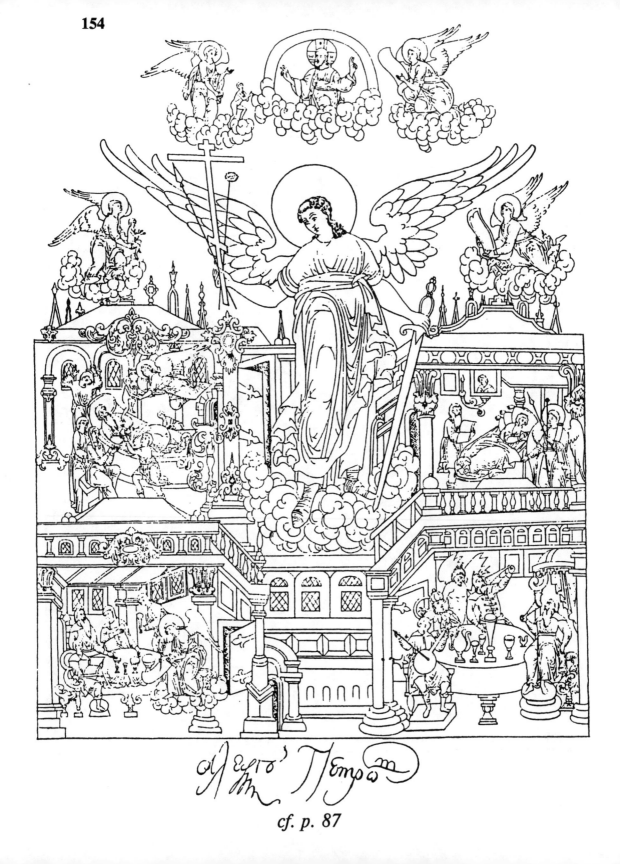

cf. p. 87

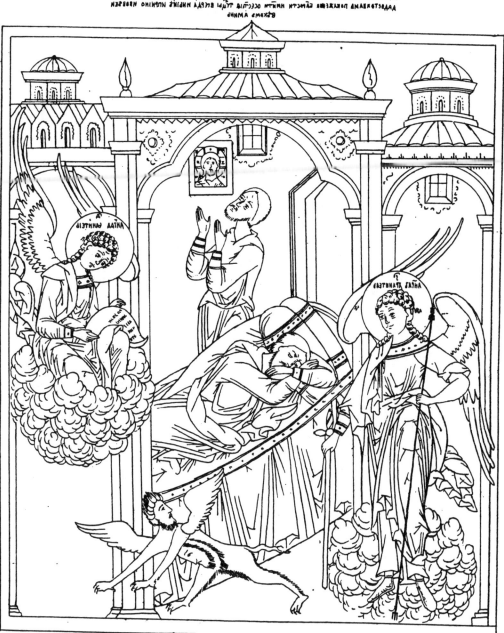

АНГЕЛЪ ХРАНИТЕЛ ДꙊШИ ЧЛОВѢЧЕСКIꙖ.

cf. p. 133

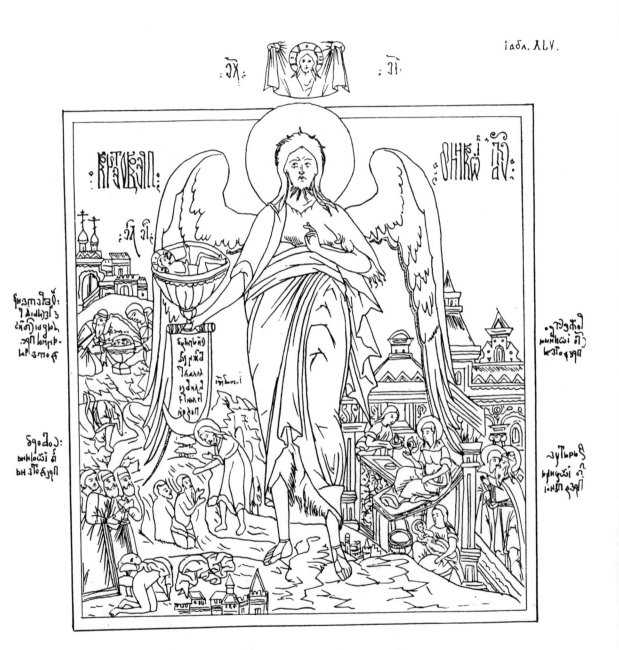

cf. p. 134

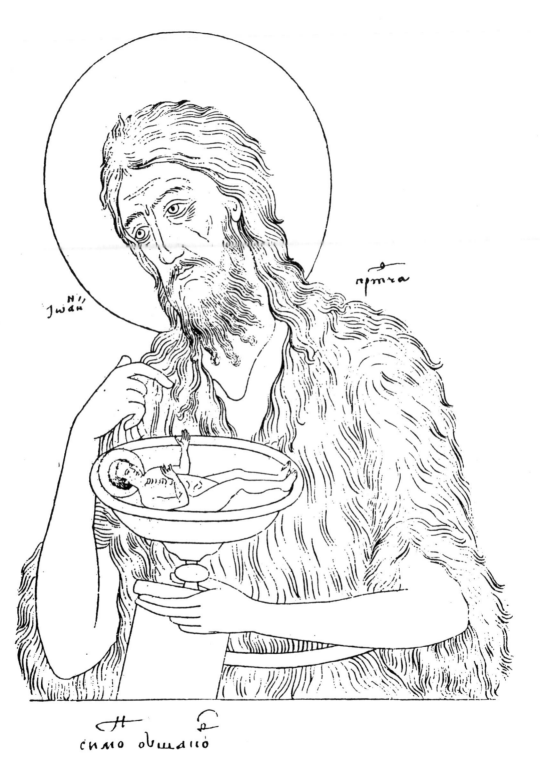

cf. p. 134

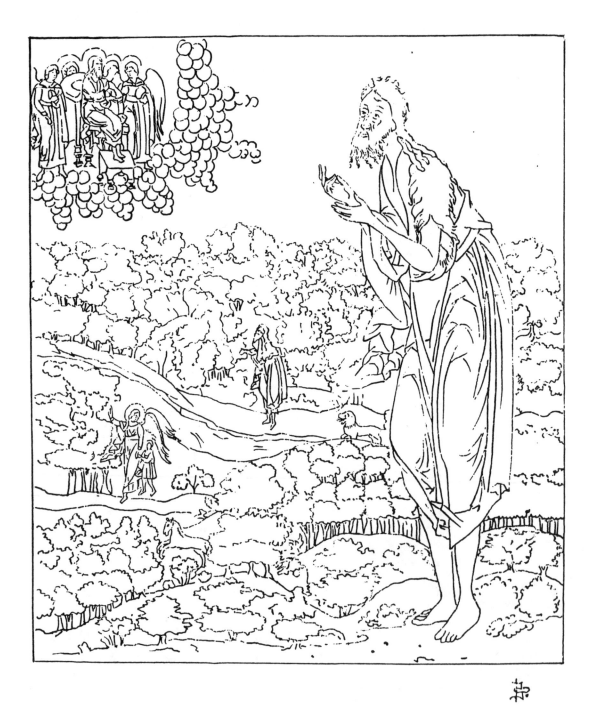

СВ. ÏОЭННЪ ПРЕДТЕЧЭ.

cf. p. 135

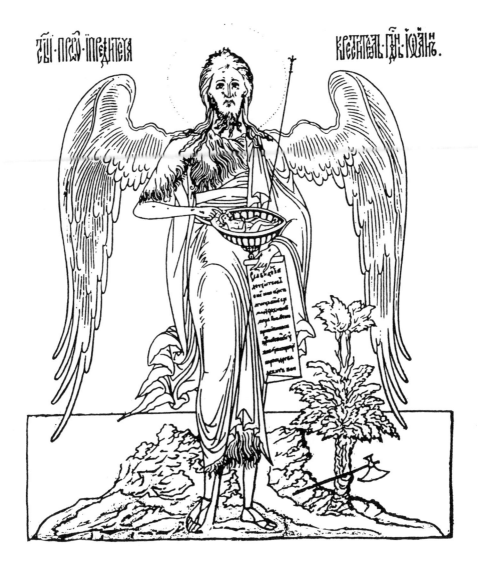

ст҃ы · пр҃дѡ · пр҃дитеⷱ҇ крⷭ҇титель · гⷭ҇н · юⷶнⷤ ·

cf. p. 135

І ю̃нь

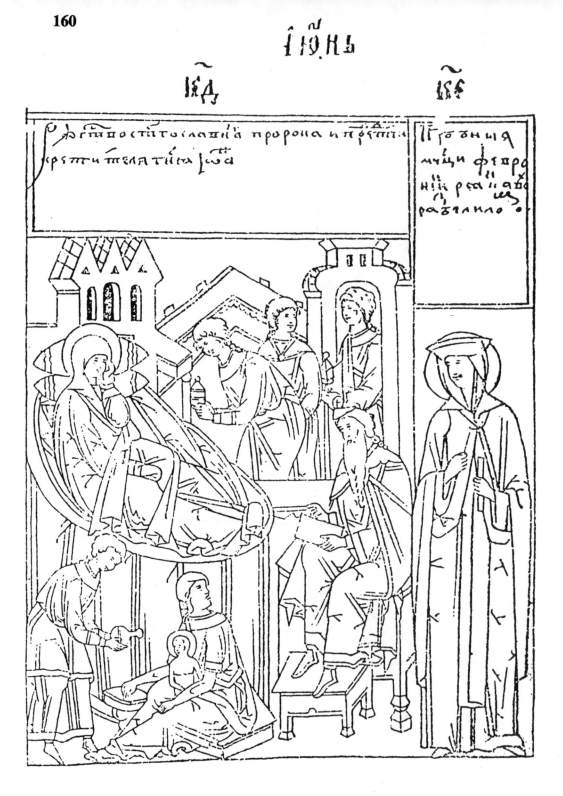

Дѣ̃ т по ст҃ӑго сла́пı̈ӑ проро́па и про̃т҃ꙑ
кр҃стите́ла тı̈на зо̃а

Пр̃о бнı҃а
м̃чꙑ фео̃про
нı҃и ра ꙑ а̃о̃
раꙃаꙑпло ⁘

cf. p. 136

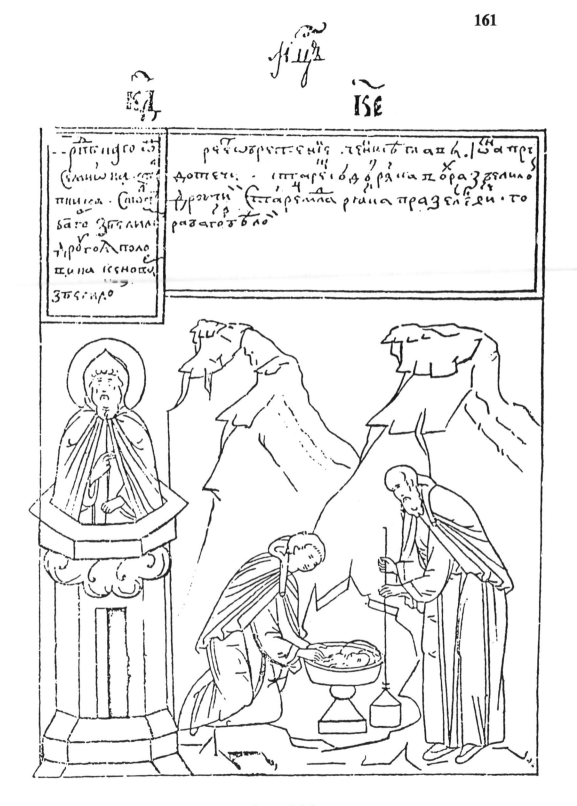

cf. p. 136

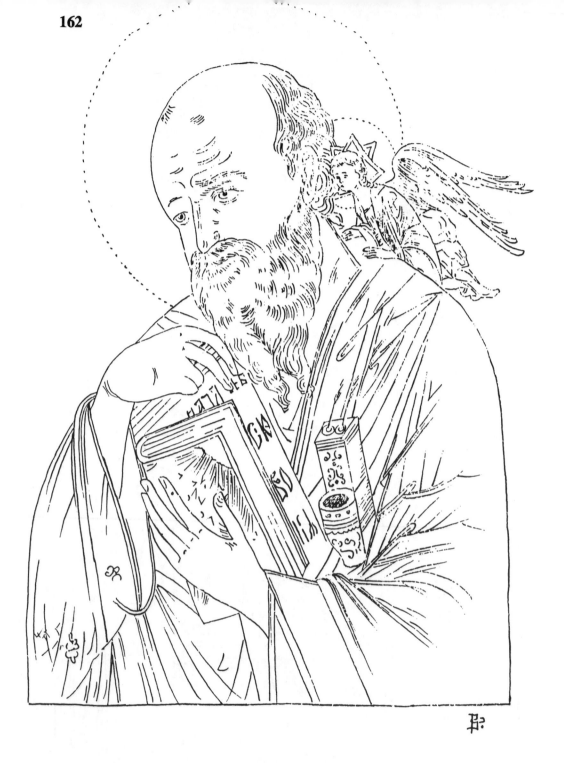

ІОАННЪ БОГОСЛОВЪ.

cf. p. 136

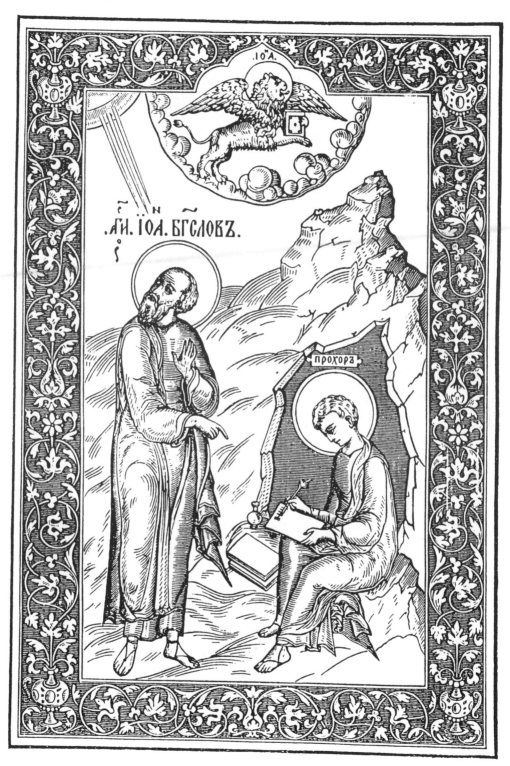

cf. p. 137

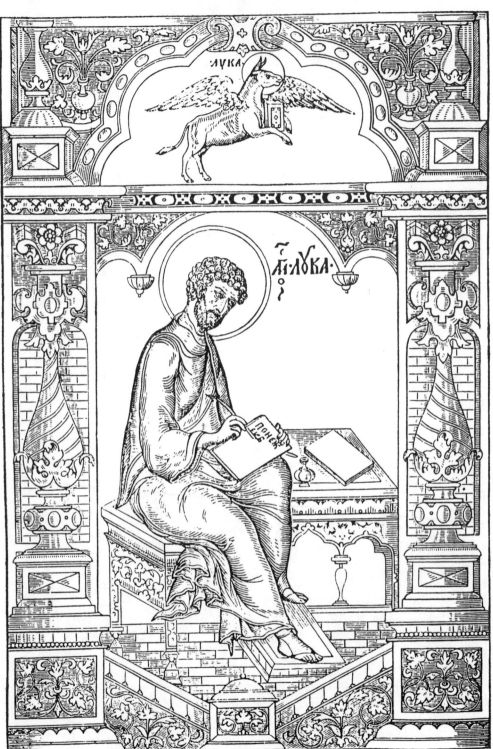

cf. p. 137

како апⷭⷭлъ еⷠⷢлистъ лꙋка

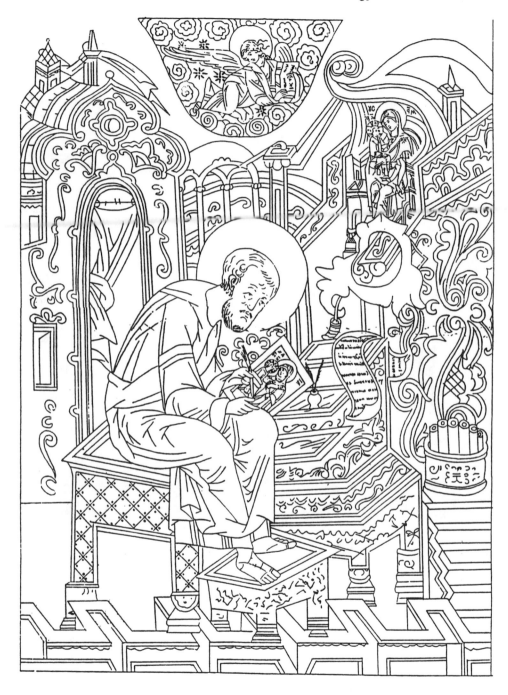

евⷢангелистъ лꙋка пишеⷮ иконꙋ богоматери .

cf. p. 137

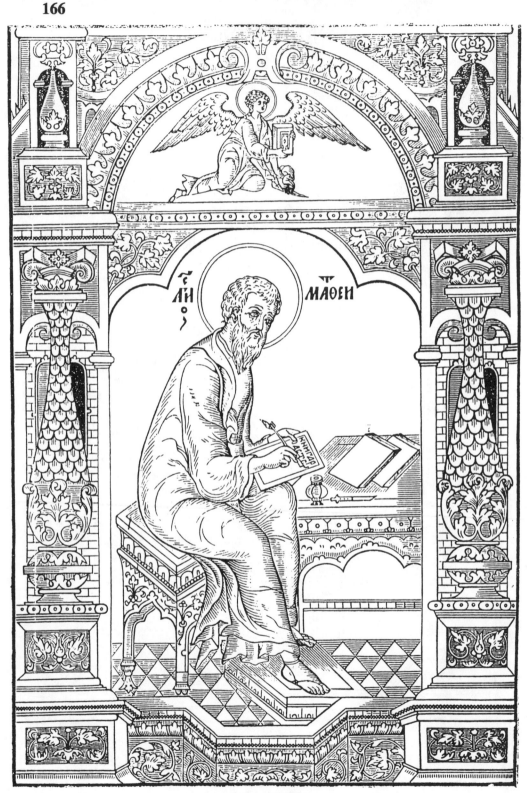

cf. p. 138

cf. p. 138

СВ. АПОСТОЛЫ ПЕТРЪ И ПАВЕЛЪ.

cf. p. 138

cf. p. 139

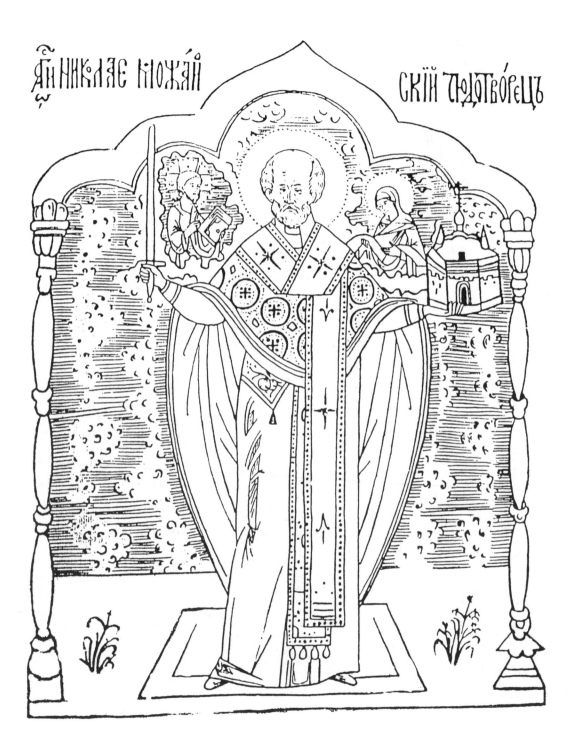

cf. p. 139

Св. Николай Чудотв. Зар.рис.

cf. p. 140

Табл. LVII.

СВ. МУЧ. ГЕОРГІЙ ПОБѢДОНОСЕЦЪ.

cf. p. 140

НАТНМЭД ХР

IC XC

СВ. ДИМИТРІЙ СОЛУНСКІЙ.

cf. p. 141

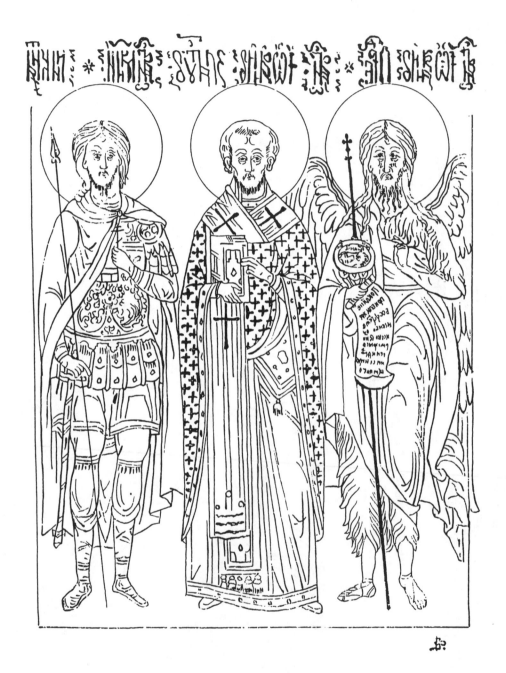

СѢ. ІОАННѢ ПРЕДТЕЧА ЇОАННѢ ЗЛАТОУСТѢ И МУЧ. НИКИТА.

cf. p. 141

ПРꙖТ҃І Ѻ Ѳ҃Ѳ Ѳ҃ДѠХ Ч҃ТІ

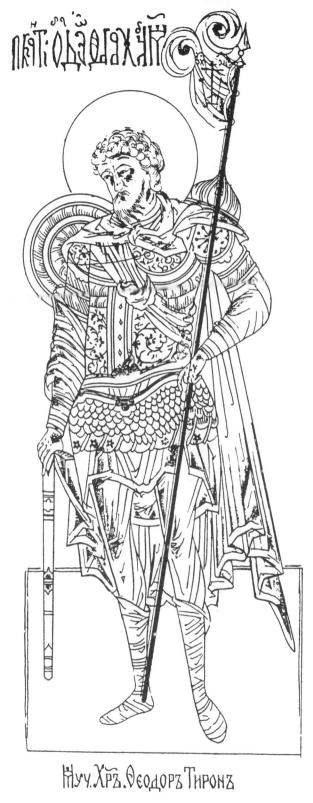

Ꙗꙋꙋ. Хр҃ъ. Ѳеодоръ Тиронъ

cf. p. 141

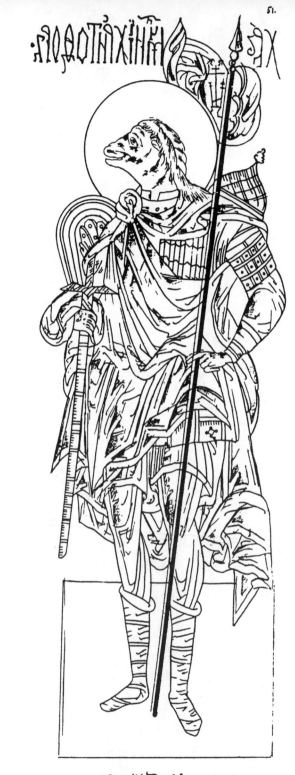

Хвⷵ Мⷱкⷩ Христѻѻрⷺ.

cf. p. 142

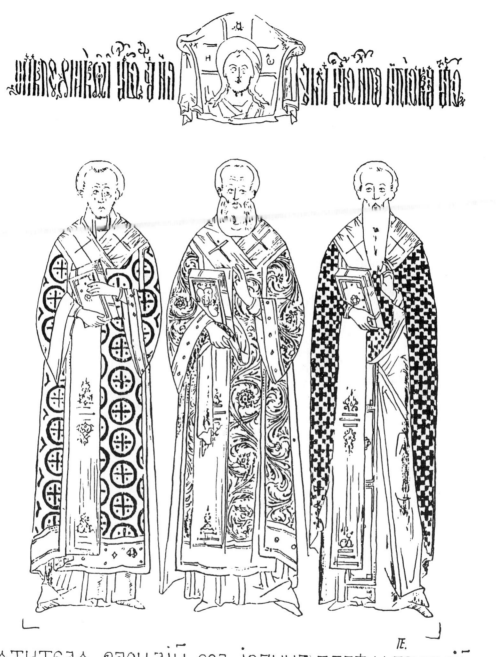

ТРИ СВТИТЕЛА ВАСИЛІЙ ВЕЛ. ІОАННЪ ЗЛАТ. И ГРИГОРІЙ БОГОС.

cf. p. 142

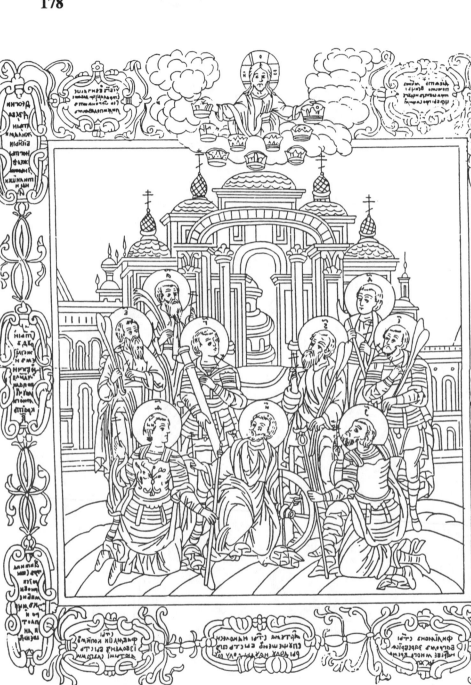

ДЕВѦТЬ МУЧЕНИКОВЪ ИЖЕ ВЪ НИЗИЦѢ.

cf. p. 143

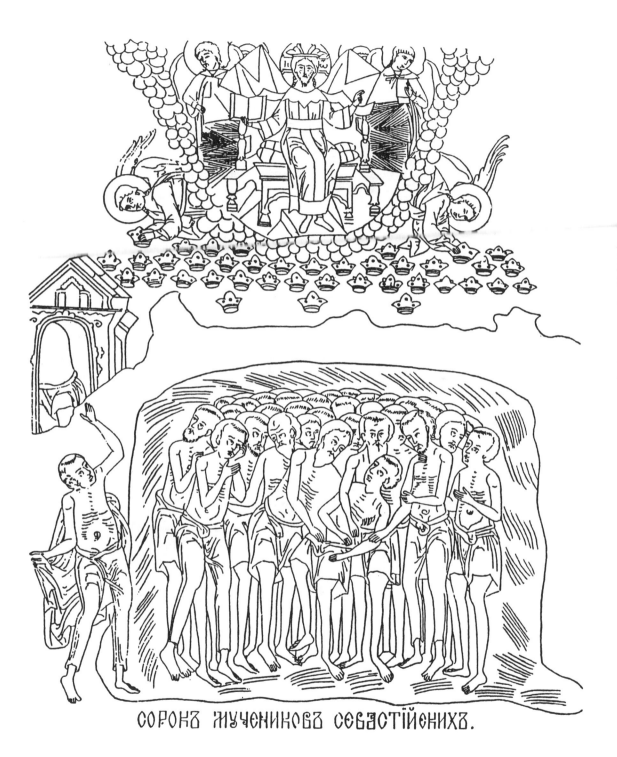

СОРОКЪ МУЧЕНИКОВЪ СЕВАСТІЙЕНИХЪ.

cf. p. 143

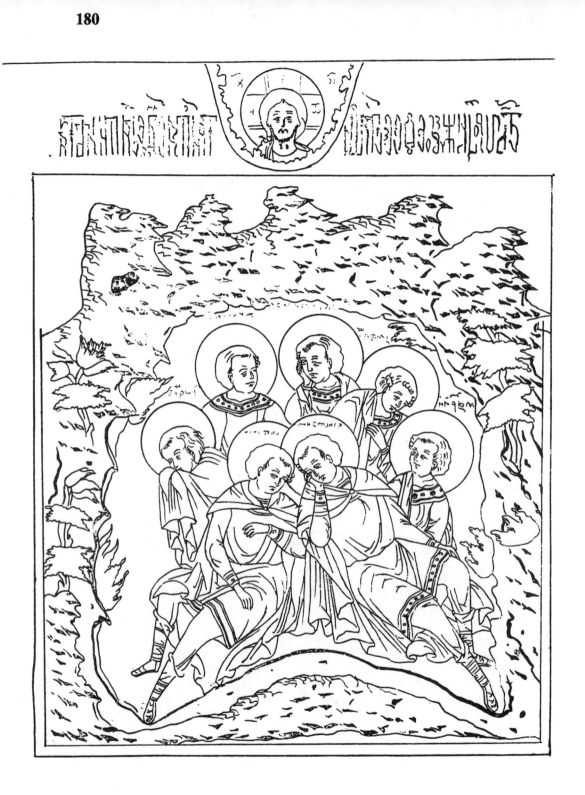

cf. p. 143

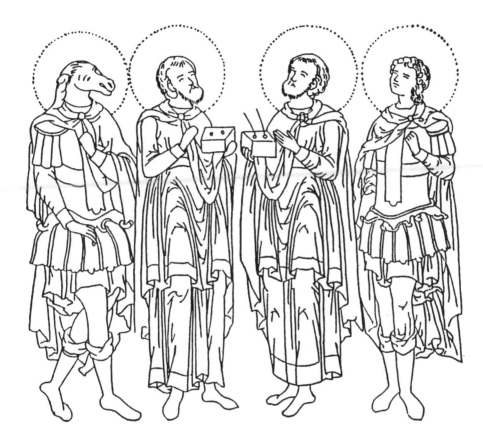

МУЧ. ГЕОРГІЙ КОЗЬМА ДАМІЯНВ И ХРИСТОФОРВ.

СВ. МУЧ. ГУРІЙ, САМОНЪ И АВИВЪ.

cf. p. 144

СВ. ФЛОРѢ И ЛАВРѢ.

cf. p. 144

МУЧ. КИРИКЪ И УЛИТѢ.

cf. p. 145

Царь Константинъ и Царица Елена.

cf. p. 145

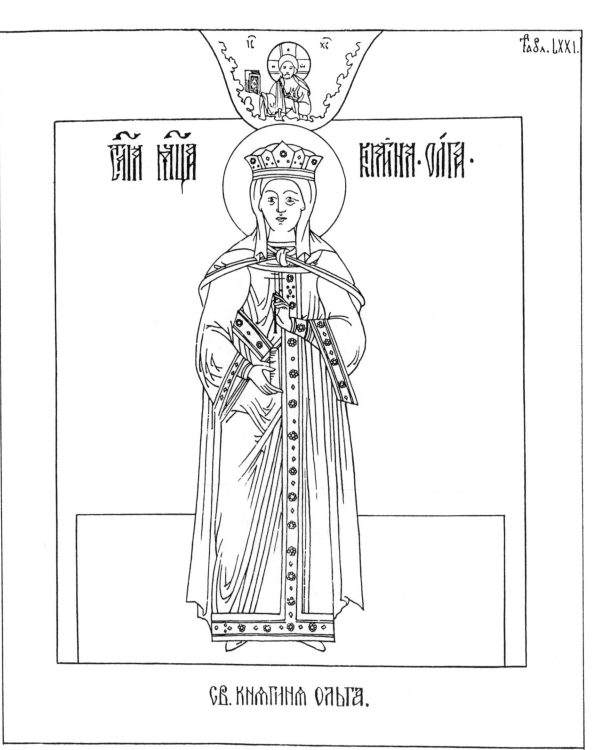

СВ. КНѦГИНѦ ОЛЬГА.

cf. p. 145

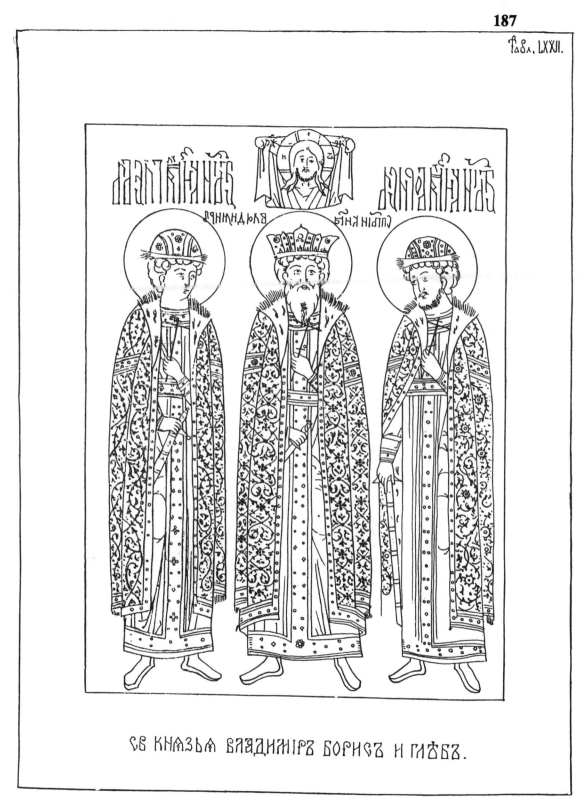

СВ КНАЗЬА ВЛАДИМІРЪ БОРИСЪ И ГЛѢБЪ.

cf. p. 146

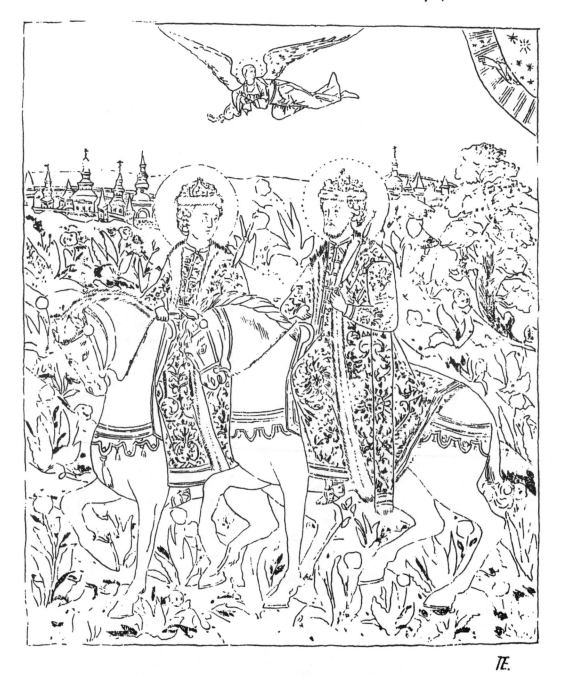

СВ. БЛАГОВѢР. КНѦЗЬѦ БОРИСЪ И ГЛѢБЪ.

cf. p. 146

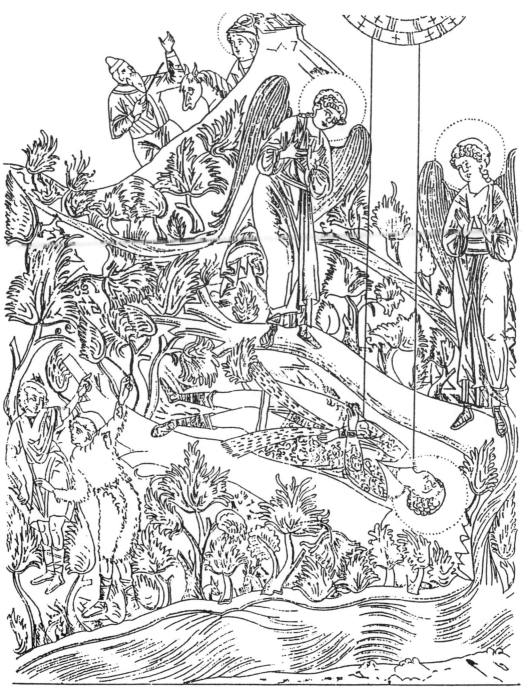

ИЗЪ ЖИТІА БОРИСА И ГЛѢБА.
СЛЫШАША МИМОХОДАЩІЄ АНГЕЛЬСКОЕ ПѢНІЄ.

cf. p. 147

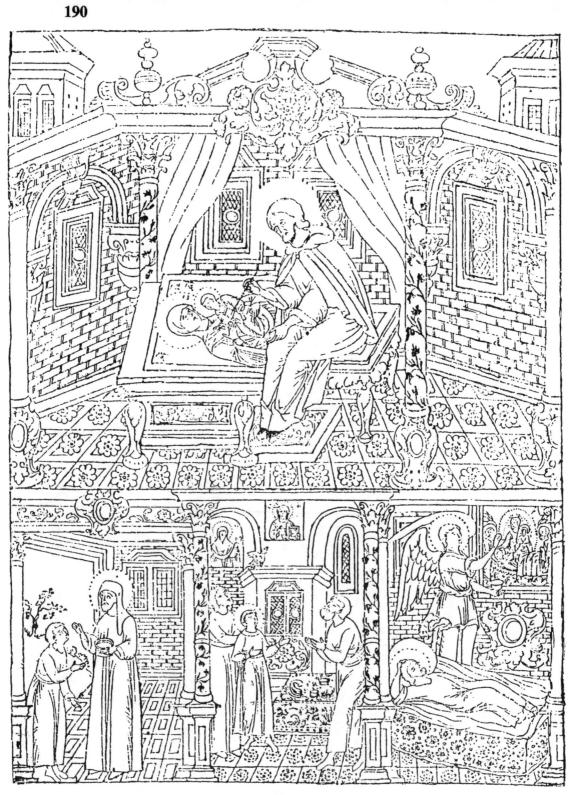

cf. p. 147

Св. Димитрій Царевичъ.

cf. p. 147

СВ. ПРЕПОД АНТОНІЙ РИМЛАНИНЪ.

cf. p. 148

cf. p. 148

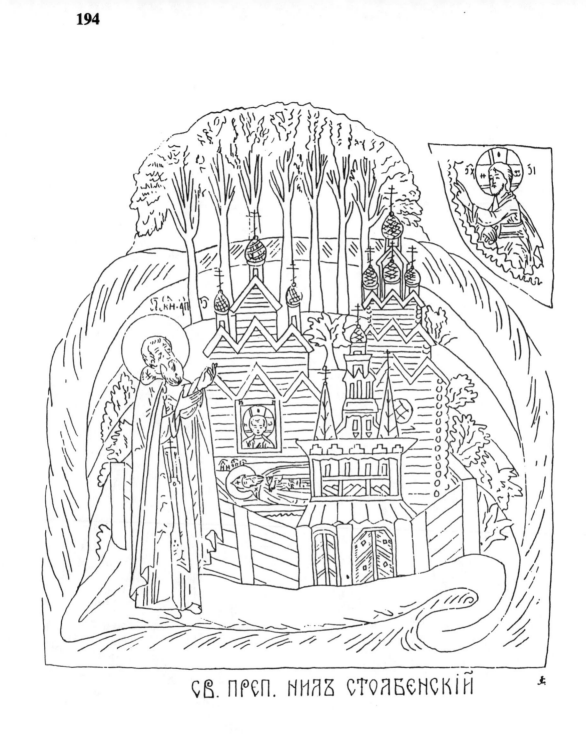

СВ. ПРЕП. НИЛЪ СТОЛБЕНСКІЙ

cf. p. 149

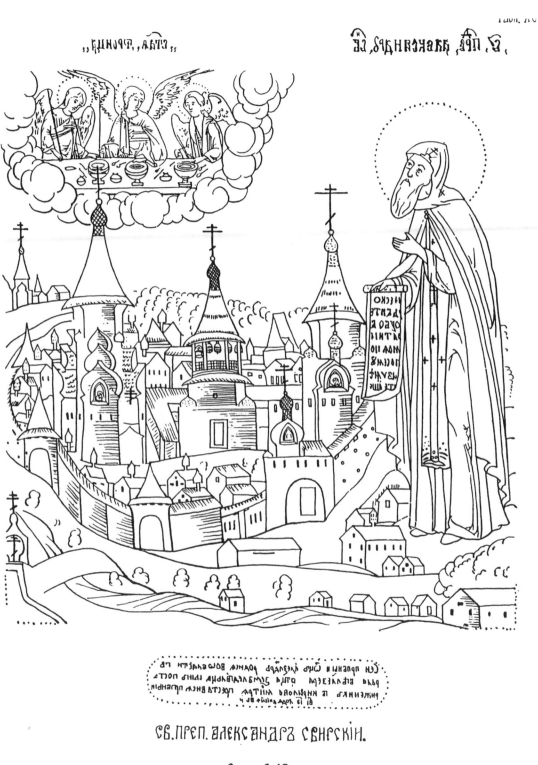

,,СТАЯ ТРОИЦА,,

БŌ ПРЕ АЛЕКСАНДРА СŌ

СВ. ПРЕП. АЛЕКСАНДРЪ СВИРСКІЙ.

cf. p. 149

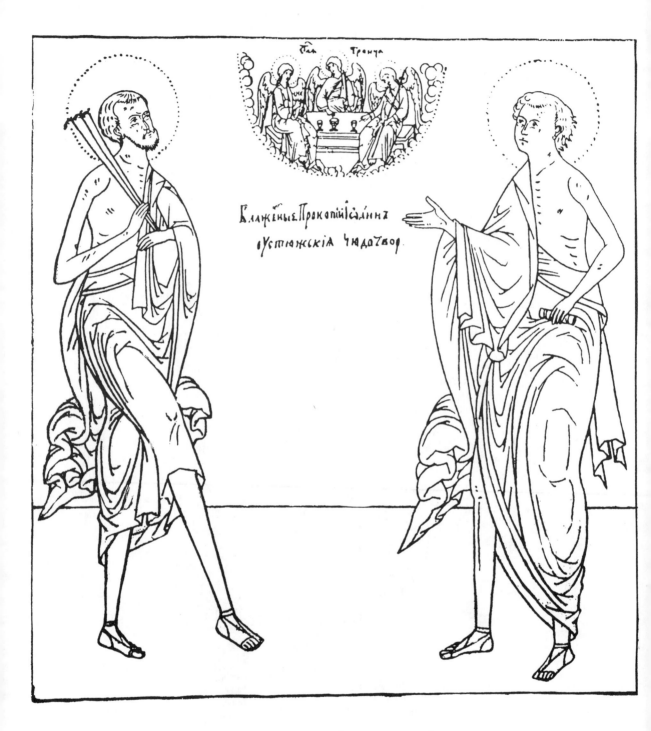

cf. p. 149

cf. p. 150

СВ. АРТЕМІЙ ВЕРКОЛЬСКІЙ.

cf. p. 150

Св. Пр. Зосима и Савватій.

cf. p. 151

а҃прѣль

PART TWO
THE MOTHER OF GOD

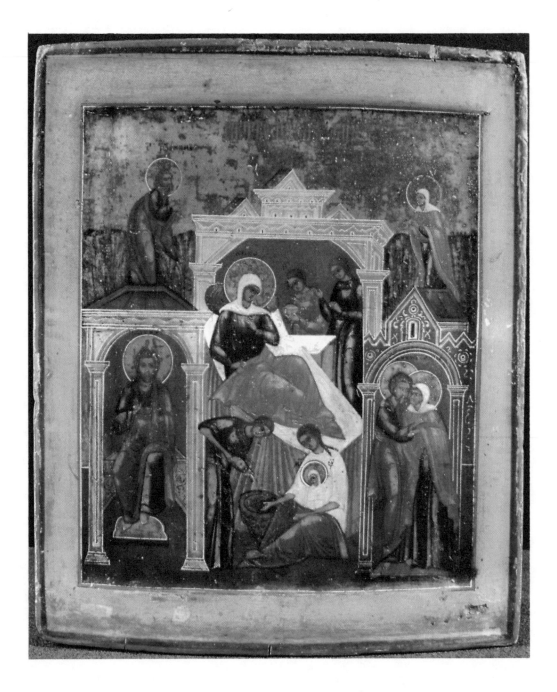

THE MOTHER OF GOD

Mary, mother of Jesus, is given the title "Most Holy Mother of God" in the Eastern Orthodox Church. The Council of Ephesus (421 C.E.) decided that Mary is mother not only of Christ's human nature, but also of his divine nature, because the two cannot be divided. This edict was made in response to the teaching of Nestorius, Bishop of Constantinople, that Mary could be only the mother of the human aspect of Christ. Nestorius was condemned, and Mary was formally given the Greek title Theotokos, in Russian Bogoroditsa, meaning "Birth-giver of God." This title is also found on some Russian icons as Bogomater, meaning literally "Mother of God." This title was, as we have seen, originally that of the Egyptian Goddess Isis, called by her worshippers "Mut Netjer" — the Mother of God.

In the Orthodox Church Mary is considered higher than the angels, and is entitled to veneration but not worship.

Icons of the Mother of God are marked with the Greek abbreviation for that title, MP ΘY (Meter Theou). She bears a star upon each shoulder and on her head, signifying her perpetual virginity before, during, and after the birth of Christ. Her usual garments are the maphorion (the burgundy-purple covering on her head and shoulders) and the blue chiton, the gown. It is on the maphorion that the three stars symbolizing her perpetual virginity are found. Beneath the maphorion is a simple head band which hides her hair.

Icons of the Mother of God provide the student with a wide area for exploration. There are well over two hundred different types, some quite famous and common and others less frequently encountered. The differences among many types are very slight, so if the title is absent or damaged great care should be taken in identification.

Though it seems confusing, there may be more than one title given icons of apparently the same type. This sometimes occurs when a copy of a celebrated icon becomes famous on its own as a miracle-working image. Thus the student may find reference books listing an icon and its famous copies or versions, such as the "Bogoliubskaya," the "Moscow-Bogoliubskaya," the "Bogoliubskaya-Zimarovskaya," etc.

Icon literature frequently mentions the Hodigitria ("Way-Shower" — Russian Odigitriya) and Eleusa ("Merciful") Mother of God icon types.

The Odigitriya depicts the Mother with the Christ Child on her arm. She gestures toward him with her right hand. Their heads are erect or nearly so.

The Eleusa, known in Russia as Umilenie ("Tenderness"), depicts the Mother holding her Child, but in this case the heads incline closely together and touch.

These two general labels tend to be over-used by some who either do not recognize individual Russian types or do not want to bother with precise identification. In this listing they are used primarily as a rough aid to identifying the forms of icons under specific type names. Those specific names should always be used for correct identification in preference to the Odigitriya or Umilenie labels.

THE "APPEARANCE" OF AN ICON

When used of an icon, the term "appearance" (Russian *yavlenie*) means the time when an image manifests itself for the first time as a wonderworking icon. Such an appearance may take place in a number of ways; the icon may have been previously unknown, and found under apparently miraculous circumstances, such as the "Kazan" icon, which was discovered after its location was revealed to a young girl in a dream. An icon may also "appear" in a tree, or floating in a river or in the sea (old damaged icons or images too dark to recognize were often disposed of by placing them in a river), or an icon long in a church may suddenly begin to work miracles.

ICONS OF THE MOTHER OF GOD

The following list includes most of the Mother of God types one is likely to encounter but is not complete.

The "origin" stories related here are religious traditions rather than the result of scholarly historical research. Several icons, for example, are said to have been painted by St. Luke, yet technical investigation has shown that to be incorrect.

Icons with a regular feast day in the Russian Church calendar have the date or dates of commemoration at the end of the entry.

Fewer icons in this section have accompanying illustrations, but actual examples are seldom difficult to identify because they usually bear a clear title. Therefore titles are generally given first in Slavonic.

<center>∽᠐ıı◦∽</center>

ABALATSKAYA ZNAMENIE

This version of the "Sign" (Znamenie) Mother of God (which see) was painted in 1637 by Matfei, protodeacon to Nektariy, Archbishop of Tobolsk. It originated in the experience of a widow named Maria, who saw the image of the "Sign" Mother of God flanked by St. Nicholas and Holy Mary of Egypt, and heard the Virgin speak to her.

The icon takes its name from the Abalatskiy Monastery near the village of Abalak, not far from Tobolsk. July 7, July 20, November 27.

ABULSKAYA

This icon appeared in Serbia in 692, and in 1570 was taken to Mount Abul (Avila) in Spain. It depicts the Mother of God holding her child on her left arm. The child holds an orb with his left hand and blesses with his right. The Mother of God holds a ladder behind her right hand. This element is also found in other types such as the Putivlskaya, Molchenskaya, and Gora Nerukosechnaya, so be careful in identification. May 8 and

June 11.

AKAFISTNAYA KHILENDARSKAYA

This is one of the famous Mt. Athos icons, and takes the second part of its name from the Khilandari monastery, one of several located on that mountain. The first part is the Russian pronunciation of the Akathist, the famous hymn to Mary by Romanos the Melodist. In 1837 the icon escaped damage from a fire which broke out while the Akathist was being sung. Umilenie variant. January 12.

AKAFISTNAYA ZOGRAFSKAYA

This type originated with a famous icon on Mount Athos. The image takes the first part of its name from the Akathist hymn and the second from the Bulgarian Monastery of Zoografou, where it is kept in the Church of the Dormition.

Tradition relates that a certain monk living as a solitary near the monastery was praying the Akathist when he heard a voice coming from the icon of the Mother of God. It warned him of impending persecution by Latin Catholics. He hurried to the monastery to warn the monks, and found that the icon had preceded him. Some in the monastery hid themselves with the icon, but the persecutors piled wood about the tower where the monks were hidden and set it alight. They were killed, but the icon survived. This event is said to have taken place on October 10, 1274.

Dawkins mentions that this icon was called by the Serbians Khairovo, "She to Whom 'Hail' Is Said." An alternate Russian name is Predvozvyestitelnitsa, "The Foreteller." Odigitriya variant. October 10.

AKHTUIRSKAYA *p. 247*

This icon appeared on July 2nd, 1739, when the priest Daniil Vasiliev found it in the grass while mowing with a scythe. It is named for the town where it was found, Akhtuirka in the province (gubernia) of Kharkov. The type is distinctive. It depicts the Mother of God half-length, in an attitude of prayer. To her right (smaller than she) is Christ crucified. July 2.

ALBAZINSKAYA "SLOVO PLOT BUIST"

See SLOVO PLOT BUIST.

ALEKSANDRIYSKAYA

Date of appearance not known. Odigitriya variant. September 1.

AMARTIYSKAYA (ARMATIYSKAYA)

Named for the Armatia cloister in Constantinople. The child is standing behind his mother's left hand. His right arm is around her neck. August 17.

ANTIOKHIYSKAYA

Most sources say the date of appearance is not known; the caption on an old engraving reproduced by Kondakov states "The image of the 'Antioch' Most Holy Mother of God appeared in the year 5680 [172 A.D.], on the 23rd day of March." The Christ Child is seated on the Mother's left arm. This type is distinguished by the upraised left forearm of the child, the palm level with his face. May 28.

ARAVIYSKAYA

This "Arabian" type, also called Arapetskaya, is said to have appeared at the time of missionary activity in India by St. Thomas, during the first century A.D. The type is virtually identical to that called O Vsepyetaya Mati (which see), except that in the latter the maphorion of the Mother of God bears an inscription along its border. A peculiarity of both (and of the Gora Nerukosechnaya) is the replacement of the three stars on the Virgin's maphorion by three circles containing heads of angels. September 6.

BALUIKINSKAYA

This icon, named for the village of Baluikin in the province of Chernigov, was painted on a cloth glued to a board. The Christ Child, clothed only about the waist, reclines on the lap of the mother, whose hands are joined as in prayer. It appeared on June 30, 1711. June 30 and the tenth Friday of Paskh.

BESYEDNAYA *p. 248*

This "Conversational" type depicts the appearance of the Mother of God and St. Nicholas to the sexton (ponomar) Georgiy Iuruish, during which she ordered him to replace the iron cross on the church dedicated to her at Tikhvin with one of wood. The

original "Besyednaya" icon was painted on a board cut from the log on which the Mother of God sat as she conversed with Georgiy during her appearance, which occurred not long after the 1383 appearance of the famous Tikhvin icon (separate type). The Mother of God is seated on the right. Georgiy kneels before her. On the left stands Holy Nicholas the Wonderworker. August 14.

BLAGODATNOE NEBO

Tradition relates that this "Blessed Heaven" icon was originally in Smolensk, and was taken to Moscow by the Great Princess Sophia Vitovtovna, who lived in the late 14th-early 15th century. It depicts the full-length Mother of God standing with her child on her left arm and a sceptre in her right hand. Mother and child are both crowned. March 6 and All Saints week.

BLAGOUKHANNUIY TSVYET

This icon, the "Fragrant Flower," was kept in the Pokrov Monastery (Cathedral Church) of Voronezh. No date of appearance is given. The child is seated on the mother's left arm, and a stalk of lily (or other flowers) is in her right hand. Do not confuse it with the "Unfading Flower" (Neuvyadaemuiy Tsvyet) type in which the Child Christ is seated on the right hand of the mother and the flower is in her left hand. November 15.

BLAGOVYESCHENIE USTIUZHSKAYA

This "Ustiuzh Annunciation" type is celebrated on the memorial day of the Holy Fool for Christ's Sake Prokopiy of Ustiuzh (died 1303). It is said that when God wished to punish the people of Ustiuzh for their sins, Prokopiy tried to warn them, saying, "Weep, friends! Weep for your sins! Pray that God will deliver you from his righteous wrath!" Eventually the sky began to darken, thunder was heard, and a terrible storm approached. The people, finally aware of their danger, hurried to the Church, where Holy Prokopiy prayed before an icon of this type to avert a terrible unnatural hail; red hot stones fell as the sky turned black, burning forests some twenty versts (one verst = roughly 2/3 mile) from Ustiuzh, but the town was saved.

The type depicts the angel Gabriel on the left, and the Mother of God on the right. It is distinguished by the image of the Christ Child against the Mother's body, just above her waist. March 25, July 8.

BLAZHENNOE CHREVO *pp. 249 & 250*

There are at least four types called the "Blessed Womb." The first is the "Barlovskaya," an Odigitriya variant that appeared on December 26th, 1392, and was kept in the Cathedral of the Annunciation in Moscow.

The second is a generally reversed variant of the Russian Mlekopitatelnitsa ("Milknourishing") type, which in turn derives from the Greek Galaktotrofousa. The type excludes two angels crowning the Mother of God, found in the Greek form. This variant may include the inscription "Blessed is the Womb that bare thee, and the paps which thou hast sucked" (Luke 11:27: Blazheno chrevo nosivshee tya, i sostsa, iazhe yesi ssal).

A third type, the Blessed Womb "With Ornament" (V Ukrasheniyakh) has the Child Christ reclining against the right arm of his crowned mother. Two angels place a crown on Mary's head while suspending an ornamental chain about her neck.

The fourth type depicts the Mother of God with her hands placed together as in prayer just above the half-length Christ Child placed before her torso (see also Pomoshch V Rodakh). December 26 and All Saints week.

BOGOLIUBSKAYA *pp. 251 & 252*

The "Bogoliubovo" Mother of God in its original form depicts only the Mother of God standing, with Christ in the clouds to her right. The "Moscow Bogoliubskia (142-B)" variant adds a contingent of saints. Another adds the image of Andrey Bogoliubskiy kneeling before the Mother of God.

The original type dates back to the year 1157, when the Mother of God is said to have appeared to Grand Prince (Velikiy Knyaz') Andrey Bogoliubsky, who had conquered Kiev, telling him to leave her "Vladimir" image in the city of that name. Prince Andrey had an icon painted which depicted the Mother of God as she had appeared to him, and this became known as the "Bogoliubskaya" Mother of God icon.

The "Moscow Bogoliubskaya" adds to this simpler original type a gathering of saints, among which may be Peter, Alexei, Jonah and Filipp, Metropolitans of Moscow; Blessed Vasili and Blessed Maxim, Fools in Christ; Onoufriy; Venerable Paraskeva; Holy Vasili (Basil) the Great; Alexei, Man of God; Simeon, Kinsman of the Lord; Mary of Egypt; Saints Zosim and Savvatiy; Varlaam Khutuinskiy; Apostle Peter; Venerable Martyr Evdokia; the Great Martyrs Barbara and Catherine.

The Mother of God holds a scroll bearing the words "Ruler most gracious, Lord Jesus Christ, my son and my God, hear the prayer of your Mother, for she prays for the world" (Vladiko mnogomilostive Gospodi Isuse Khriste suine i bozhe moy, ousluishi molitvou materye svoe...). June 18.

BORKOLABOVSKAYA

This icon was brought to the Borkolabov Convent in Mogilev province on July 11, 1659. July 11th.

BRANILOVSKYA

This icon was kept in the Vinnitsk-Branilov Cathedral Monastery at Branilov in the Province of Podolsk, where it was brought by Mikhail Kropivnitsky in 1635. It is an Odigitriya variant. October 1 and Pentecost.

A second type kept at the Branilov Monastery is the Branilovskaya-Pochaevskaya, which was brought from the Pochaev Lavra in the 19th Century. In this type the child is on the mother's left arm; Mary is being crowned by two angels, one of which holds a sceptre.

BUIST CHREVO TVOE SVYATAYA TRAPEZA

See Nikeyskaya "Your Womb Has Become the Holy Table" type.

BYELUINICHSKAYA

This icon was kept in the Nikolaev Monastery Church at Byeluinich in Mogilev province. The date of its appearance is not known. The Christ Child, holding an orb, is seated on the mother's left arm. She holds a sceptre in her right hand. April 12.

CHENSTOKHOVSKAYA

This is one of a number of icons said to have been painted by the Evangelist Luke. It was taken to Constantinople in 326 by the holy Empress Helena, and is later said to have been brought to Russia by Prince Lyov, who died in 1300. It was placed in a church in Galicia, then was taken to Yasna Gora near the town of Chenstokhovsk, thus the name. This type has become very famous as a national icon of Poland. The Christ Child, holding the Gospels, is seated on his mother's left arm. In the famous original two scars are visible on the mother's right cheek. Both mother and son are crowned. March 6 and August 27.

CHERNIGOVSKAYA-GEFSIMANSKAYA *p. 253*

This is a copy of the "Ilinskaya-Chernigovskaya" type. It was given to The

Mikhailov Church of the Gethsemane Skete at the Trinity-Sergeiev Lavra by a certain A.G. Filippov in 1842, and in 1869 it began working miracles, the first of which cured a peasant woman of palsy. Odigitriya variant. September 1.

CHIRSKAYA

This type, also called "Pskovskaya," takes its name from Chirsk (Chersk) in the Province of Pskov, where the icon drew attention when it began to weep tears in the year 1420. The icon wept again while it was carried in procession to the town of Pskov, where it was placed in the Holy Trinity Cathedral. Odigitriya variant. July 16.

CHISLENSKAYA

Date of appearance is not known. The Mother of God stands full-length on clouds, holding her son on her right arm. She is crowned. October 30.

DALMATSKAYA

This icon depicting the "Dormition" was brought to the Uspenskiy-Dalmatov Monastery on the banks of the river Iset in the province of Perm by the monastery's founder, Hegumen Dalmat, in 1644. February 15 and August 15.

DAMASKINSKAYA

This icon is said to be either an icon painted by John Damascene in the 8th Century or a copy of that icon. It was kept in the Gethsemane Skete of the Trinity-Sergeiev Lavra. Odigitriya variant. December 4.

DEVPETERUVSKAYA

The appearance of this icon took place on February 29, 1392. A particularly famous copy of it was kept in the Nikolaev Church of the village of Batatkova (or Batiushkova) in the Dimitrovsk district (uyezda) of Moscow province. The Christ Child stands against his mother's bosom on her right, his cheek touching hers. She is shown half-length. February 29.

DOLINSKAYA (DOLISSKAYA)

Date of appearance unknown. The Christ child is seated on his mother's left arm, his body, clothed only at the waist, turned away from her. February 13.

DOMNITSKAYA (DUMNITSKAYA)

This icon was found in 1696 in a popular tree in a meadow near the banks of the river Domnits in Chernigov province. Odigitriya variant. September 8 and the tenth Friday of Paskh.

DOMOSTROITELNITSA (EKONOMISSA)

Another of the famous Mt. Athos icons, this one is said to have been painted to commemorate a miracle which took place in 963. St. Athanasios had been commissioned to build a monastery at Mt. Athos, but he faced so many problems there that he decided to abandon the project and depart. But as he was leaving, the Mother of God appeared to him and told him to go back and continue his project with her assistance. She said also that she was to be called Oikodomissa, meaning "House Builder" (the house being the new monastery). The title was later altered slightly in Greek to Oikonomissa (House Directress), but the Russian title Domostroitelnitsa preserves the original meaning. At the time of her original appearance she also caused water to pour forth from a stone, and in commemoration of this a church dedicated to the "Life-Giving Fountain" was constructed on the site.

The Mother of God is shown seated on a throne; the Christ Child is on her left arm. The two saints depicted with the Mother of God in this icon are St. Athanasios, holding a church symbolizing his role as founder, and Saint Mikhail Sinadskiy. July 5.

DONSKAYA *p. 254*

This type is associated with the victory of Great Prince Dmitriy Donskoy over the Tartars at the Battle of Kulikovo on September 8, 1380. It is said to have been brought to Dmitriy by the Don Cossacks to aid him in battle. After Dmitriy's victory he took it to Moscow. There it was used again to repel an invasion of Tatars in 1591. The icon is said to have been painted by Theophanes the Greek, and bears on its reverse side the image of the Annunciation. Umilenie variant. August 19.

DOSTOINO EST

There are two famous "It Is Meet" types. One shows the Mother of God full-length in a circle, surrounded by angels and saints, with Christ above. The liturgical basis is "Dostoino est iako voistinou blazhiti tya bogoroditse, prisno blazhennouiu i preneporochnouiu, i mater boga nashego" — "It is truly meet to bless you, Birthgiver of God, ever-blessed and most undefiled and Mother of our God.

The second "Miluyushaya" type is a Mt. Athos icon said to be the most venerated in Greece. In the 8th Century a soldier attacked it with a sword, and the icon bled into the sea at Constantinople. As penance the soldier went to Athos, later finding there the same icon, still bleeding, in the sea. He took it to the Protatos Church, where the bleeding stopped. The icon was honored by monks singing "It is truly meet to bless you....", thus the Russian title. These words of veneration were said to have been given to a monk of the Karea Cloister by the Archangel Gabriel in 980. He appeared as a mysterious stranger who added the words to the beginning of a hymn the monk was singing before an icon of the Mother of God. The icon began to emit light, and the monk was so moved that he asked the stranger to write down the words. Gabriel wrote them on a stone which softened like wax at his touch, and then he vanished. The scroll held by the Christ Child reads "The spirit of the Lord is upon me, because he has anointed me to preach the gospel to the poor..." (Luke 4:18). June 11 and July 13.

DUBOVICHSKAYA

This icon is said to have "appeared" in the mid-16th Century, when it was found by a shepherd in the grass on the banks of the River Reti. It takes its name from the village of Dobovich, in Chernigov province, where it was kept. It is an Odigitriya variant resembling the Chenstokhovskaya type. September 10 and the tenth Friday of Paskh.

EGIPETSKAYA

Little is known of this "Egyptian" icon other than its appearance in the year 1060. Odigitriya variant. The Christ Child holds an open scroll. January 11.

ELETSKAYA

This icon, apparently a copy of the ELETSKAYA CHERNIGOVSKAYA type, was kept in the Cathedral Church of the Mother of God of Smolensk, at Elets in Orlov Province. It is said to have appeared in the year 1060. January 11th.

ELETSKAYA CHERNIGOVSKAYA

This icon is said to have been found surrounded by light in a fir tree by St. Antoniy Pecherskiy on Mt. Boldino near Chernigov in the year 1060. Umilenie variant. February 5.

ERMANSKAYA (GERMANOVSKAYA)

This icon appeared to patriarch German in Constantinople in the year 732. October 12.

FALKOVICHSKAYA

This icon was found at the beginning of the 18th century in a grove of birches near a river. It is named for the church where it was kept at Falkovits, near Vitebsk. Odigitriya variant; the child holds an orb, the mother holds a flowery sceptre in her right hand. August 15 and 22.

FEODOROVSKAYA KOSTROMSKAYA *p. 255*

This icon, another of those attributed to St. Luke, is said to have been found hanging in an evergreen tree in the area of Kostroma by Prince Vasiliy Yaroslavich of Kostroma, on August 16, 1239. According to legend, the icon was previously in a church dedicated to Holy Theodore Stratilates in Gorodets. When the mongols invaded the townspeople fled in terror, leaving the icon behind. But in 1239 the inhabitants of Kostroma saw the icon being carried through town by a mysterious warrior whom they believed to be Holy Theodore (Feodor) himself, thus the name "Feodorovskaya" (Theodorovskaya).

In the early 17th Century the icon was carried by the deputation which implored young Mikhail Romanov to become Tsar of Russia, and it was used to bless him upon his ascension to the throne. It thus became the patron of the House of Romanov, whose power ended with Tsar Nicholas II. Umilenie variant distinguished by the left leg of the Christ Child, which is bare below the knee. March 14 and August 16.

FILERMSKAYA

Another icon attributed to St. Luke, this type was said to have been taken to Constantinople in the 5th Century by the Empress Eudokia. There it was placed in the Church of the Blachernae. It was taken by the Crusaders to Palestine in 1204, and form there went to Malta. Through an odd set of circumstances, Tsar Paul I was declared

Grand Master of the Knights of Malta, and the icon, then in the keeping of one segment of that order, was taken to Saint Petersburg and was kept in the church at the Winter Palace. The icon apparently derives its name from Mount Filermos on Rhodes. The Mother of God is shown alone and half-length. October 12.

GAENATSKAYA

This icon is said to have belonged to Holy Queen (Tsaritsa) Tamara of Georgia, and was kept in the Gaenatsk Cathedral near Kutaisa. August 15.

GALATSKAYA (GALATIYSKAYA)

This icon is named for the district in Constantinople where it was found. Odigitriya variant; the child holds an orb, the mother a sceptre. July 4.

GERBOVETSKAYA

This icon was kept in the Gerbovetsk Monastery in the district of Orgyevsk in Bessarabia province, where it was brought about 1790. It is painted on a cloth attached to a linden-wood board. Odigitriya variant; the child's head inclines toward that of the mother. October 1.

GERONDISSA

This is another of the famous Mt. Athos icons. Its name means "Old Woman" in Greek, but it is likely that this is a distortion of the original meaning. The icon is kept in the Pantokrator Monastery on Athos. It depicts the Mother of God standing beside a jar overflowing with oil, which commemorates a miracle. April 4.

GOLUBINSKAYA

Little is known of this icon other than that it was kept at the Church of the Resurrection in the town of Torzhka, in the Province of Tver. It derives its name from the dove (Russian golub) held by the Christ Child. It does not significantly differ from the KONEVSKAYA. June 12.

GORA NERUKOSECHNAYA *p. 256*

This type has no "Church" history. It depicts the Mother of God enthroned. A stone is before her breast. A ladder is in her left hand, and the Christ Child is in her right hand. Some versions give the Virgin's garments a stylized cloud ornamentation. The stars on her head and shoulders are replaced, as in the Arapetskaya and O Vsyepyetaya Mati types, with the heads of angels.

The stone is taken from Daniel 2:34: "Thou sawest till that a stone was cut out without hands..." The stone symbolizes Christ, born of a virgin. The ladder is an Akathist symbol of Mary the "heavenly ladder on which God descended."

The "Uncut Stone" Mother of God is shown half-length as an element in the Neopalimaya Kupina type.

GORBANEVSKAYA

This icon takes its name from that of the Kazak Gorban, associated with its finding in the 18th Century. It is an Umilenie variant which appears to be a copy of the Korsunskaya type (which see). June 30.

GREBNEVSKAYA

This icon was given to the Great Prince Dmitriy Donskoy after the Battle of Kulikovo by the citizens of the town of Greben, located on a tributary of the River Don, in the 14th Century. Odigitriya variant; child is on mother's right arm. July 28th.

GRECHESKAYA-ANDRONIKOVA

This "Greek-Andronikov" type takes its name from the Byzantine emperor Andronikos Paleologus, in whose family the icon was kept until he gave it to a monastery in 1347. In 1839 it was taken to Russia, where it worked miracles. The Mother of God is shown shoulder-length, alone, the head tilted slightly to her left. May 1 and July 8.

GRUZINSKAYA

This icon, kept at the Krasnogorsk Monastery in the Pinezh district of the province of Arkahangelsk, was said to have come from Georgia (Gruziya), where it became part of the booty of the conquering Shah Abbas of Persia in 1622. It was brought to Russia in 1629 by a Yaroslavl merchant named Stefan. The type is accredited with helping to end a plague which raged in Moscow in 1654. Odigitriya variant. August 22.

IERUSALIMSKAYA *p. 257*

Another of the icons attributed to St. Luke, this image is said to have been taken from Jerusalem to Constantinople in the 5th Century. In the 9th Century it was taken to Kherson (Korsun), where it was presented to the Great Prince Vladimir after his conquest of the city in 988; he, in turn, presented it to the people of Novgorod at the time of their conversion and baptism. It is named for Jerusalem. Odigitriya variant. October 12 and November 13.

IGOREVSKAYA

This icon takes its title from Prince Igor Olgovich, who was deposed after ruling only twelve days. He retired from the world to a monastery, where he took the name Gavriil, but this did not end his political troubles. A mob broke into the monastery during the liturgy and took him; he was rescued temporarily, but was attacked again at a home where he was given refuge, and was viciously martyred. This type originated in the icon before which he was praying at the time of his murder in the year 1147. Shoulder-length Umilenie variant similar to the Korsunskaya type. June 5.

ILINSKAYA CHERNIGOVSKAYA

This icon was painted in 1658 by the monk Gennadiy Konstantinovich. It was kept in the Ilinskiy-Chernigovskiy Monastery on Mount Boldino near Chernigov. Odigitriya variant. April 16.

IPATMENSKAYA

No date of appearance or history available. November 15.

ISAAKOVSKAYA

This icon, said to have been noted as early as the year 492, is also believed to be an imperial Byzantine icon before which prayed an emperor named Isaak (thus the name), though whether it was Isaak Komneniy in the 11th Century or Isaak Angel in the 12th seems uncertain. September 8.

There is a second, unrelated icon under the same name. It represents an image of the "Birth of the Mother of God" (Rozhdestvo Presvyatuiya Bogoroditsui) held aloft by two angels. It was kept in a monastery near the village of Isaakova, in the Pozhekhonsk district of Yaroslavl province, thus the name.

ISPANSKAYA

This "Spanish" icon "appeared" in the 8th Century. A feast was instituted in its honor to commemorate the help of the Mother of God in the overcoming of the Saracens by the Spanish King Pelagius in the West, and by Emperor Leo in the East. The type depicts the enthroned Mother of God holding her child on her lap. April 8.

IVERSKAYA

This Mt. Athos icon takes its name from the Iveron (Iberian) monastery there. It is another of those attributed to St. Luke. A pious Constantinople widow hid it in her home during the iconclast period, and finally, to save it from desecration, she threw it into the sea, where it stood upright and floated away. Some seventy years later it appeared out to sea in a pillar of fire off Mt. Athos, but the monks were unable to retrieve it until a voice came from the icon saying that only the hermit Gabriel of Ribera could bring the icon to land. It was rescued and placed in the Iveron Monastery of Athos, from which it derives its title.

It became particularly famous in Russia after Tsar Alexei Mikhailovich had a copy made and sent to Russia in 1648, where a chapel was built for it. Legend says that in order to insure the effectiveness of the icon, 365 fathers of the Iviron Monastery held an all night service. Both the original icon (called the Portaitissa in Greek) and the panel on which the replica was to be painted were washed with holy water blessed with the relics of saints. Then the wash-water was given to the painter to mix with his paints.

The Iverskaya, an Odigitriya variant, is distinguished by the bleeding wound on its cheek (for another "bleeding" type see Zaklannaya). It is said to be the result of a cut inflicted by a Saracen named Barbaros (likely a mythical name meaning "barbarian"). Another version of the tale attributes the wound to a slash by a soldier who found the icon in Constantinople before the image was set adrift. March 31 and Holy Tuesday.

IZBAVLENIE "OT BYED STRAZHDUSHSCHIK"

This "Deliverance of the Suffering from Distress" type, though not assigned a day in the Church calendar, was nonetheless very popular and is commonly found. The title is usually written Otbyed Strazhdushchikh; Kondakov gives it as Obyed Strazhdush-chikh. It is an Umilenie variant with the child on the mother's left arm. Her right hand is at his feet.

KALIGORSKAYA MILUIUSHCHAYA

Honored since the beginning of the 18th Century, this icon has no day in the Church

calendar. It was kept in the Church of St. John the Theologian in the village of Sukhaya Kaligorka, Zvenigorod district, Kiev province. Odigitriya variant; the child, on his mother's left arm, holds an orb.

KALUZHSKAYA

It was found in the year 1748 in the village of Tinkova, near Kaluga, in the attic of the boyar Vasiliy Khitrov. It healed the boyar's ill daughter, Evodokia, and in 1771 was used to fight the plague. The Mother of God is shown half-length and alone, holding a book in her right hand. September 2 and October 12.

KASPEROVSKAYA

This icon was brought to Russia from Transylvania in the 16th Century. By 1840 the image, then kept in the home of a woman of the Kherson province surnamed Kasperova, had become dark with age. She prayed before the image to ease her sorrows, and saw that it had miraculously become clear and fresh again. The icon is credited with sparing the city during the siege of Odessa in the Crimean War (1853-1856). Shoulder-length Umilenie variant which should not be confused with the similar Igorevskaya and Korsunskaya types. June 29 and October 1.

KAZANSKAYA *p. 258*

It is said that this icon was dug up in 1579 by a girl named Matrona and her mother in Kazan after the Mother of God appeared repeatedly in the girl's dreams, telling her of the buried icon. It was found in the ashes of a destroyed house, beneath the stove, wrapped in cloth. One of the two most famous icons in Russia (with the "Vladimir-skaya"), it accompanied soldiers freeing Moscow from the Poles in 1612, and was with the troops fighting Napoleon in 1812, though in the latter case a copy is said to have been used. Some believe the original icon was destroyed in a fire, and that the image later considered to be the "original" was actually a re-creation. The icon regarded as the true "Kazan," copy or not, disappeared in 1905. Many regard it to be the same icon which was sold in America in 1970 to a Roman Catholic society. The image is now kept in the Marian shrine of Fatima, Portugal. The original is believed to have burned in the time of Peter the Great, when it was housed in the St. Petersburg Cathedral of the Mother of God of Kazan. The Christ Child stands waist-length or longer before his mother's left shoulder. She inclines her head toward him. July 8 and October 22.

KHOLMSKAYA *p. 259*

Tradition says it was painted by Luke the Evangelist and was later brought to Russia from Constantinople by the Greek Prince Vladimir after his conversion to Orthodoxy. Its name derives from the town of Kholm in the province of Liublin, where it was kept in the cathedral church. Odigitriya variant with child on mother's right arm. September 8.

KIEVO-BRATSKAYA

This icon appeared in the town of Vuishgorod, Kiev province, in 1654. In 1662 the Crimean Tatars invaded, plundering the church where the image was kept. As they left, the image fell into the Dniepr River, and floated to the Bratsk Monastery, where it was retrieved. May 10th, June 2nd, September 6th.

KIKKSKAYA MILOSTIVAYA

This image, another attributed to St. Luke, is said to derive its name from a hill on the island of Cyprus called Kikkos or Kokkos. The icon originated in Egypt, then was taken to Constantinople, and then, in the time of Alexis Komnenus (1081-1118), to Cyprus. Its arrival there was foreseen by an elder named Isaiah, who received the news by divine revelation. Once there it became known as a miraculous healing image, and was kept in the Kikkos Monastery. It is an Umilenie type which may be set in an interior scene among other saints. August 11, November 12 and December 26.

KIPRSKAYA

This icon appeared at the grave of Lazarus on the island of Cyprus in the year 392, and was kept in a church built on the site of its appearance. There are several icons under this name. The Mother of God is enthroned, the child on her left arm. Two angels flank the throne. Do not confuse this with the Tsiklanskaya (Tsilkanskaya). February 16, April 20, June 2, July 9, and Whit-Monday.

KIPYAZHSKAYA

Date of appearance unknown. The Mother of God is seated on a throne; the child is seated on her left arm. April 20.

KOLOCHSKAYA

This icon was found in 1413 in a tree by the River Koloch, near a village of the same name, in the vicinity of the town of Mozhaisk. Odigitriya variant. July 9.

KONEVSKAYA *p. 260*

This icon was brought to Russia from Mt. Athos by the "wonder-worker" Arseniy Konevskiy (died in 1447) in 1393. It was kept in the Konevskiy Monastery on the island of Konev in Lake Ladoga. The Christ Child is on his mother's left arm. He holds a bird in his right hand; two strings or ribbons run from Christ's right hand to the bird. See also GOLUBINSKAYA. July 10.

KORSUNSKAYA EFESSKAYA *p. 261*

Another of the many said to be painted by St. Luke, this icon is said to have been brought by the Great Prince Vladimir from Korsun (Kherson) on the Black Sea to Kiev in 988. There is an alternate story that it was brought to Russia the 12th Century by Princess Evfronsinia. It is a shoulder-length Umilenie type. Other related images have become known under local names — among them the "Korsunskaya Uglitchskaya," "Azurevskaya" and "Sosnovskaya" icons. October 9.

KOSINSKAYA *p. 262*

According to tradition this icon, also known as Modenskaya, was brought to Russia from Modena in Italy by Count Boris Petrovich Sheremetev in 1717. It was kept in the Dormition Church of the village of Kosin, in the Province of Moscow, after its donation by Tsar Peter the Great. The image is said to have cured many people, and was used to end an outbreak of disease in 1848. The Mother of God stands full-length, her son seated against her left shoulder. His body is turned away from her. June 20.

KOZELSHCHANSKAYA

This is said to have been a family icon of Count Kapnist. It had once belonged to an Italian maid of honor, married, at the wish of Empress Elizabeth, to a military clerk. It began to manifest healing on February 21, 1881. The original is described as in the Italian style of the 15th or 16th Century. The Mother of God is seated; the Christ Child reclines on her lap, holding a cross in his right hand. A table holding a chalice is on the left of the image. February 21.

KRUPETSKAYA

This icon is named for the village of Krupts, not far from Minsk, where it was kept. Odigitriya variant much like the Chenstokhovskaya type. October 1.

KUPYATITSKAYA

This icon appeared in 1182 to a girl named Anna, who saw it in a blaze of light in a tree. It derives its name from the village where it appeared, Kupyatich in the district of Pinsk, in Minsk province. It is in the form of a small copper cross. On one side is the Mother of God standing with the Child Christ in her arms; on the other side is the Crucifixion. November 15th.

KURSKAYA ZNAMENIE *p. 263*

Also called the Kurskaya Korennaya (Kursk "Root"), this icon is said to have appeared in 1295, discovered on the root of a tree by the banks of the River Tuskara, near the Village of Ruilsk in Kursk Province. It is a Znamenie variant with added figures about the central image. September 8 and the ninth Friday of Paskh.

LADINSKAYA

This icon was kept in the Ladinsk-Pokrov Monastery near the town of Priluk in the province of Poltava. No date of appearance is given, and it has no listed festal day. Odigitriya variant; mother and child are crowned, flanked by two half-length angels in upper corners.

LIUBECHSKAYA *p. 264*

According to tradition this icon appeared in the 11th Century. It takes its name from the place where it was kept, Liubech in the province of Chernigov. Odigitria variant. May 7.

LORETSKAYA

This icon is said to have made its appearance in the 11th Century at a monastery on Mt. Loreto in Italy. Odigitria variant. September 14.

MAKSIMOVSKAYA *p. 265*

This icon is said to have been painted in the year 1299. It depicts the Mother of God holding the Christ Child in her left hand, while with the right she presents a bishop's stole (Greek omoforion, Russian omofor) to Metropolitan Maxim (died 1305). April 18 and December 16.

MATELIKIYSKAYA (METELINSKAYA)

Nothing is known of the history of this icon beyond the year of its appearance, 991. The Christ Child is seated on his mother's right arm, his body turned away from her toward the left of the image. May 29.

MEZHETSKAYA (MEZHITSKAYA)

This icon appeared near Kiev in 1492. The Mother of God is crowned, with the child on her left arm. February 26.

MIASINSKAYA

The name is derived from the Miasinsk Monastery in Armenia. The image is said to have been cast into the sea during the iconoclastic period in the 8th Century, and was retrieved from the water on September 1st, 864. Umilenie variant. September 1.

MIROZHSKAYA

This icon is said to have appeared in 1198. It takes its name from the Spaso-Mirozh Monastery in Pskov province, where the image began shedding healing tears during a plague in 1567. The image depicts the Mother of God full-length, with arms outstretched and Christ Child on her breast (the "Znamenie" form). Beside her stand the saints Prince Dovmont (died 1299) and his wife Martha. September 24 and October 7.

MLEKOPITATELNITSA *p. 266*

This "Milk-Nourishing" image is said to have been found in the Lavra of St. Savvas the Blessed in Jerusalem, who predicted that the icon would be given to the Archbishop of Serbia. This was done six centuries later, when another Saint Savvas, Archbishop of Serbia, received the icon during a visit to Jerusalem. The image was placed in the

Khilandari Monastery on Mount Athos. See also Blazhennoe Chrevo. January 12 and August 15.

MOLCHENSKAYA *p. 267*

A beekeeper is said to have discovered this icon in the branches of a linden tree near a Molchen bog, Putivlsk district, Kursk province, in the year 1405. The Mother of God holds her child on her left arm. A ladder is behind her right hand. Do not confuse this with other "ladder" types such as the Putivlskaya. April 24, September 18.

MOLDAVSKAYA

This icon was kept in the Moldavia Monastery in the town of Nikolaev in the province of Kherson on the Black Sea (another source places it in the Ekaterinoslav province). The Mother of God holds her son against her right shoulder; he faces away from her, his right hand raised to his brow. March 13.

MUROMSKAYA RYAZANSKAYA

This icon was brought from Kiev to Murom by Prince Konstantin Muromskiy, at the beginning of the 12th Century. He is said to have used this icon in attempts to covert the pagans of Murom. In the 13th Century Bishop Vasiliy of Murom was unjustly accused of sin, and was threatened with murder. During the night he took the icon to the River Oka, spread his cloak (mandyas) upon the water, and standing upon it he miraculously floated with the icon upstream to Staraya Ryazan, where he and the icon were welcomed. The Christ Child, holding an unrolled scroll, is seated on his mother's left arm. Her head inclines slightly toward him. April 12.

NECHAYANNAYA RADOST

This " 'Unexpected Joy' Most Holy Mother of God" (Nechaennuiya Radosti Presvatuiya Bogoroditsui) depicts an interior in which a man kneels before a large icon of the Mother of God, who holds the child Jesus on her left arm. The child bears the wounds of the crucifixion. The tale illustrated is this: A certain man who led a sinful life was nonetheless devoted to the Mother of God and daily venerated her icon, repeating the words of the Archangel Gabriel's greeting — "Rejoice, Blessed One..." (the Slavonic version of "Hail Mary, full of grace"). One day he made ready to go and do more sinful deeds, but before leaving he turned to the icon to pray. He began to tremble with fear as he saw the image of the Mother of God begin to move; wounds

appeared on the hands, feet, and side of the child Jesus and blood began to pour out of them. Falling to the floor the sinner cried out, "O Lady, who has done this?" (O gospozhe kto se sotvori).

The image replied, "You and the other sinners who crucify my Son anew with your sins" (Tui i prodchiy gryeshnitsui izhe paki raspinaete suina moego gryekhami iakozhe podee).

The sinner, of course, repented and was forgiven, so the experience was a great "unexpected joy," thus the title of this icon type.

This story was written down by Saint Dimitriy Rostovskiy in his work The Dew-Wet Fleece. The lettered panel usually seen below the image of the Mother of God in this type provides the beginning of the tale: "A certain lawless man had a daily rule to pray to the Most Holy Mother of God with the words of the Archangel's greeting: 'Hail, Blessed One...'" (Chelovyek nyekiy bezzakonen imyeyashe pravilo povsednevoe ko presvyatoye bogoroditsye molitisya slovesem arkhangelskago tsyelovaniya — raduisya blagodatnaya...).

The man looks up to the icon, and his words are sometimes written on a strip extending from his mouth like a cartoon bubble: "O Lady, did this?" And the Mother of God's reply, written on another strip, is "You and other Sinners, who with your sins—." January 25, May 1, December 9, and All Saints week.

NEOPALIMAYA KUPINA *p. 268*

The "Unburnt Thornbush" depicts the Mother of God in a circle set in a four-pointed blue star upon a red star. She holds the Christ Child on her left arm, and in her right is a ladder (a symbol of Mary in the Akathist Canon), near which a circle with the head of Christ Immanuel is sometimes found. On Mary's breast is the "stone not cut with hands" (see the Gora Nerukosechnaya type) in front of which is a shoulder-length image of Christ crowned and robed as a bishop ("Great High Priest").

In the four points of the red star are the symbols of the Four Evangelists: The winged man of Matthew, the eagle of Mark, the ox of Luke, and the Lion of John.

In the blue star and in the petals against which the blue and red stars are set, angels are depicted which represent virtues and elemental powers. The accompanying inscriptions vary, giving such titles as "The Spirit of Wisdom, the angel who kindles fire..." — "The Angel of Thunder and Lightning, who reveals the second coming of Christ..." — "The Spirit of Understanding, Angel of the voice..." — "The Angel of Rainbows and Clouds..." — "The Spirit of Wisdom, Angel of Storm and Rain..." — "The Angel of Dew and Hoarfrost..." — "The Angel of Frost and Ice..." — "The Angel of Scorching..." (see the apocryphal "Prayer of Azariah and the Song of the Three Young Men in the Fiery Furnace"). Also often found is the inscription "Who makes his angels spirits and ministers..." (see Hebrews 1:7 — "Who maketh his angels spirits, and his ministers a flame of fire").

In the upper left corner Moses sees the bush which burns but is not consumed (Exodus 3:2). At upper right a Seraph purifies Isaiah's lips with a coal taken from the altar (Isaiah 6:5-7). At lower left is Ezekiel seeing the closed door to the East (Ezekiel 44:1-3). At lower right Jacob dreams of the ladder reaching to heaven (Genesis 28:11-17). All of these scenes are considered Old Testament prefigurations of the Mother of God and her role in the Incarnation.

This icon was an early form of fire protection. It was used not only to ward off fire from a home or building but also was held up to stop a fire once it had begun. September 4 and the sixth week in Paskh.

NERUSHIMAYA STYENA

This "Indestructible Wall" type derives its title from the twelfth "house" (Greek oikos) of the Akathist Canon — "Rejoice, indestructible wall of the kingdom" (Radouisya tsarstvou neroushimaya styeno). The Mother of God is shown standing full-length in the orans position (arms raised with palms forward); sometimes a wall is behind her. The type is celebrated on May 31 and All Saints Week.

NEUVYADAEMUI TSVYET

This "Unfading Flower" image depicts the Mother of God holding her child on her right arm and a stock of blooming lily in her left. Do not confuse it with the Blagoukhannuiy Tsvet ("The Fragrant Flower"). April 3.

A different image under the same name, depicting the child, not the mother, holding a flower, is celebrated on December 31.

NIKEYSKAYA

This icon is said to have been venerated in the year 304 in the town of Nike in Asia Minor. It depicts the Mother of God standing behind a table. Both of her hands are raised with the palms out. In front of her, seated in a chalice on the table, is the Child Christ. An orb is beside the chalice. Some versions show the table with the Christ child in the chalice placed against a building, all before the Virgin's bosom. The Nikeyskaya type may also be titled "Your Womb Becomes the Holy Table" (Buist Chrevo Tvoe Svyataya Trapeza). The holy table is, of course, the altar. May 28.

NOVONIKITSKAYA

It is said that this icon "appeared" to the martyr Nikita in the 4th Century. It shows

the Christ Child standing full-length against his mother's left shoulder. He holds a cross in his left hand. September 15.

ODIGITRIA

See SMOLENSKAYA.

OGNEVIDNAYA

The "Fiery Visage" or "Fire-Appearing" Mother of God (Slavonic Ognevidnuiya) is distinguished by her fiery-red face. She is depicted without her child. The time and place of origin of the type are unknown. One might hazard a guess that the fiery visage may relate to the description of Mary as "The Unconsumed Thornbush," the bush which Moses saw burning yet not consumed by fire, just as Mary is believed by Orthodoxy to have carried God within her womb, yet was not harmed. Mary is thus described in Ode Eight, Hiermos, of the Akathist Canon: "Moses discerned in the [burning] bush the great mystery of your giving birth, and the youths clearly prefigured it, standing in the midst of the fire yet not burned, uncorrupted pure Virgin. Therefore we sing to you and exalt you forever." February 10.

OKONSKAYA

This type was kept in the village of Luiskova in the Nizhegorod district of Nizhegorod province. July 30.

OKOVETSKAYA

This icon was found in 1539 in a pine tree at the village of Klochka in the Rzhevsk district of Tversk province. The image, also called the "Okovetskaya-Rzhevskaya" (after the Okovetsk area of Rzhevsk), was taken by Tsar Ivan "The Terrible" from Rzhevsk to Moscow in 1540. It is easily recognizable by the presence of St. Nicholas the Wonderworker, who stands on the right of the image beside the Mother of God and her child. July 11.

OLONETSKAYA

Nothing is known of the origin of this icon. November 20.

O TEBYE RADUETSYA *p. 269*

This "in Thee Rejoices" type is based on a hymn from the Liturgy of St. Basil, which begins "In you rejoices every creature...[O tebye raduetsya vsyakaya tvar]." It depicts the Mother of God enthroned in a central circle with her child. Angels stand about them, and behind is a great church. Before her is a multitude of saints. Her throne sits on a rocky prominence amid trees and plants. The type is similar to the "Assembly of the Mother of God," but lacks the elements of the Nativity.

OTRADA

This "Consolation" type, also called VATOPEDSKAYA ("Of Vatopedi") is another Mt. Athos icon, kept at the Vatopedi Monastery on that mountain. It is said that Arcadius, son of the Byzantine Emperor, fell overboard off the coast of Mt. Athos but was miraculously brought to shore, where he was discovered, sound and well, in the bushes near the monastery — thus the name Vatopedi, from Greek vatos paidos — "bush of the boy." In 807 the icon warned a hegumen praying before it of an impending attack by robbers. The Christ Child is on the left arm of the Mother of God. She holds his right hand near her lips, the distinguishing feature of this type. January 21 and All Saints week.

OVINOVSKAYA

This is a "Dormition" icon deriving its name from the boyar Ivan Ovinov, to whom, in the days of Dmitriy Donskoy, two beautiful youths appeared with an icon of the Mother of God. August 15.

O VSEPYETAYA MATI *p. 270*

The history of this icon is not known. The type, however, is popular and the image is interesting. The Mother of God is shown with the Christ Child. In place of the usual simple stars on her head and shoulders she is given three circles containing faces often resembling those of the anthropomorphized winds on old maps. They appear to be angels, stars represented (as in the Book of Enoch) as intelligent beings (these are found also in the Gora Nerukosechnaya and Molchanskaya types, but in those the Mother of God holds a ladder). Some see them as the Trinity.

Her head-covering is edged with a wide band containing, in Slavonic lettering, Kontakion Thirteen from the Akathist Canon: "O All-Hymned Mother [O Vsepyetaya Mati] bearer of the holiest of holies Word, accept what we offer now, deliver us all from every attack, and deliver from the coming torment all those who cry to you.

Alleluiya." (O vsepyetaya mati, rozhdshaya vsyekh svyatuikh svyatyeishee slovo, nuinyshiee prinoshenie priemshi, ot vsyakia napasti izbabi vsyekh i gryadushchiya izmi muki, vopiiushchuiya ti, alliluiya). October 6.

OZERYANSKAYA

This icon appeared at the end of the 16th Century, in the village of Ozeryanka near Kharkov. It is similar to the Chenstokhovskaya type; mother and child are crowned, and stars border their heads. September 30, October 30, and the first week after Easter.

PAKHROMSKAYA

This icon appeared on the River Pakhra, near Moscow, in December of 1492. The Christ Child stands against the right shoulder of his mother, his left hand raised near her chin, with the palm facing outward. Do not confuse this type with the Devpeteruvskaya. December 3.

PECHERSKAYA *p. 271*

There are several icons associated with the Pecherskaya name. Here we will distinguish two:

The first, the PECHERSKAYA-NERUKOTVORENNAYA ("The Pecherskaya 'Not Made by Hands') is said to have appeared by itself in the Great Dormition (Uspenskiy) Church of the Monastery of the Caves (Pecherskaya Lavra) in the year 1085. It depicts the Mother of God enthroned with her child on her lap. Her hands rest on the shoulders of Saints Antoniy and Feodosiy, who kneel before her. Two attending angels may be included in the background. The saints do not bear scrolls.

The second, the SVYENSKAYA-PECHERSKAYA, is said to have been painted by St. Alipiy, the first Russian icon painter to be canonized. The image is regarded as savior of the town of Bryansk from Napoleon's troops in 1812. It shows the Mother of God seated with her child on her lap. Antoniy and Feodosiy stand beside her holding scrolls. That of Feodosiy begins "Master, Lord God Almighty, maker of all things visible and invisible..." (Vladuiko Gospodi Bozhe Vsederzhitelio, Tvorche vseya tvari vidimuikh i nevidimuikh...")

The scroll of Antoniy begins "I pray you therefore children, to remain temperate and avoid sloth" ("Moliu ubo vui, chada, derzhimsya vozderzhaniy i ne lyenimsya").

In some examples the monks bear scrolls reading "Ruler most gracious, Lord Jesus Christ, Son of God, I pray that all the brothers may love one another."

Both icon types are celebrated on May 3rd.

PETROVSKAYA *p. 272*

This icon was painted by the future Metropolitan Peter when he was still hegumen of a monastery in Volhynia, in the year 1307. It is a shoulder-length Umilenie type similar to the Korsunskaya and Igorevskaya. August 24.

PIMENOVSKAYA MIROTOCHIVAYA

This icon, named after Metropolitan Pimen of Constantinople, who is said to have brought it to Russia in 1381, was kept in the Cathedral of the Annunciation in Moscow. Because it had been known to exude healing oil, it was called Mirotochivaya, "Myrrh-flowing." Odigitriya variant. June 6.

PISIDIYSKAYA-MIROTOCHIVAYA

This icon, another "myrrh-flowing" image, takes its name from Pisidia in Asia Minor, where it is said to have begun working miracles in the 6th Century. The child is on the mother's left arm. Her right hand is raised in the symbol of Christ's name (see Gospod Vsederzhitel under icons of Christ). September 3.

POCHAEVSKAYA

This icon, popular in Russia and in the Balkans, was brought to the Pochaev region of Volhynia (Voluinsk province) in 1559 by Neofit, Metropolitan of Constantinople. He gave it to Anna Goyskaya, after which time the icon began to manifest miracles. At times it shone with a mysterious light, and is said to have healed Filipp, Anna's brother. In 1597 Anna gave the icon to the community of monks on Pochaev Hill, a site already renowned for an appearance of the Mother of God in 1340, when she was seen surrounded by flames and left her footprint in stone.

A Lutheran nephew of Anna fell heir to Pochaev Hill after Anna's death, and he plundered the monastery and took the icon home. There he mocked the image by dressing his wife in priestly robes; she screamed abuses at the icon, but was then tormented by an evil spirit until the sacred painting was returned to its rightful place.

In 1675 when the region was invaded by Turks, the monks prayed before the icon. They began the Akathist Hymn, and the Turks were astonished to see a vision appear above Pochaev, a radiant woman holding her protective veil over the place while surrounded by an army of sword-bearing angels. The invaders shot arrows at the apparition, but some of these fell back, killing their own men. The Turks gave up the siege and fled in terror.

This image is distinguished by the cloth which the Mother of God holds in her left

hand as she supports her son with the right. July 23, September 8, and Bright Week.

POKHVALA PRESVYATUI BOGORODITSUI *p. 273*

This "Praise of the Mother of God" type shows the Mother of God seated on a central throne; her hands are raised, palms out, before her breast. Around her are prophets holding in their hands open scrolls with Old Testament texts prefiguring Mary. This type is sometimes called "The Prophets Foretold You."

POKROV BOZHIEY MATERI

This type combines two subjects whose celebration falls on October 1st — the vision of the Holy Fool Andrey, who saw the Mother of God appear in the air in the Church of the Blachernae at Constantinople, and Romanos the Melodist (sladkopyevets), who could not sing well until the Mother of God appeared to him in a dream, gave him a scroll to eat, and thereby granted him the gift of song.

The Mother of God is seen standing on a cloud in the air within the church. She is accompanied by a gathering of saints, and holds her mantle in her arms. She will spread it above the congregation as a symbol of her protection. Below stands Romanos the Melodist. He holds a scroll reading "Today the Virgin stands in the church." At the right the Holy Fool Andrey raises his arm toward the Mother of God, showing her to his disciple Epifaniy. To the left stands the Patriarch of Constantinople, and beside him the Emperor and Empress. Some icons include the Mother of God appearing to Romanos in his sleep, and granting him the gift of song.

There are variants. In one the mother of God appears in the upper center of the image, facing the viewer directly. In another, she appears at upper left, turned to the side and looking upward at Christ, who is shown in the upper left corner. October 1.

POMOSHCH V RODAKH *p. 274*

This "Helper in Birth" type was used by Russian women in the "old days" to ease the pains of birth. It depicts the Mother of God with her hands held together at the fingertips; just below her hands the Christ Child is seen in a mandorla of light. December 26.

PREZHDE ROZHDESTVA I PO ROZHDESTVYE DYEVA

This "Before the Birth and At the Birth a Virgin" type was kept in the Pyesnozhk-Nikolaevsk Monastery, Dimitrovsk district of Moscow province. It began working

miracles in the year 1827. The icon is said to have healed many of cholera in 1848, and it regained a certain captain his unjustly-lost position. It is an Odigitriya variant. The mother holds the Christ Child on her left arm; her hand supports an orb. The Christ Child rests his left hand upon the orb and holds a sceptre in his right. Both mother and child are crowned. October 17.

PRIBAVLENIE UMA *p. 275*

This "Increase of Understanding" (or "of Reason") type, also called "Giver of Reason" (Podatelnitsa Uma) was kept in the Savior-Transfiguration Church at Ruibinsk in Yaroslavl province. August 15.

PRIZRI NA SMIRENIE

This "Regarded the Humility" (Luke 1:48) icon appeared in 1420 at Kammenoe Ozero (Stone Lake) in Pskov province. The image, which was later taken to the city of Pskov, depicts the Mother of God with a sceptre in her right hand and the Christ Child, holding an orb, in her left. September 16.

PUTIVLSKAYA

This icon appeared on May 2, 1635. It takes its name from the town of Putivl in Kursk province, where it was kept in the Molchansk-Pechersk Monastery. It is very similar to the Abulskaya type. In both the Mother of God holds a ladder with her right arm. May 2.

RIMSKAYA

This icon, also called LIDDSKAYA is said originate with a "not made by hands" (miraculously-appearing) image from a church founded by Saints Peter and Paul at Lydda, near Jaffa (Palestine). A copy is said to have been made at the request of the Holy Patriarch German. When imprisoned, he put a letter to Pope Gregory in Rome with the icon, and placed it in the sea. Within twenty-four hours the miraculous icon reached Rome (thus the name Rimskaya), where Gregory retrieved it on the shore and had it placed in the Church of St. Peter. It is later said to have been taken to Constantinople. Odigitriya variant. March 12, June 26.

RUDENSKAYA

This image appeared on October 12, 1687, at the Rudnye Monastery in the Diocese of Mogilevsk. It was moved in 1689 and again in 1769, when it was taken to the Kievsk-Florovsk Monastery at Podol. A second old icon under this name was kept at the Pokrov Cathedral in Aleshkakh, in the Lebedinsk district of Kharkov province. Odigitriya variant. October 12.

RZHAVETSKAYA *p. 276*

This icon was painted in 1572. It takes its name from the Rzhavets (or Irzhavets) Monastery in Poltava (Poltavsk) district, where it was originally kept. Odigitriya variant; the Christ Child, on his mother's left arm, holds a book. May 24.

SEDMIEZERNAYA

This "Seven Lakes" type takes its name from the seven lakes which once surrounded the cloister where it was kept. The icon was brought there about the year 1615 by a monk named Evfimiy. In 1654 the icon was brought to Kazan to ward off a terrible plague which took thousands of lives in the mid-seventeenth century. The plague seemed to flee before the image as it was carried from dwelling to dwelling, and after the worst was over a dark storm mysteriously arose each time the monks attempted to take the image back to the cloister. They saw this as a sign, and left the image in Kazan for a time, finally taking it back in 1655. Odigitriya variant. June 26, July 28, and October 13.

SEMISTRYELNAYA *p. 277*

This "Seven Swords" Mother of God was kept in the Tozhensk-John the Theologian-Seven Swords Church in the region of Vologda. It first became known when a lame and suffering man heard a voice telling him to go to that church and to pray before the icon of the Mother of God. He did so, and was, of course, healed. The type depicts the Mother of God with seven swords in her breast. This image must not be confused with the almost identical Umyagchenie Zluikh Serdets, which differs only in the positioning of the swords (Three on each side and one at the base, as opposed to three on one side and four on the other in the Semistrelnaya). August 13.

SHUISKAYA ODIGITRIA *p. 278*

The residents of the town of Shui ordered this icon painted during the 1654-55 plague epidemic, and it is said that by means of the icon the inhabitants were preserved. This type, an Odigitriya variant, is easily recognized by the bare, raised right leg of the Christ Child. July 11, July 28, and November 2, etc.

SITSILIYSKAYA

This icon appeared in Sicily in the year 1092. It was brought to Russia near the end of the 15th Century by the Greek monks Xenofont and Ioasaf. It is said to have been used to ward off Cholera in 1831. The Mother of God is seated on a throne; her son is on her lap. Four angels, two on each side, flank the throne. Do not confuse with the Kiprskaya and Tsiklanskaya types. February 5 and July 1.

SKOROPOSLUSHNITSA

This is another of the famous Mt. Athos icons from the "Holy Mountain" of Greece, and its name, meaning "Quick to Hear," originates in a peculiar story: In the year 1664 the icon at the Dokheiariou Monastery was kept in a chapel open on both sides, and a serving man was accustomed to pass through it from the kitchen to the refectory. To light his way he carried a smoky torch. He was making his usual trip through the chapel and past the icon when he heard a voice warn him not to pass that way again with a torch, "carelessly and shamelessly blackening my image." He thought it was merely someone playing a joke, but a few days later he heard the voice again, after which his eyes went blind. As is usual in these stories he repented, and the icon spoke again, telling him how the Mother of God is "quick to hear" prayers —thus the name of the icon, which is called in Greek Gorgoepikoos. Odigitria variant.

A wonderworking Russian copy of this type was kept in the Chapel of the Great Martyr Panteleimon in Moscow. November 9 and Bright Week.

SLOVENSKAYA

This icon appeared on September 23, 1635, and was kept in the Slovensk-Mother of God Hermitage in the Makarevsk district of Kostroma province. The Christ Child reclines slightly on his mother's left arm. His right hand is on her cheek. September 23.

SLOVO PLOT BUIST-ALBAZINSKAYA

This "Word Was Made Flesh" type (see John 1:14) is said to have been brought to Albazin in 1666 by the priest-monk Ermogen. In 1868 it was kept at Blagovyeshchensk on the Amur. In this easily recognizable type the Christ Child stands before his mother's breast, facing the viewer, in a mandorla of light. Do not confuse with the Pomosch V Rodakh. March 9.

SMOLENSK ODIGITRIA *p. 279*

Attributed to the Apostle Luke, this "Hodigitria" type is said to have come from Byzantium to Chernigov when the Greek Princess Anna wed Vsevolod of Chernigov in 1046. Vladimir Monamakh gave it to the Smolensk Cathedral in 1101. The icon was taken to Moscow in 1308. It was returned to Smolensk in 1456. The original and a copy were appealed to for success during the Battle of Borodino in 1812. The original was then returned to Smolensk. This is one of the most famous of the national "miracle-working" icons. July 28.

SPORUCHNITSA GRYESHNUIKH *p. 280*

This "Surety of Sinners" type is of uncertain origin and date, and, having darkened with age, was kept in an old outdoor chapel at the Nikolaev Odrin Monastery in the Karachev district of Orlov province. In 1843 it began its miracles after people of the vicinity began to have dreams revealing the icon as a wonder-worker. After the two-year-old son of a man named Pochepin was healed, the image was cleaned and placed in the monastery church. In 1848 it began to shine with light and exuded "myrrh."

In this type the Christ Child is seated on his mother's left arm. His hands hold her right hand. Both figures are crowned. It is easily recognized by the four narrow scrolls which surround it, bearing an inscription beginning "I am the surety [intercessor] of sinners before my son/who gave me for them assurance to hear me always/that those who always bring joy to me/may joy eternal solicit through me" (Az sporuchnitsa gryeshnuikh k Moemu Suinu...). March 7 and May 29.

STARORUSSKAYA

This type is said to have come to the Novgorod area from the Kherson region in the early days of Russian Christianity. In 1570 it appeared in the region of Novgorod. From 1665 to 1888 it was "on loan" to the city of Tikhvin, but in September of the latter year it was returned to the town of Staro Russ, from which it takes its name. In this type the Christ Child is seated on the mother's left arm. His right hand is raised, the palm nearly

level with his face. Do not confuse with the Antiokhiyskaya, which it resembles. May 4.

STRASTNAYA p. 281

Roman Catholics will instantly recognize this "Passion" Mother of God as identical to the image known in the West as "Our Lady of Perpetual Help."

In 1641 the Virgin spoke to a woman of the town of Palets (or Palitza) named Elizabeth. She was told to go to an icon painter in Nizhni-Novgorod named Grigoriy, and to have an icon painted. After Elizabeth gave the painter seven silver coins to ornament the icon, she was healed. The Christ Child is on his mother's left arm. He holds her right hand in his, and looks over his left shoulder at one of two angels flanking the pair. The angels bear the instruments of the Passion — cross, spear, and sponge. August 13 and sixth week of Paskh.

SYAMSKAYA

This icon originated in a vision of Ivan Rodionov at the village of Otvodnago, sixty versts from Vologda, in the year 1524. It is a version of the "Birth of the Most Holy Mother of God." September 8.

TAMBOVSKAYA-UTKINSKAYA

This icon, named for the town of Tambov, is said to have appeared in 1692, and gained fame as a "wonder-working" image in the first half of the 19th Century. It was kept in the Church of the Archdeacon Stephan (called the "Utkinskoy" from the name of the builder). Odigitriya variant. April 16.

TEREBINSKAYA

The icon takes its name from the place where it was kept, the Terebinsk-Nikolaevsk Hermitage in the Province of Tversk. It was "glorified" in the year 1654. The Mother of God is shown in the orans position (arms raised at her sides, palms facing the viewer); the full-length child before her breast stands with feet apart and arms outstretched to the sides. May 14.

TIKHVINSKAYA p. 282

The "Tikhvin" Mother of God was believed to have been painted by St. Luke, who

sent it as a gift to the ruler Theophilus at Antioch. After Theophilus' death it went to Jerusalem. In the 5th Century it was sent as a gift to Pulcheria, sister of Theodosius the Younger, in Constantinople. It was sent by Eudokia, wife of Theodosius. The Church of the Blachernae was built to house it, and it remained there for over five hundred years under the title Hodigitria.

In 1383, knowing of the approaching fall of Constantinople to the Turks, the icon left that city for Russia (it is not uncommon in these origin stories for icons to act like living beings). Some fishermen saw it in a circle of light over Lake Ladoga, and then it appeared again near Lake Onega, then on the Oyat River, and then twice more, moving ever closer to Tikhvin. Finally it appeared on the bank of the Tikhvinka River in 1383, during the reign of Dmitriy Donskoy. The icon was placed in a wooden church which then burned in 1390, but the icon was found unharmed in a juniper bush. In 1395 it survived another fire, and in 1500 yet another. In the 16th Century it was placed in a brick church dedicated to the Dormition, and in 1613, after the vision of a blind widow, it was used to repel the Swedes by being carried in a procession, following the instructions given by the Mother of God. Many copies exist. Its feast day is June 26.

TOLGSKAYA *p. 283*

This image is said to have appeared to Bishop Prokhoriy near a midnight in the year 1314. He saw it floating in a column of light beyond the river. He crossed over a bridge leading to the apparition and prayed before the image, leaving his staff there when he returned. Later, when servants were sent to fetch the staff, they found the icon in the branches of a tree. A church was built to house the image, and in the year 1392 the icon began to exude fragrant healing oil ("myrrh"). The Christ child is on his mother's left; he appears as though clambering up her lap to place his right hand about her neck and his left hand against her breast. The Mother of God may be full-length or half-length. August 8 and September 16.

TREKH RADOSTEY *p. 284*

This type was brought to Moscow from Italy at the beginning of the 18th Century. There a troubled woman heard a voice telling her to seek out the icon and pray before it. She did so, and was granted "three joys": Her husband was to return from exile, her captive son was released, and seized property was returned. Thus the title "Three Joys."

Copies of this icon, originally called "The Holy Family," show the Mother of God, the child Jesus, the child John the Baptist, and Joseph as an old man. In some depictions the icon is indistinguishable from the famous Madonna with Child and John the Baptist of Raphael. December 26.

TROERUCHITSA

The "Three-Handed" Mother of God (Greek Trikherousa) is a famous Mt. Athos icon still kept at the Serbian Monastery of Khilandari on that "Holy Mountain."

It is said that in the 8th Century the noted anti-iconoclast John of Damascus was in the service of the Caliph of that city. The iconoclast Byzantine Emperor Leo attempted to alienate John's employer with forged letters in John's handwriting which urged Leo to attack the Caliph. These forgeries were accepted by the Caliph, who had John's hand struck off as punishment. John took his severed hand to an icon of the Mother of God (attributed to St. Luke), and prayed to be healed so that he might continue to write against the iconoclasts. The Mother of God heard his prayer and promised to heal him if he would compose hymns to her and to Christ.

In gratitude for his healing, John had a commemorative silver hand affixed to the lower part of the image. Later painters, copying this image, often misunderstood the added hand and made it a third hand of the Mother of God. Odigitriya variant. June 28 and July 12.

TSAREGRADSKAYA

This image, attributed to St. Luke, is said to have "appeared" in 1071. April 25th.

There is another image under this name celebrated on September 17th. It was said to have been brought to the Cathedral Church of Staro-Russ in Novgorod Province by two monks from Constantinople. The Christ Child, naked to the waist, is seated on his mother's right arm. Her left hand is on his knees. April 25 and September 17.

TSEZARSKAYA

This image appeared in the year 792 and was kept in the Annunciation Cathedral in Moscow.

A second image, the "Tsezarskaya-Borovskoya," appeared at a place called Bor in the 12th Century, and was kept in the village of Usvyat in Vitebsk province. It was believed to have warded off the cholera from the village in 1859. The Christ Child holds an orb in his left hand. He is seated on the mother's left arm. She holds a sceptre in her right hand. April 9 and May 29.

TSIKLANSKAYA

Little is known of this "Tsiklan" or "Tsilkan" image, which is said to date from the time of Holy Equal-to-the-Apostles Nina, Enlightener of Georgia (4th Century). It takes its name from the Tsiklan Cathedral in Kartalin. Odigitriya variant; the Mother of God

is half-length, her child on the left arm. They are flanked by two angels. Do not confuse with Kiprskaya, etc. August 15.

TSYELITELNITSA

One image under this name, "The Healer," is associated with the 4th-Century Saint Nina, Enlightener of Georgia.

Another better-known image was kept in the Aleksyeyev Cloister in Moscow, where it began working miracles in the 18th Century. A miracle involving the appearance of an angel and of the Mother of God is recounted in the Dew-Wet Fleece of Dimitriy Rostovski. It tells how a certain cleric of the Navarinskoy Church named Vikentiy Bulvinenskiy had a pious custom, on entering and leaving the church, of kneeling before the icon of the Mother of God and praying, "Hail, Blessed one! The Lord is with you. Blessed is the womb which bore Christ, and the breasts which nourished our Lord God and Saviour!" Once the pious cleric fell ill with a dangerous and painful disease. His tongue began to decay, and the pain was so strong that he lost consciousness. Coming to himself, he began his customary prayer; suddenly he saw a beautiful youth standing beside the bed. He knew it was his guardian angel. Looking with compassion upon the sufferer, the angel prayed to the Mother of God for healing. Then the Mother of God herself appeared and had compassion on the sufferer. He immediately felt quite well, and went to church.

The image shows the Mother of God standing in a blaze of light beside the bed of a sick man. September 18.

UMILENIE

The "Tenderness" title is a general one given to many icons which depict the cheek of the Christ Child inclined to and touching that of the Mother. The titles of individual Umilenie types, such as the "Vladimir," should be used in preference to the general term.

There is, however, an Umilenie type which does not fit the above description. It is the UMILENIE V NOVGOROD ("At Novgorod"), which depicts the Mother of God standing alone, her hands crossed before her breast. This icon was "glorified" on July 8, 1337, when the watchman of the Novgorod Trinity Church heard a noise in the building. An icon had fallen from the iconostasis, and the eyes of the image were shedding tears. July 8.

UMYAGCHENIE ZLUIKH SERDETS *p. 285*

There are two images found under the title "Melter of Evil Hearts." One, apparently

borrowed from Roman Catholicism, depicts the Mother of God with seven swords in her breast, three on the left, three on the right, and one from below. This image is also known as the "Prophecy of Simeon" (Simeonovo Prorochenie), because it depicts the prediction of the aged Simeon (Luke 2:35) that a sword would pierce the soul of Mary. Do not confuse this with the "Semistryelnaya" type, which shows Mary pierced by three swords on one side and four on the other, with no sword from below. February 2.

The other type under this name is quite different. It shows the Mother of God half-length above a wall; she holds her son on her left arm. In a circle on her breast is the Holy Spirit as a dove. The Virgin is ornamented with a necklace, and both son and mother are crowned. This type was very popular in the nineteenth century. February 2.

UTOLI MOYA PECHALI

This "Sooth my Sorrow" type was brought to Moscow by Cossacks and placed in the Church of St. Nicholas the Wonderworker in 1640, after which a woman with a difficult long-standing illness heard a voice telling her to go to that icon for healing.

The type depicts the Mother of God with her right hand raised to her head. The child Jesus reclines or is seated in an often-illogical position in front of her — sometimes apparently on her knee, sometimes not supported at all, because her left hand is free. He holds a scroll with words taken from Zechariah 7:9-10: "Render true Judgments, show kindness and mercy each to his brother, do not oppress the widow, the fatherless, the sojourner, or the poor; let none of you devise evil against his brother in your heart" (Sud praveden sudite, milost i schschedrotui tvorite kiyzhdo ko iskrennemu svoemu; vdovitsu i siru ne nasilstvuite i zlobu bratu svoemu v serdtsye ne tvorite).

The type is sometimes titled "Sooth the Ills" (Utoli Bolyezni) after the first words of the troparion beginning "Sooth the ills of my much-sighing soul..." (Utoli bolyezni mnogovozduikhaiushschiya dushi moeya...). It appears that under the title Utoli Moya Pechali, the type generally depicts the Mother of God with her head turned slightly to the right, with the fingers of her left hand resting against her cheek; the son is on her right. Under the title Utoli Bolyezni, however, the mother's head is generally turned to the left, the son is on her left, and the fingers of the right hand against her cheek are distinctly in the two-fingered blessing position favored by the Old Believers. January 25 and October 9.

VERTOGRAD ZAKLIUCHENNUIY

This "Enclosed Garden" type takes its title from the Song of Solomon 4:12 — "A garden enclosed [vertograd zakliuchennuiy] is my sister, my spouse; a spring shut up, a fountain sealed."

The type pictures the Mother of God richly dressed, with her crowned child on her left arm. Angels place a crown on the mother's head as she stands in a fenced-in garden filled with flowers.

VIFLEEMSKAYA

This "Bethlehem" icon was kept in the Kashoetsk Cathedral in Tiflis, Georgia. August 15.

VILENSKAYA OSTROBRAMSKAYA

This icon was brought to Vilna (in Lithuania) from the Crimea in the 14th Century by Prince Olgerdom Gediminovich. At the end of the 15th century Vilna was girdled by a stone wall, in which was an arch called the "Pointed Gate" (Ostruiya Vorota, Polish Ostra Brama) from which the second part of the icon's name is derived. The Mother of God is shown alone, her hands crossed on her breast, her head inclined to the left of the image. She is crowned, and a circle of stars is about her head. March 25, December 26.

VIZANTIYSKAYA

This "Byzantine" icon appeared on April 7, 732. It was brought from Rome to Russia, and Peter the Great prayed before it in thanks for the victory at the Battle of Poltava. The Christ Child is seated on the mother's right arm. She holds an orb in her right hand or in both hands. April 7, May 1.

VLADIMIRSKAYA *p. 286*

The "Vladimir" Mother of God is a classic Eleusa type. It is the most famous of the icons traditionally attributed to St. Luke. It was brought to Kiev from Constantinople in 1155, then taken by the Great Prince Andrei Bogolyubsky during his sacking of Kiev. In 1161 it was placed in the city of Vladimir, from which the name is derived. The "Vladimirskaya" is said to have saved Moscow from Tamerlane in 1395, and from the Poles in 1612. The icon still survives today in Russia. It has been repainted several times, and after restoration only the faces of the Mother and Child remained from the original. It is considered a great miracle-worker, and consequently multitudes of copies exist. Its feast days are May 21, June 23, and August 26.

VLAKHERNSKAYA

This "Blachernae" icon is another of those attributed to St. Luke. It is said to have been kept first at Antioch, then at Jerusalem, from which it was taken to Constantinople by Empress Theodosia (Feodosiya) in the fifth century. It takes its name from the Church of the Blachernae in Constantinople. Odigitriya variant. July 7, etc.

VODODATELNITZA *p. 287*

Of this "Water-Giver" icon old authorities say only that no reliable information exists. Umilenie variant. October 11.

VOLOKOLAMSKAYA *p. 288*

This icon appeared on March 3, 1677. It takes its name from the Iosifov-Voloko-lamsk Monastery, to which it was brought from Moscow. March 3.

VOSPITANIE

Authorities say little more of this wonder-working icon than that a copy was kept in the Kazan Cathedral in Moscow. Odigitriya variant. March 5.

VSEM SKORBYASHCHIM RADOST *p. 289*

In this "Joy of All Who Suffer" type the crowned Mother of God stands in the center. In some images she holds the infant Christ on her left arm and a sceptre in her outstretched right hand. In others she holds only the sceptre. Suffering humans are gathered on both sides of her, with angels among them. Open scrolls bear the petition of the people: "O Most Holy Lady, Mistress, Mother of God, higher than all angels and archangels, and more honorable than all creatures, you are the help of the injured, hope of the weak, intercessor of the poor, consolation of the sorrowing, feeder of the hungry, clother of the naked, healer of the ill, salvation of sinners, aid and defense of all Christians! (O, Presvyataya Gospozhe Vladuichitse Bogoroditse, vuisshi esi vsyekh angel i arkhangel i vseya tvari chestiyeishi. Pomoshchnitsa esi obidimuikh, nenadyei-ushchikhsya nadyeyanie, ubogikh zastupnitsa, pechalnuikh ytyeshenie, alchushchikh kormitelnitsa, nagikh odyeyanie, bolnuikh istsyelenie, gryeshnuikh spasenie, khristian vsyekh pomozhenie i zastuplenie). In some examples a ship with sailors and an angel is included, with the words "Mistress of those upon the waters."

A frequent inscription placed below the Mother of God is the kontakion "O

All-Hymned Mother" (O vsepyetaya mati) from the Akathist Canon (for text see the type O Vsepyetaya Mati). Another text sometimes found is the General Troparion of the Mother of God, Tone 4: "To the Birthgiver of God let us, sinners and humble, fall down before her, calling from the depth of our souls, 'O Mistress, help us by having mercy on us, hurry to our help for we are perishing from the multitude of our sins; do not turn your servants away empty, for you are the only hope we have'" ("K Bogoroditsye prilyezhno nuinye pritetsem gryeshniy i smirenniy..." etc. This type appeared in 1643 in the Church of the Transfiguration in Moscow. October 24.

VSEM SKORBYASHCHIM RADOST BLIZ STEKLYANNAGO ZAVODA p. 290

This "Joy of All Who Suffer 'Near the Glassworks' " (also known as the "Joy of All Who Suffer 'With Coins' " is a variant of the "Joy of All Who Suffer." It differs from the main type in that coins are depicted stuck here and there on the surface of the image.

It originated in a miracle which took place in the village of Klochka near Saint Petersburg, not far from a glass factory, in 1888. An image of the "Joy of All Who Suffer" was hanging in a chapel. The building was struck by lightning, shattering the alms box and charring the chapel walls. The icon "Joy of All Who Suffer" was found lying face down on the floor. When it was turned over, the image was found to have become fresh and clear, and coins from the alms box were sticking to its surface. Previously the icon, which had originally been found washed ashore on the Neva River, was dark and obscure. Its "renewal" was seen as a sign from heaven, and its fame spread. July 23 and October 24.

VUTIVANSKAYA

Nothing more seems to be known of this icon than its form and date of celebration. The Mother of God is seated on a throne; the child is on her left arm. They are flanked by two angels. Do not confuse with Kiprskaya, etc. May 2.

VZYGRANIE MLADENTSA

This icon of the "Playing Child" appeared on November 7, 1795 and was kept in the Nikolo-Ugryeshsk Monastery Cathedral Church not far from Moscow. Icons by this name are also found both in the Vatopedi Monastery on Mt. Athos (the type is obviously a Russian rendering of the Greek Pelagonitissa icon) and in the Novodyevitchi Monastery in Moscow. The Christ Child, held by his mother, is twisted in an awkward position with his right hand reaching up and the left extending down behind him and

holding a scroll. He appears like a wriggling child, thus, no doubt, the name. November 7.

VZUISKANIE POGIBSHIKH *p. 291*

This "Seeking of the Lost" type became known in Russia in the 18th Century, though the original is said to be as old as the 6th Century. The name is attributed to the rescue from damnation of a monk in Asia Minor by the image. This type was very common in the 19th Century. It is called the "Borskaya" Vzuiskanie Pogibshikh.

A different, less-common icon type under the same name is also found. This second type is an Umilenie variant showing the child seated on his mother's right arm. Their heads touch; his left hand reaches toward her neck, and her hands are clasped, fingers interlaced against his legs. February 5.

YAKHROMSKAYA *p. 292*

This icon first appeared miraculously in 1482 to a young man named Kosmas, who was travelling with an ailing elderly companion. The two rested near a spring. While his companion slept, Kosmas heard a voice and saw the icon shining with light in a tree. He showed the icon to his ailing companion, who was immediately healed. Later Kosmas became a monk in the Pecherskaya Lavra, after which he returned with the icon to the Yakhroma River near Vladimir, the place where it appeared. There he founded a monastic community and built a church for the image. Umilenie variant; the child, on his mother's right arm, reaches up to touch her face with his left hand. October 14.

YAROSLAVSKAYA

According to tradition this icon was brought to Yaroslavl in the 13th Century by Princes Vasiliy and Konstantin (June 8).

Two other "Yaroslavl" types are celebrated: The Yaroslavskaya-Pecherskaya, associated with the healing of Alexander Dobuichkin in 1823, is a Pecherskaya variant (May 14). Another, the Yaroslavaskaya-Kazanskaya, is celebrated on July 8.

YASKINSKAYA

There are two images by this name. The first appeared in the year 682, and was brought from Constantinople to the Monastery of the caves. Nothing is known of the origin of the second, which depicts the child on the mother's left arm, nestling close to her. May 3.

ZAGAETSKAYA

This icon was kept in the Zagaetsk Monastery in the area of the Pochaevskaya Lavra. The image is similar to the Chenstokhovskaya type. It has no set festal day.

ZAKLANNAYA

This image was kept in the Vatopedi Monastery on Mt. Athos. It is an Odigitriya variant characterized, like the Iverskaya, by a bleeding wound, in this case high on the right cheek of the Mother of God. January 21.

ZHIROVITSKAYA

This icon appeared in 1470 near the village of Zhirovits in Grodnensk province (Poland). A shepherd found it in a tree in the wood belonging to of the Lithuanian nobleman Alexander Saltuik. It is an Umilenie variant usually easy to recognize by the oval in which it is set, lettered with the words "More honorable than cherubim and incomparably more glorious than seraphim, you who without stain bore the Word of God" (Chestnyeyshuiu kheruvim i slavnyeyshuiu bez spravneniya serafim bez istlyeniya Boga Slova rozhdshuiu sushchuiu Bogoroditsu tya velichaem). These words are taken from the famous "Dostoino Yest" hymn from the liturgy of John Chrysostom. May 7.

ZHIVONOSNUIY ISTOCHNIK *p. 293*

This type originates in the tale of a healing spring which existed in a grove of trees near the Golden Gate of Constantinople. Once noted, it was gradually forgotten and became overgrown and slime-filled. In the year 450 a soldier named Leo encountered a thirsty blind man lost on the road. He placed the man beneath a tree and went to look for water, but heard a voice telling him he need not look elsewhere, because water was there amid the trees. He was told further that within the grove he would find a spring from which he was to take water for the blind man's thirst and slime to place upon his unseeing eyes. Strangely, the voice called him "Emperor Leo." He was also ordered to build a temple there to which people might come for healing. He did as instructed and the blind man was healed. In 457 Leo did become emperor, and recalling the voice, he had a church erected on the site of the spring, giving it the name Zoodokhos Pigi — "The Life-Giving Wellspring."

In the "Life-giving Wellspring" Mary is seated with her child in a chalice-form fountain set in the middle of a constructed pool. Water from the chalice pours into the fountain, and those suffering various ills cluster about to take the life-giving waters. In some versions two angels standing on clouds flank the Mother of God. Each holds a

disk on which are the Cyrillic letters ST,' abbreviating the word Svyat, meaning "Holy" (in others they bear the IC XC abbreviation of the name Jesus Christ). Some images have ship captain in the foreground pouring water over a Thessalonian who is thereby brought back to life.

In the Akathist Mary is called "Unfailing Well of Living Water." April 4 and Friday of Bright Week.

ZNAMENIE *p. 294*

The "Sign" Mother of God is derived from a prototype which was a marble relief in the Photinos Chapel of the Church of the Blachernae in Constantinople. In Russia the type became greatly venerated after its use by the City of Novgorod against the invading army of Andrey Bogolyubskiy in 1170. Archbishop John of Novgorod heard a voice telling him to take the "Sign" icon from the church to the city walls. Once there, the icon was struck by a Suzdal arrow. Miraculously, the image began to shed tears, and turned its face toward the city as a visible "sign" that the Mother of God was interceding on its behalf. The invasion was repelled.

Though usually half-length, the Mother of God with the child in a circle on her breast is also found full-length under the title "The Great Panhagia," primarily a Greek form. The full length Mother of God without the Child, with her arms out to the sides, is known as the "Unshakeable Wall" (Nerushimaya Stena)." November 27.

ZOSIMO SAVVATIEVSKAYA

This type, not assigned a day in the Church calendar, was kept in the Cathedral Church of Solovetskiy Monastery.

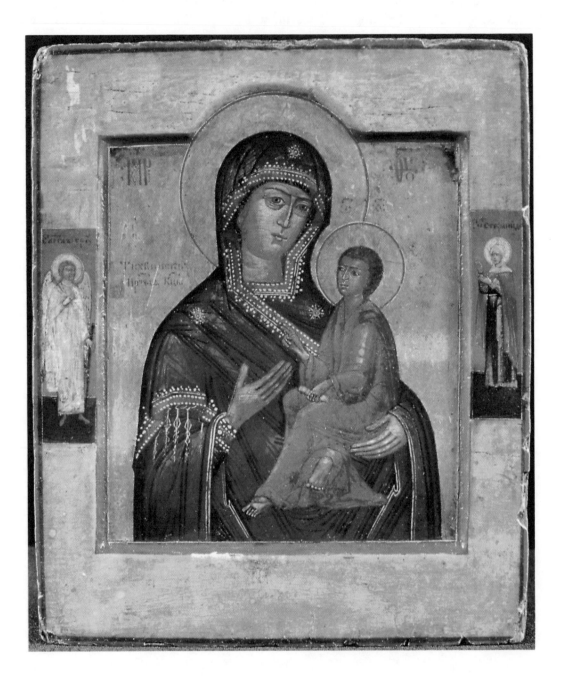

cf. p. 205

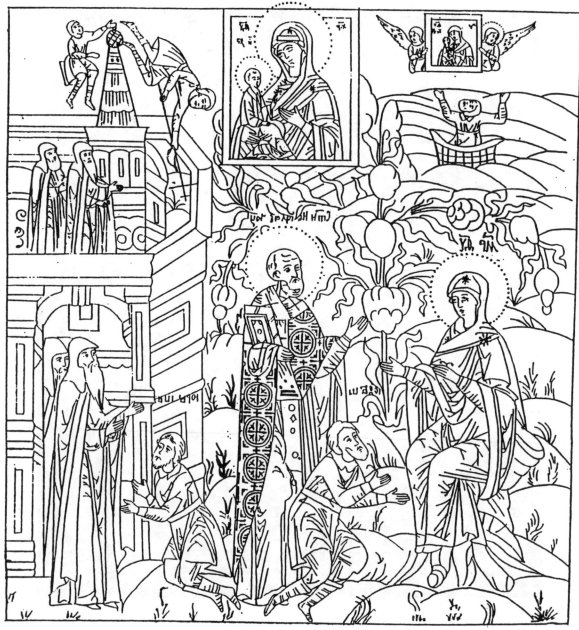

ѪВЛЄНІЄ Б. М. ГЕОРГІЮ

cf. p. 206

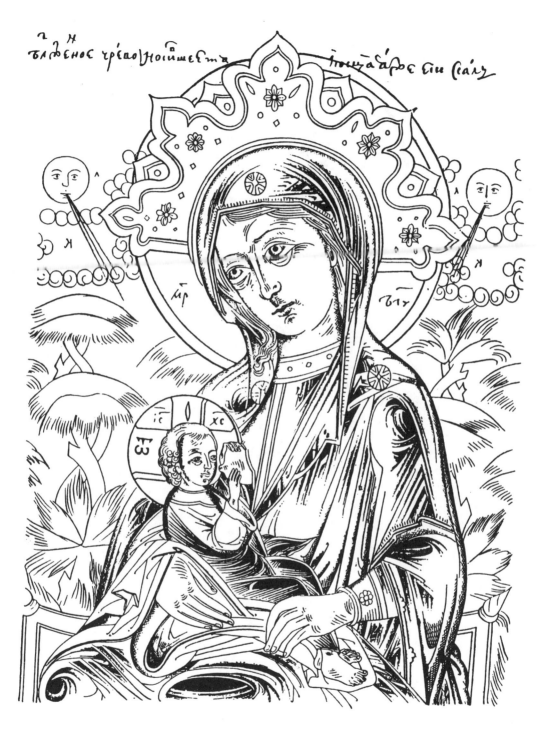

cf. p. 208

cf. p. 208

БОГОЛЮБСКАЯ ИКОНА Б. М.

cf. p. 208

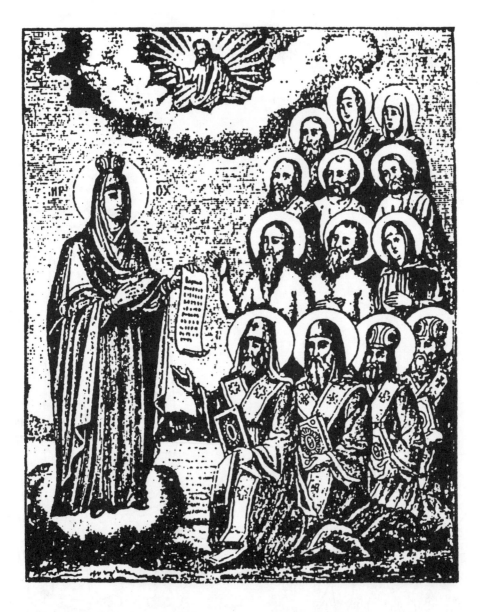

Боголюбская въ Москвѣ.

cf. p. 208

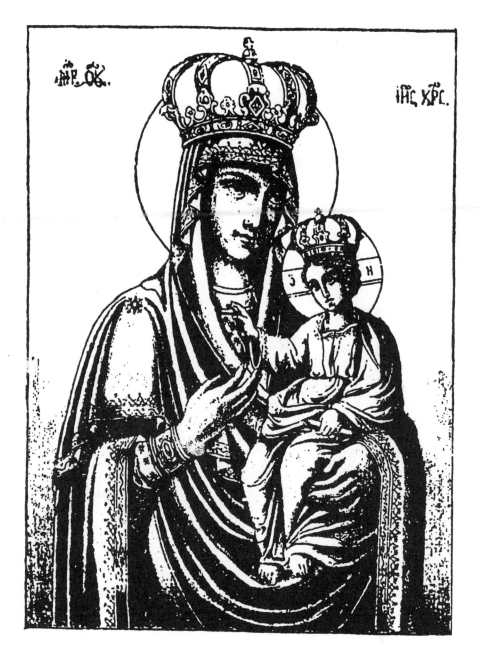

Черниговская-Геѳсиманская.

cf. p. 209

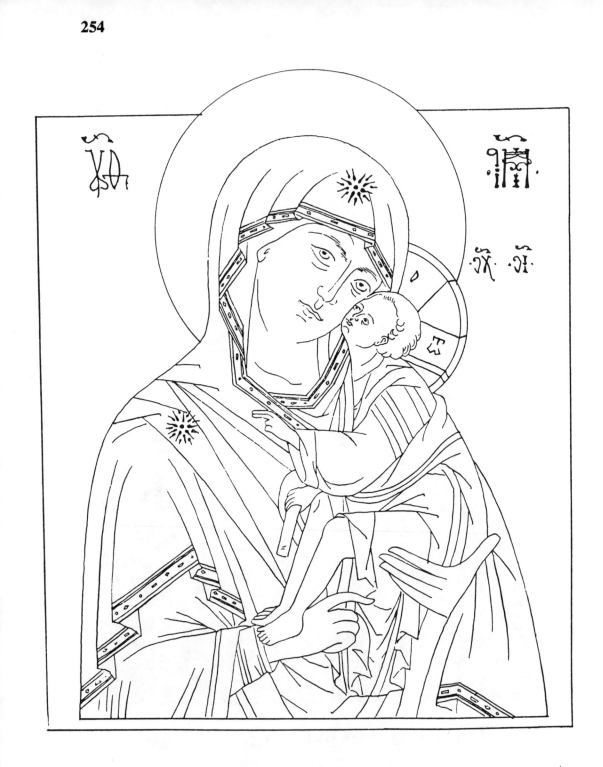

ДОНСКАѦ ИКОНА Б.М.

cf. p. 211

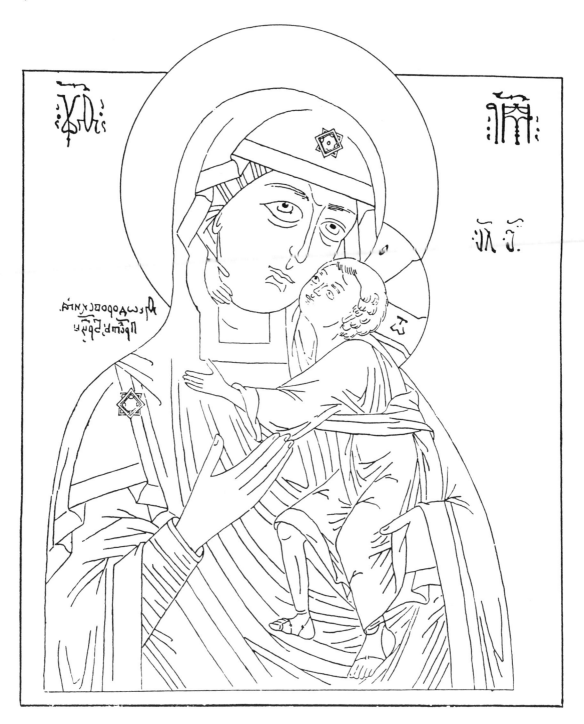

cf. p. 213

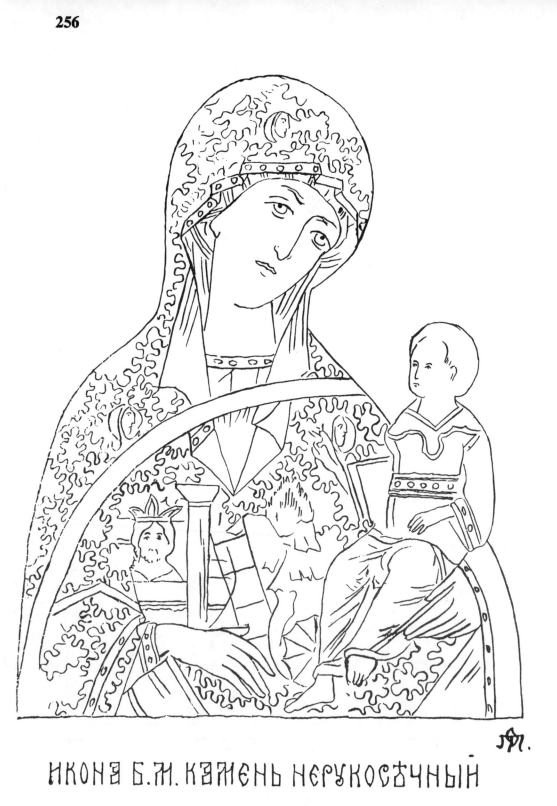

ИКОНЭ Б.М. КЭЖЕНЬ НЕРУКОСѢЧНЫН

cf. p. 215

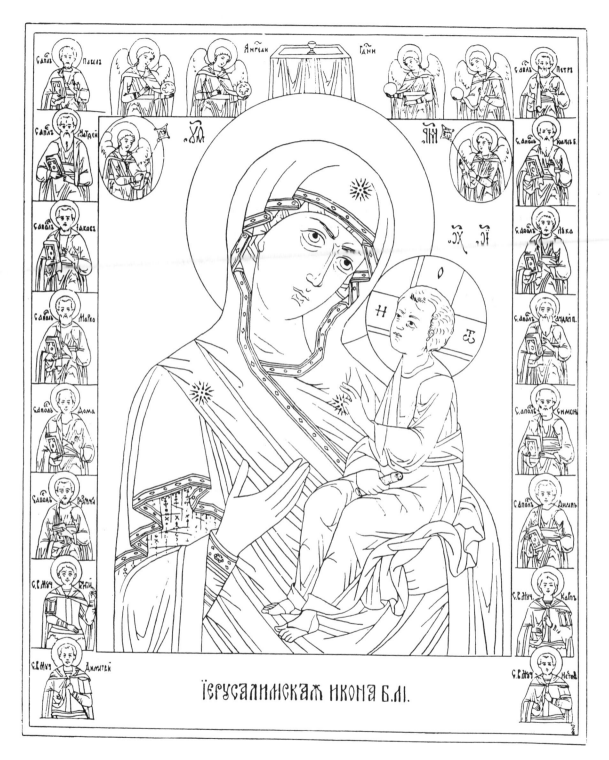

ЇЄРУСАЛИМСКАЖ ИКОНА Б.М.

cf. p. 216

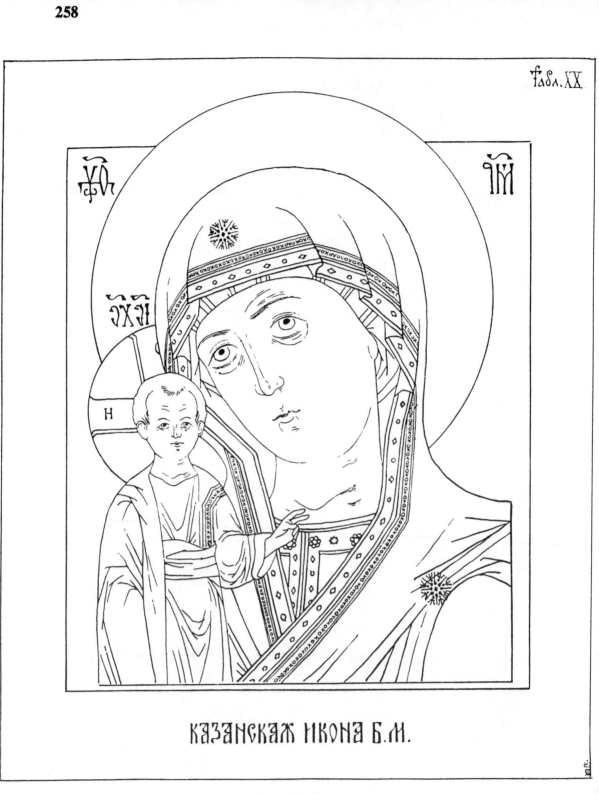

КАЗАНСКАЯ ИКОНА Б.М.

cf. p. 218

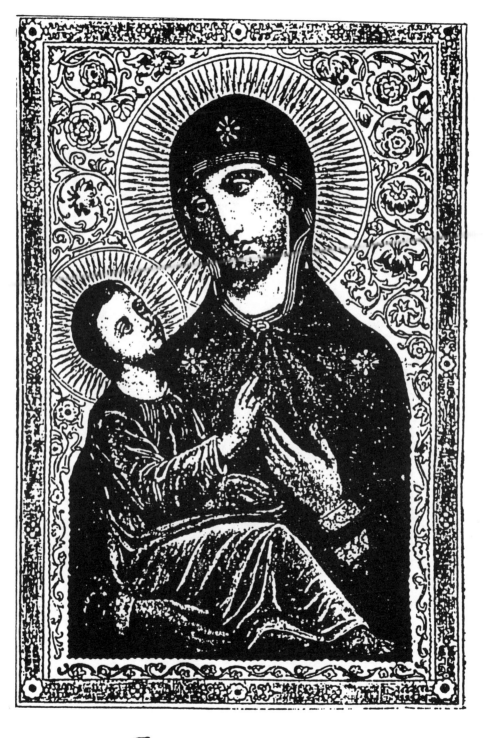

Холмская

cf. p. 219

в
КОНЕСКИѦ
ПРТЫѦ БЦЫ

ꙗвиса вцрҍ гдҍ
оусобїи премѹ
бжнї

cf. p. 220

cf. p. 220

Моденская въ с. Косинѣ

cf. p. 220

Табл. XXIV

КУРСКАЯ ИКОНА Б. М.

cf. p. 221

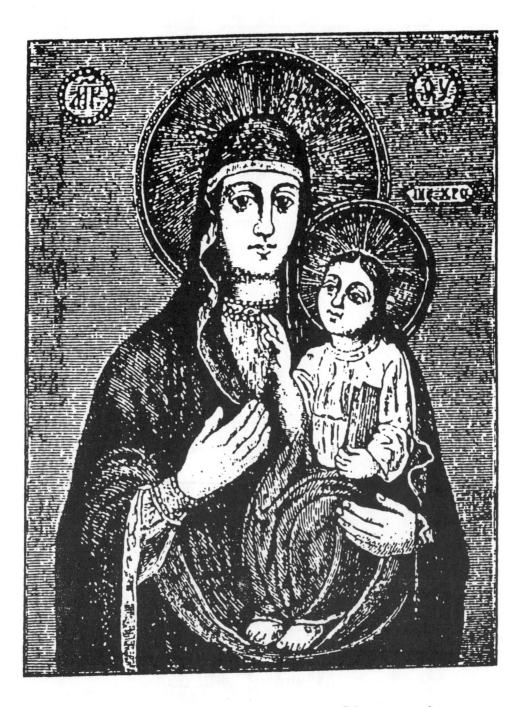

Любечская въ Кіевѣ

cf. p. 221

Максимовская

cf. p. 222

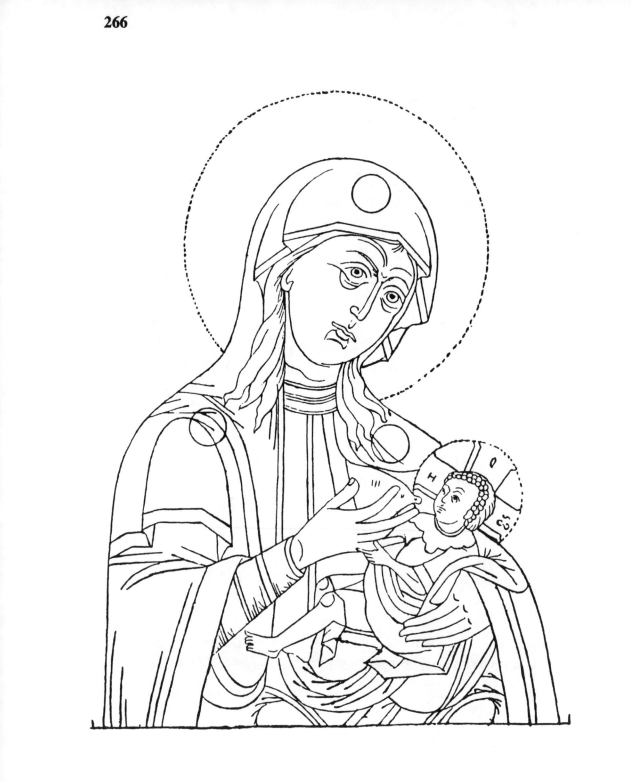

cf. p. 222

Молченская въ Молченскомъ
Путивльскомъ мон., Курск. г.

cf. p. 223

cf. p. 224

cf. p. 227

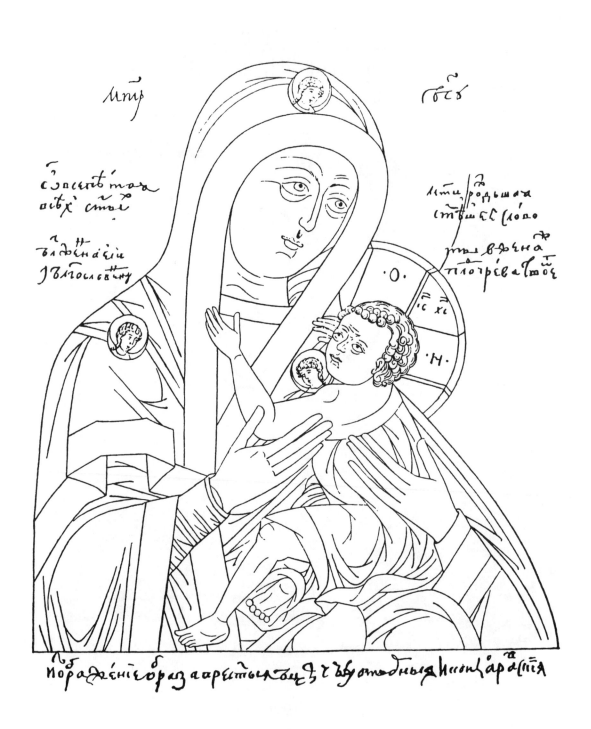

cf. p. 227

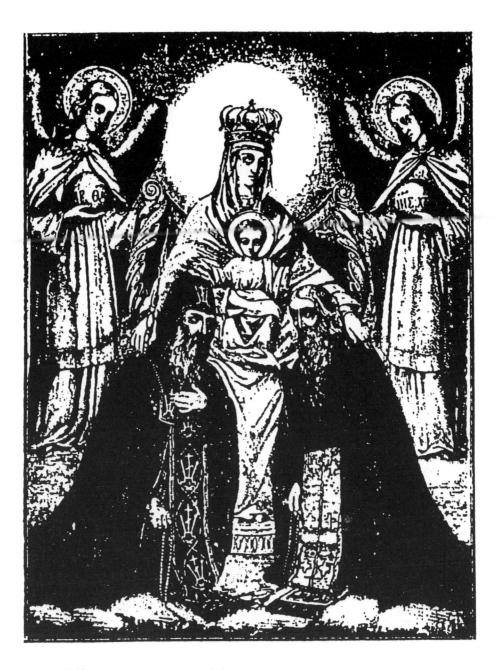

Печерская-Нерукотворенная

cf. p. 228

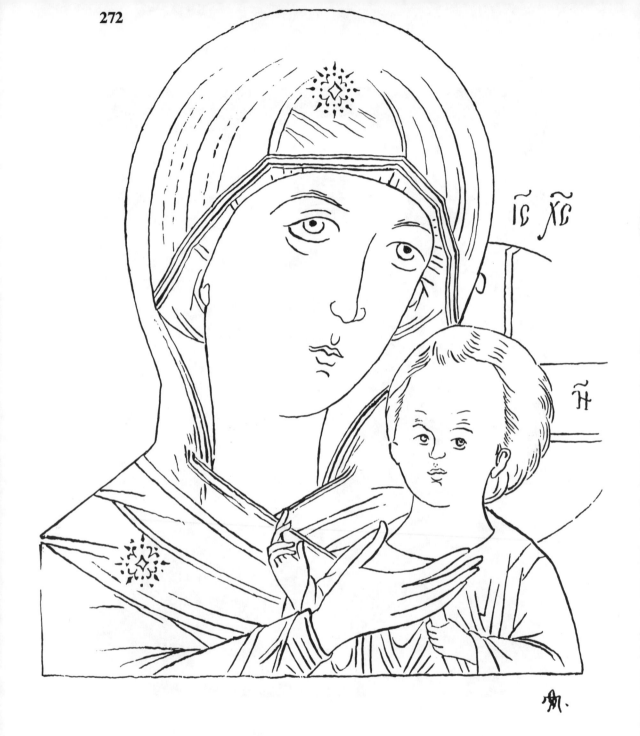

ПЕТРОВСКАѦ ИКОНА Б.М.

cf. p. 229

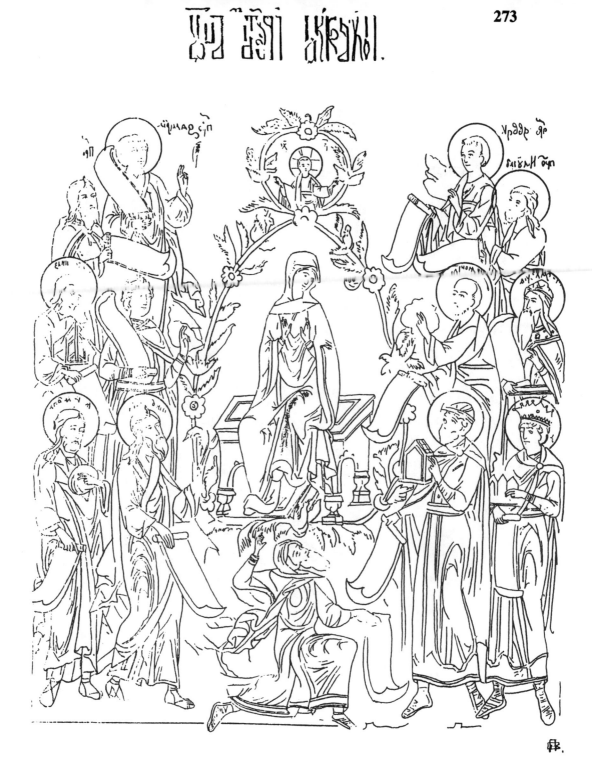

ПОХВАЛА ПРЕСВ. БОГОРОДИЦЫ.

cf. p. 230

Помощь въ родахъ

cf. p. 230

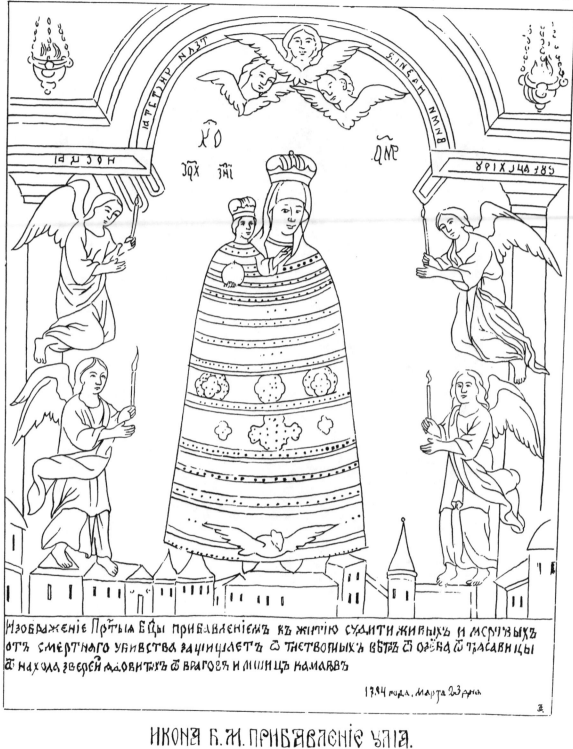

Изображеніе Прстыя Бцы прибавленіемъ къ житію судити живыхъ и мертвыхъ отъ смертнаго убивства защищаетъ ѿ тлетворныхъ ветъ ѿ огня ѿ трасавицы ѿ находа звѣрей ядовитыхъ ѿ враговъ и мшицъ камаевъ

1784 года. Марта 23 дня

ИКОНА Б. М. ПРИБАВЛЕНІЕ УМА.

cf. p. 231

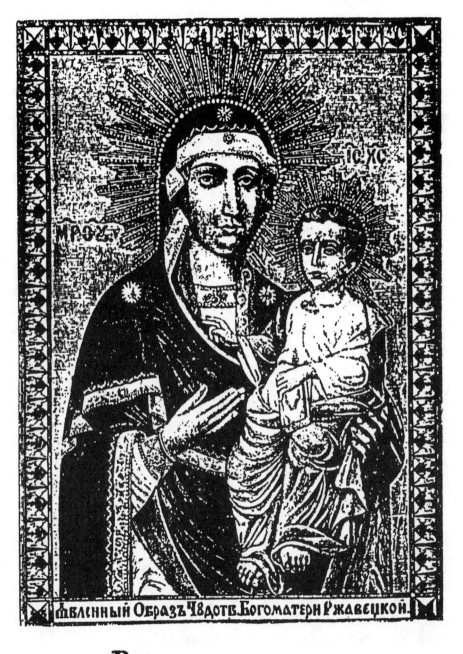

Ржавецкая

cf. p. 232

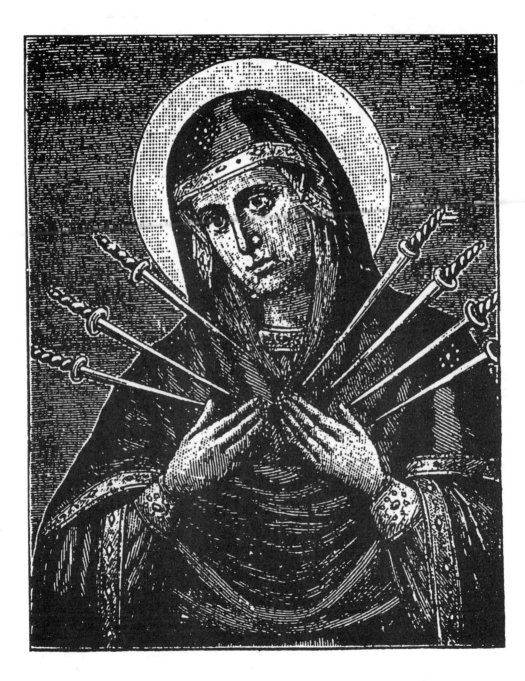

Семистрѣльная

cf. p. 232

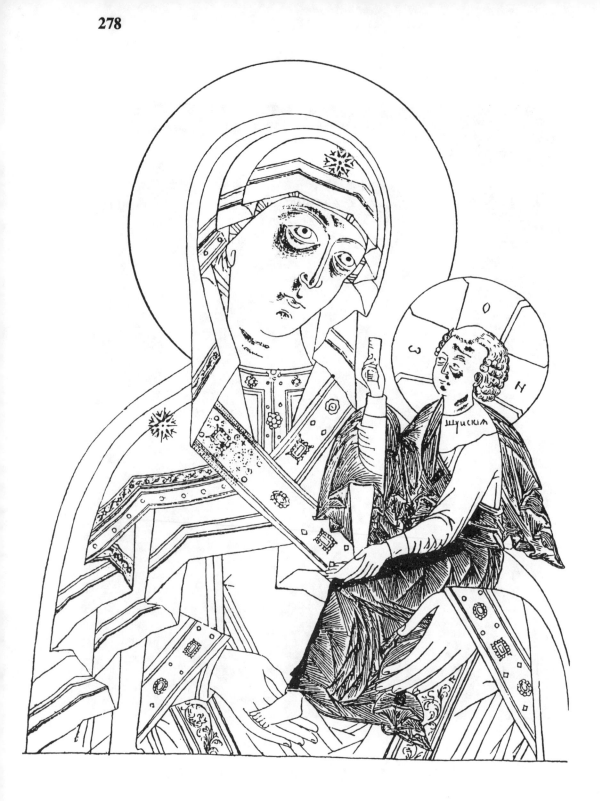

cf. p. 233

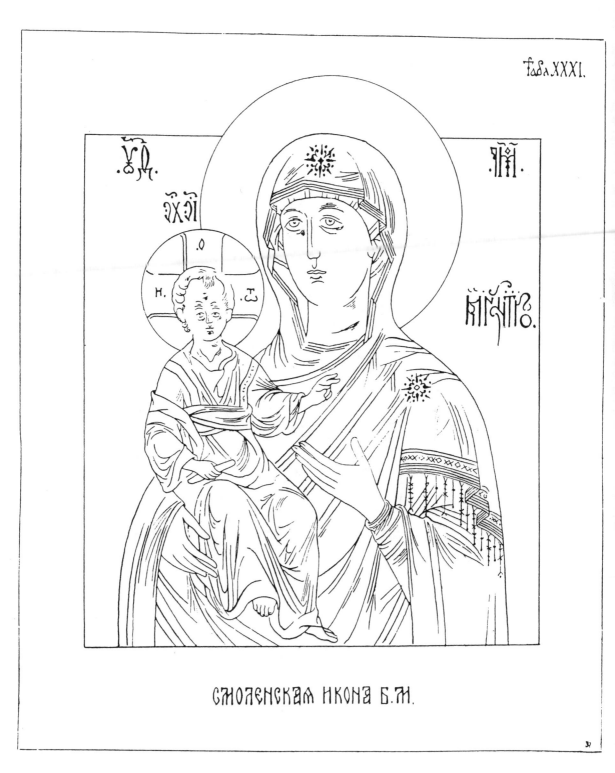

Смоленская икона Б. М.

cf. p. 234

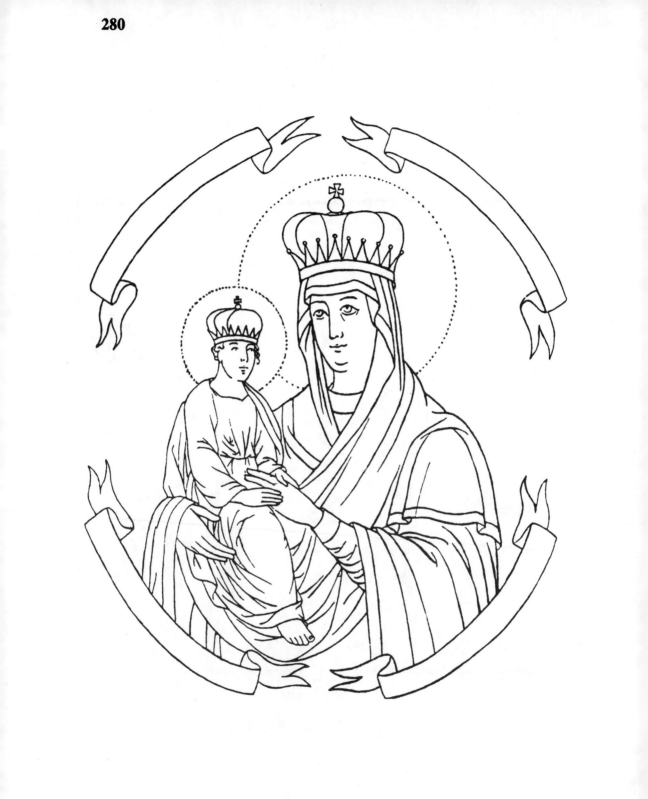

cf. p. 234

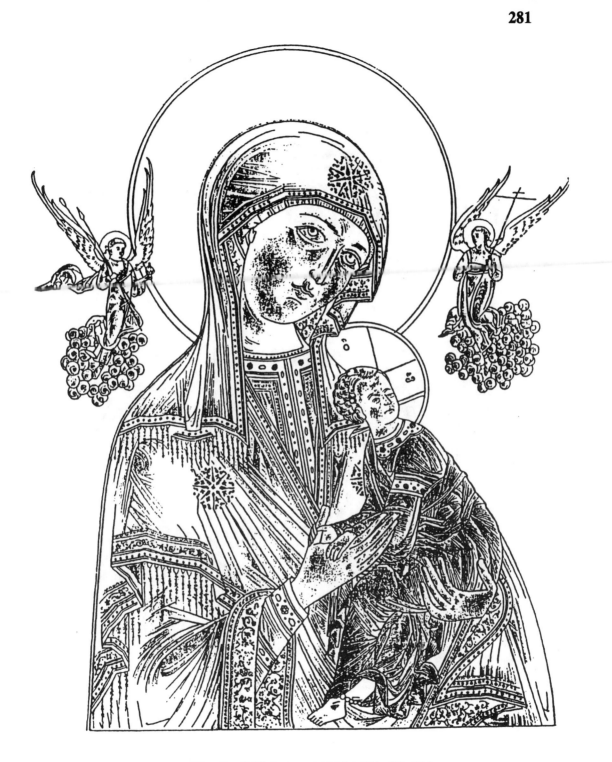

СТРАСТНАѦ ИКОНА Б.М.

cf. p. 235

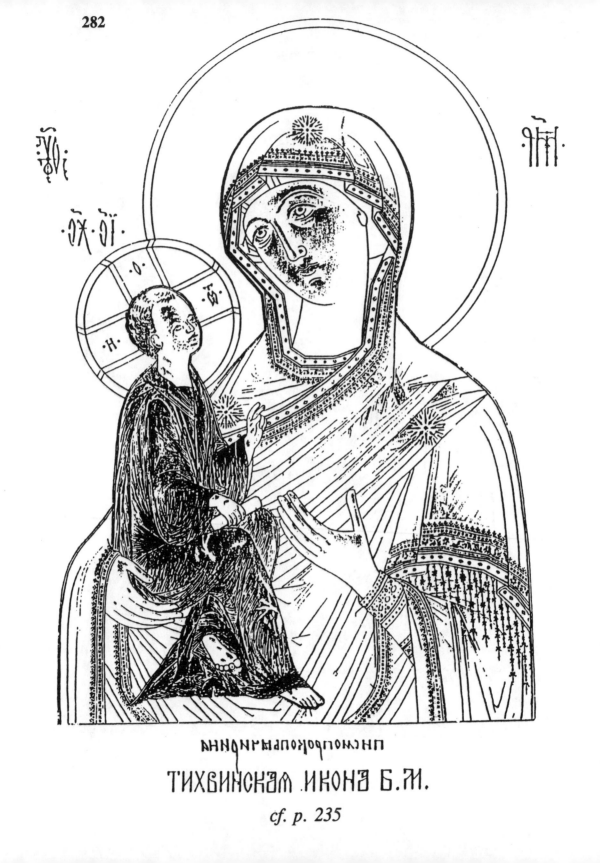

ТИХВИНСКАЯ ИКОНЭ Б.М.

cf. p. 235

cf. p. 236

ИКОНЭ Б.М ТРЕХЪ РЭДОСТЕЙ

cf. p. 236

Умягченіе злыхъ сердецъ

cf. p. 238

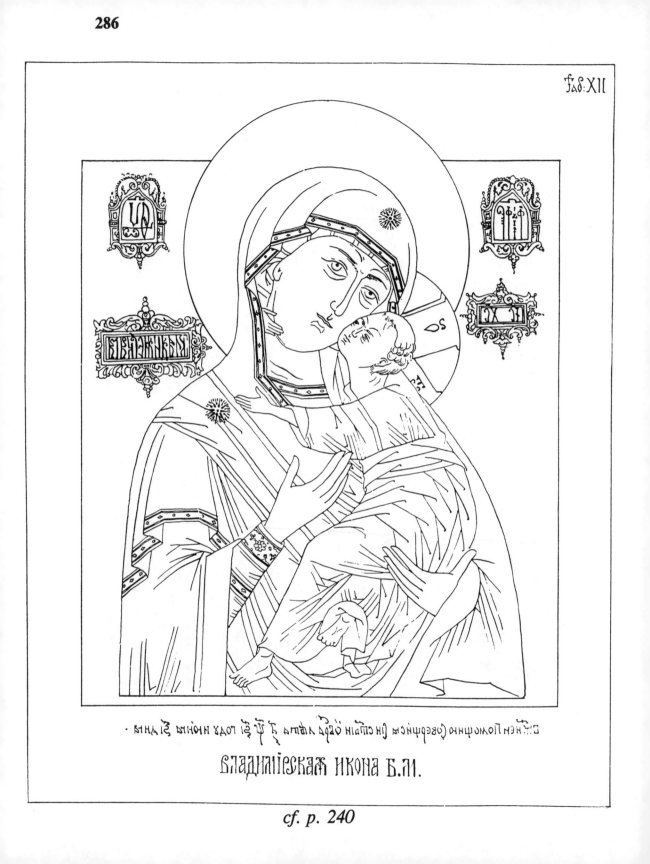

Tab: XII

Владимiрскаж икона Б.М.

cf. p. 240

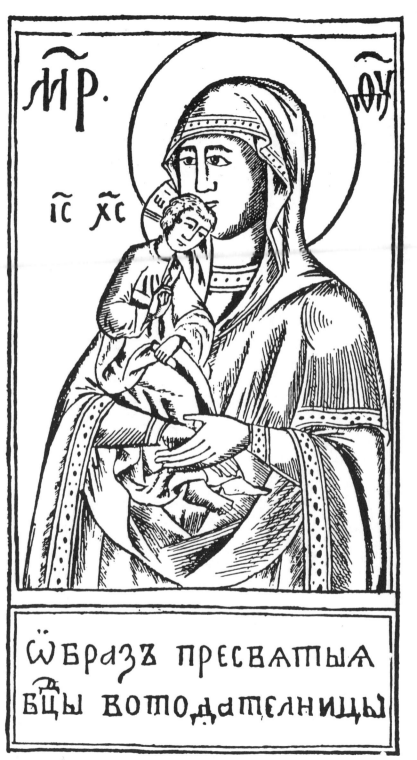

cf. p. 241

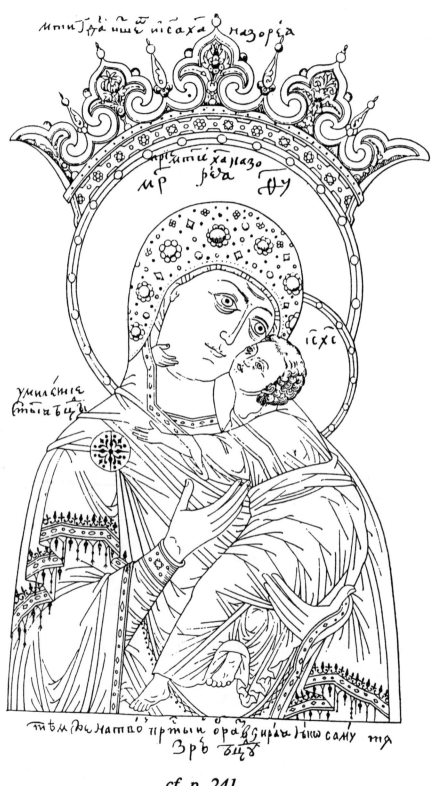

cf. p. 241

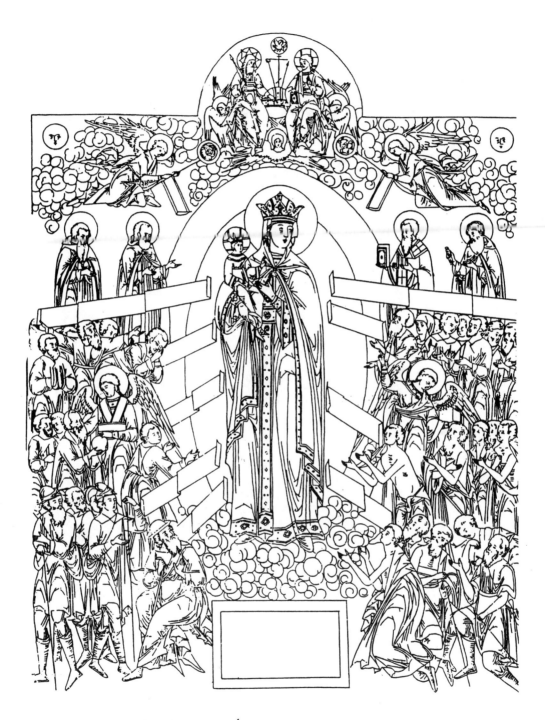

ИКОНА Б. М. ВСѢХЪ СКОРБЯЩИХЪ РАДОСТЬ.

cf. p. 241

„Всѣхъ скорбящихъ Радость" близъ Стокляннаго завода, въ С.-Петербургѣ.

cf. p. 242

cf. p. 243

с: ꙗ҃а҃ …

ΔΧΡΕΜΙΣΚΔΛ ΝΚΟΝΔ Б. М.

cf. p. 243

ИКОНА Б.М. ЖИВОНОСНЫЙ ИСТОЧНІКЪ

cf. p. 244

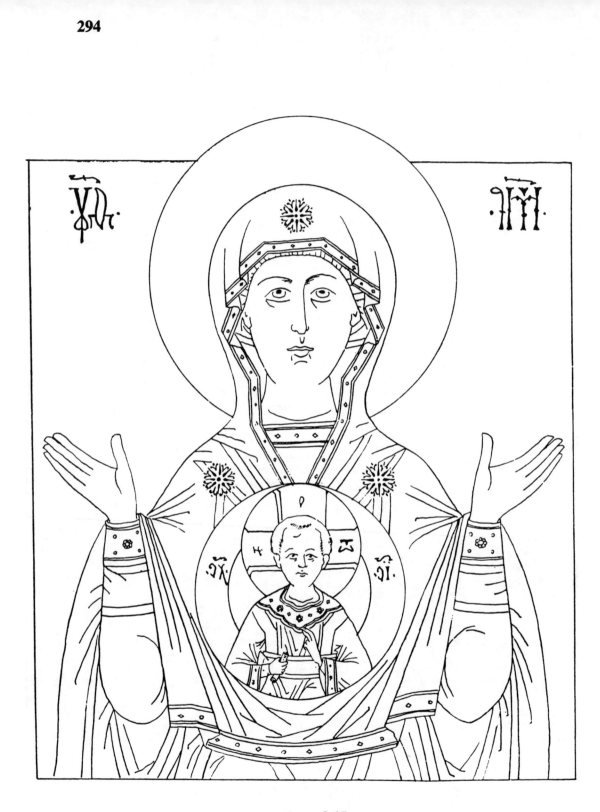

cf. p. 245

PART THREE
Understanding the Liturgy, Symbols and Practices of the Russian Orthodox Church

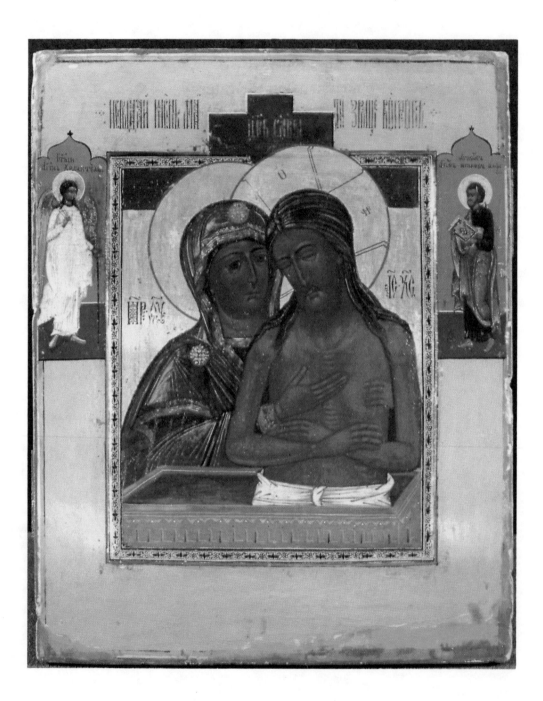

THE ICONOSTASIS (Russian Ikonostas)

The ikonostas (image stand) is a large wooden framework inset with rows of icons, forming a solid screen or wall between the congregation and the altar in Russian Churches. The number and size of the icons included vary according to the size of the church, but there are generally-accepted standards for placement of the various icon types.

The "Tsar Doors" (Tsarskiye Dveri), also called the Royal Gates (Tsarskiye Vrata), at floor level in the center of the iconostasis, allow the priest entry to the altar. They are usually (but not always) painted with icons of the Four Evangelists, and at the top of the doors is the "Annunciation," with the angel Gabriel on the left panel and Mary on the right. The "Mystic Supper" is often shown in the space above the Tsar Doors, and icons in this position are often oval in form. Sometimes one encounters these icons in collections, and many examples are easily recognized as having been removed from an iconostasis because of their oval shape. In some churches the place of the "Mystic Supper" is filled by another type, "The Communion of The Apostles," in which Christ is shown standing beneath a dome on pillars, and behind an altar table. He gives the Eucharistic bread to six disciples approaching on the left. The image is repeated on the right, with Christ giving the Eucharistic wine from a chalice to six more disciples. The figure of Christ is often doubled when the type is shown on a single icon. In some Ukrainian and southwest border region churches the position above the Tsar Doors is taken by the "Not Made With Hands" image of Christ.

The jambs of the Tsar doors on some iconostases are painted with images of the "Holy Liturgist Fathers, " Saints Basil the Great and John Chrysostom. The openwork doors are called the Tsar Doors because Christ in the form of the Holy Gifts, that is, the transubstantiated bread and wine of the Eucharist, passes through them — and one title of Christ is Tsar Slavuiy, "The King of Glory."

The other two doors in the iconostasis, one on the north (to the left of the Tsar Doors, giving entry to the prothesis) and one on the south, (to the right of the Tsar Doors, giving entry to the vestry) are decorated either with the Archangel Gabriel and the Archangel Michael, or with holy deacons.

To the left of the Tsar Doors is a large icon of the Mother of God with the Christ Child, and to the right is an icon of Christ and another of the saint or event to which the church is dedicated. Other unspecified icons are found in this first row of "local icons," so called because if space permits, icons of the saints particularly venerated in that locale are included. The first tier is also sometimes called the "Veneration Tier" because it is physically accessible to worshippers who may kiss the icons.

The second row up from the floor consists of smaller icons than in the rest of the screen — holy day types such as the Birth of the Mother of God, the Presentation of the Mother of God in the Temple, the Birth of Christ, the Theophany of Christ, the Entry into Jerusalem, the Crucifixion, the Elevation of the Cross, and so on — in short, the major feasts (prazdniki) of the Church Year.

The third row up is the "Deisis Tier." In the Center is the "Lord Almighty" type of Christ (either in the usual form or with Christ robed as a king or bishop) with the Mother of God on his right and John the Forerunner on his left; then an angel on both right and left, then various other apostles and saints, the actual number depending on the size of the iconostasis. They stand in rows on each side, as though petitioning Christ. They may be life-size or larger on a very big iconostasis.

Some screens reverse the Deisis Tier and the Holy Days Tier, and make the Deisis Tier second from the floor.

The fourth row up is the "Prophets Tier," which has the Mother of God with the Christ Child in the center (though sometimes Christ as Vsederzhitel is substituted). On each side are rows of prophets bearing scrolls. The prophets may be shown half or full-length.

Some very large screens add a fifth tier made up of Old Testament patriarchs or prophets, but with the "Fatherhood" (Otechestvo) type as the central icon (or this tier may display martyrs and holy bishops).

At the very top of some large iconostases, the center bears an image of the Crucifixion; to the left of that is the Descent from the Cross, and farther left the Betrayal by Judas. To the right of the Crucifixion is the Placing in the Tomb, and on the far right the Prayer of Christ in Gethsemane.

Icons which have been removed from an iconostasis may often be recognized by their large size (though they may be relatively small if from a small church), or by a difference in color about the edges where they were fitted into the screen. They are sometimes oddly shaped, such as the oval or round icons from certain Baroque-style screens.

Sometimes very small portable iconostases are found. These folding screens were used for the performance of the liturgy outside the church when that proved necessary, such as in the field with an army. They may be found cast in metal or painted on wooden panels. Sometimes a detailed iconostasis is found painted on a single panel.

THE SANCTUARY

To understand the meaning of the iconostasis and of some icons it is necessary to know something of the internal arrangement of a church and of what is done there.

Behind the Tsar Doors and the curtain beyond is the area called the Sanctuary (Altar). It contains the square altar, also known as the throne (prestol) because Christ is believed to be present on it, or the Holy Table (Svyataya Trapeza). It has a covering of white linen, over which is placed the visible covering in ornate brocade.

A cloth called the Antimins is placed on the altar before the liturgy. It is rectangular, and is decorated with the "Placing in the Tomb" icon type. The Antimins has a relic of a saint sewn into it. The purpose of this cloth, which is consecrated by a bishop, was originally to permit the performance of the liturgy in places without a consecrated altar

— it can be folded up and taken anywhere. In time the antimins became a standard feature of every altar, even those which had been consecrated and already contained a relic beneath.

An altar cross (Krest) is laid flat on the right side of the table. On the left is a copy of the Gospels, usually ornately bound, often with metal cover fittings having images of the four Evangelists and a central image of the Crucifixion or Resurrection.

In the center of the Altar behind the antimins is the tabernacle (Darokhranitelnitsa, Sion or Ierusalim), a container in which the Holy Gifts may be kept for communion when the Liturgy is not possible. The tabernacle is frequently in the form of a domed Russian church. Beside it on the right side of the altar is another container called the Daronositsa, which is used to carry the Holy Gifts to the ill at home.

There are also lights on the altar. In the center behind the tabernacle is the polykandil, which holds seven or twelve candles, symbolizing the seven gifts of the Holy Spirit or the twelve apostles. To the left is the dikirion, which holds two candles symbolizing the dual nature of Christ as God and man. On the right is the trikirion, with three candles symbolizing the Holy Trinity. A peculiarity of the dikirion and trikirion is that the candles lean inward rather than standing straight.

Behind the altar a rapida or liturgical fan is kept at each side, the face of each fan ornamented with the image of a cherub.

THE PROTHESIS

Behind the north door to the left of the Tsar Doors is the Prothesis (offering) Chapel (in Russian Zhertvennik or Predlozhenie) which contains the Table of Oblations on which the vessels used for preparing the Eucharist are kept. These consist of the chalice (potir or chasha) for the wine and the paten (diskos) on which are placed pieces of bread cut out of the prosfora, the loaf used in the ceremony. There are two plates which go with the paten. The first is stamped with a cross and inscribed "We venerate your cross, Master, and praise your holy Resurrection." It is used for the bread from which the portion symbolizing Christ is taken. A second plate is for the bread from which a portion symbolizing the Mother of God was taken. It bears an image of her and the inscription "It is meet to honor you as truly the Mother of God."

Further, there is the asterisk or zvezditsa (star) which is simply two metal bands fastened in the center with a bolt or screw. The screw permits the bands to be moved into a cross-shape when the asterisk is placed on the paten to keep the portions of bread in a certain order after they have been removed from the prosfora. It symbolizes the star of Bethlehem and the cross.

The remaining implements are a dipper which is used for water and wine, a spoon (the lzhitsa, often of ornamented gilt silver) for administering the sacraments, the lance (kopie, actually a lance-shaped knife for cutting out portions of the prosfora, and a sponge used for cleaning the sacred vessels after the ceremony. Beyond this one need

mention only three cloths (the two small pokrovtsi and the larger vozdukh) used for covering the sacred implements, and the liturgical fans.

THE VESTRY

Behind the south door in the iconostasis is the Vestry (Riznitsa), which is the area in which the church vessels are kept when not in use. Also the vestments and liturgical books are kept here. These items are the responsibility of the deacons, which is why the south door is sometimes called the "Deacons' Door."

THE NAVE

The greater part of the church in front of the iconostasis is occupied by the nave, in which the worshippers traditionally stand during the liturgy. They have access to the space in front of the iconostasis in order to venerate the icons on the screen, but they are not permitted behind the Tsar Doors, where only the celebrants may enter (an exception is made for the Tsar of Russia, who may enter the sanctuary during his coronation to take communion).

At the front of the nave, on each side of the iconostasis, are areas where portable icon banners on staffs are kept for use in processions and for celebration of the liturgy outside the church. The stand on which the icon representing the current feast is kept (or a menological icon) is farther out to the front of the iconostasis.

The doors which give entry to the nave and separate it from the vestibule are called the "Beautiful Doors" (or "Beautiful Door" in a small church).

In Orthodox churches one sometimes finds images of two angels. One bears a sword to strike down lazy worshippers who leave the church before the end of the liturgy. The other angel holds a long scroll on which he keeps a record of those who faithfully come to church.

READING ICON INSCRIPTIONS

The Church Slavonic Alphabet *p. 302 ff*

The traditional language of the Orthodox Church in Slavic countries is Church Slavonic, a modified form of Old Church Slavonic, the language used by the early Macedonian missionary monks Cyril and Methodius. It is written in the Cyrillic alphabet, named after Cyril. This language is used in the Bible, in the liturgical books of the Church, and also for inscriptions on icons. It is closely related to modern Russian but differs in many respects (Romania once used Cyrillic letters on icons, but replaced them with Roman letters).

Anyone wishing to become familiar with icons must learn to read a little Church Slavonic. It is not a difficult task. Because the titles of saints and icon types are very repetitive, a little knowledge gives great rewards. The reader who learns the Slavonic alphabet, becomes familiar with the standard saint "titles," and who uses the transliterated inscriptions given in this book as a reference source, should be able to translate the majority of standard icons.

As may be seen from the illustration, the letters of Church Slavonic are based largely on a system of thick vertical lines and thin horizontal or angled joining lines, with a few letters deviating from the norm.

Note that some letters may also be used as numbers. These letter-numbers are often found on dated icons, though some are in "Western" numerals. Letter-numbers are also used for chapter and verse in the Church Slavonic Bible.

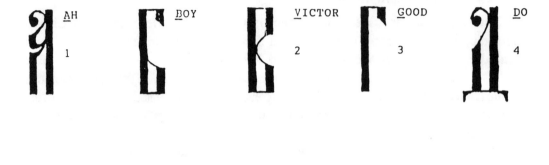

<u>A</u>H
1

<u>B</u>OY

<u>V</u>ICTOR
2

<u>G</u>OOD
3

<u>D</u>O
4

<u>E</u>BB
5

LE<u>I</u>SURE
(<u>ZH</u>)

<u>Z</u>ONE
6

<u>Z</u>ONE
7

F<u>EE</u>T
(<u>I</u>)
8

F<u>EE</u>T
(<u>I</u>)
10

<u>K</u>EY
20

<u>L</u>ine
30

<u>M</u>AN
40

<u>N</u>EW
50

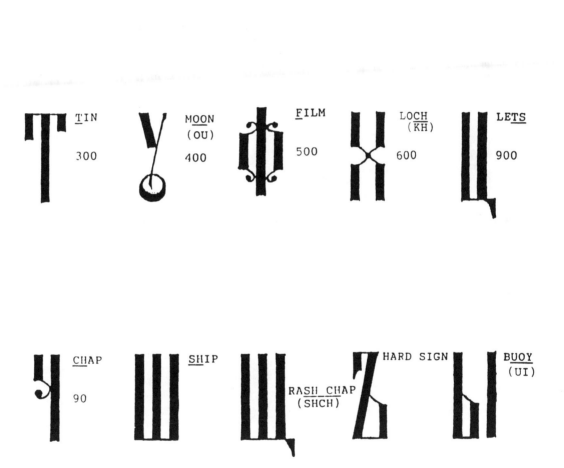

The hard sign generally indicates that the preceding consonant is unpalatalized. It is omitted in the transcriptions used in this book.

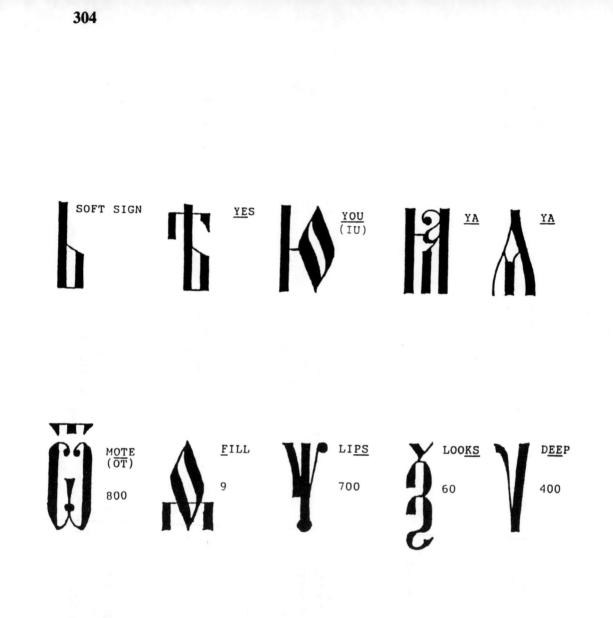

*The soft sign indicates that the preceding consonant is palatalized.
It is omitted in the transcriptions used in this book.*

Quick-reference Alphabet

Яа **A**	Бб **B**	Вв **V**	Гг **G**	Дд **D**
Єє **E**	Жж **ZH**	Ѕѕ **Z**	Зз **Z**	Ии **I**
Іі **I**	Кк **K**	Лл **L**	Мм **M**	Нн **N**
Оо **O**	Пп **P**	Рр **R**	Сс **S**	Тт **T**
Ѹѹ **U / OU**	Фф **F**	Хх **KH**	Ѿѿ **OT**	Цц **TS**
Чч **CH**	Шш **SH**	Щщ **SHCH**	Ъъ **HARD**	Ыы **UI (Y)**
Ьь **SOFT**	Ѣѣ **YE**	Юю **IU / YU**	Ѡѡ **O**	Ꙗꙗ **YA / IA**
Оо **O**	Ѯѯ **KS / X**	Ѱѱ **PS**	Ѳѳ **F**	Ѵѵ **EE**

Quick-reference number letters
for icon dates and bible verses

а҃	в҃	г҃	д҃	е҃	ѕ҃	з҃	и҃	ѳ҃	і҃
1	2	3	4	5	6	7	8	9	10

а҃і	в҃і	г҃і	д҃і	е҃і	ѕ҃і	з҃і	и҃і	ѳ҃і	к҃
11	12	13	14	15	16	17	18	19	20

к҃а	к҃в	к҃г	к҃д	к҃е
21	22	23	24	25

к҃ѕ	к҃з	к҃и	к҃ѳ	л҃
26	27	28	29	30

м҃	н҃	ѯ҃	ѻ҃	п҃	ч҃	р҃
40	50	60	70	80	90	100

с҃	т҃	у҃	ф҃	х҃	ѱ҃
200	300	400	500	600	700

ѡ҃	ц҃	҂а҃	҂в҃
800	900	1000	2000

TITLES AND ABBREVIATIONS

In the majority of icons dating from the 17th to the early 20th Century, each saint is identified by a title and name written above or in the halo. Titles are frequently abbreviated. Shortened forms may vary from those given here. Abbreviations are usually indicated by a curved horizontal line above the word. Letters left out may be written in above the abbreviation but in smaller form. Spelling of titles and names may also vary slightly.

SVATUIY/S/ST/SV: "Holy"; the equivalent of the Latin sanctus, from which our word "saint" is derived. One may translate Svatuiy Ioann as "Holy John" or as "Saint John." This is the standard term preceding any saint's name and other titles. Occasionally, even on icons of the late nineteenth and early twentieth centuries, one may find the Greek equivalent (H)O (H)Agios, particularly on icons of Saint Nicholas the Wonderworker (the parenthesized letters indicate the older Greek pronunciation; modern Greek drops the "H"). Unlike English, Slavonic changes the word when it is used of a female. It then becomes SVATAYA.

MOUCHENIK/MOU (MU): "Martyr"; if used of a female, it becomes MUCHENITSA. So a Svataya Muchenitsa is a female "holy martyr."

SVYATAGO: This is a different grammatical form of SVATUIY; it is best rendered by "of the Holy," as in Obraz Svyatago Slavnago Proroka Ioanna Predtecha — "Image of the Holy, Glorious Prophet John the Forerunner."

VELIKOMUCHENIK/V MOU: "Great Martyr"; and if a female, a VELIKOMUCHENITSA. St. George is a Velikomuchenik, and Varvara (Barbara) is a Velikomuchenitsa.

SVYASHCHENNOMUCHENIK/SSHCH MOU: "Priest-martyr"; Used of martyred priests such as Svashchennomuchenik Kharlampiy, (Kharalampos).

BLAZHENNUIY/BLAZH: "Blessed"; used of "holy fools" such as Blazhennuiy Aleksiy (Alexei, Alexius), or in the feminine form of such as Blazhennaya Kseniya (Xenia).

BLAGOVERNUIY/BLAG: "Good-believing"; this means a "true, pious Orthodox believer," and may be used of royalty such as Blagovernaya Evfrosiniya (Euphrosinia).

KNYAZ/KN: "Prince"; sometimes translated "Grand Duke"; this title is used of rulers such as Knyaz Aleksandr Nevskiy (Alexander Nevskiy), or, in the feminine form, of such as Knyagina Iulianiya (Princess Juliana).

APOSTOL/AP: "Apostle"; used of the New Testament figures sent by Jesus to preach the Gospel, such as Apostol Petr (Peter).

RAVNOAPOSTOLNUIY/RAVNOAPOST: "Equal-to-the Apostles"; used of saints equal to the Apostles of Jesus, such as Ravnoapostolnuiy Velikiy Knyaz Vladimir (Equal-to-the-Apostles Great Prince Vladimir, who converted Russia to Orthodoxy, or of women such as Ravnoapostolnaya Knagina Olga (Equal-to-the-Apostles Princess Olga).

PREPODOBNUIY/PRED: "Venerable"; frequently used of monks and nuns such as

Prepodobnuiy Sergiy (Sergei, Sergius) or Prepodobnaya Marfa (Martha). Do not confuse it with Pravednuiy.

PRAVEDNUIY/PRAD: "Righteous"; often used of Biblical figures such as Pravednuiy Iosif (Joseph) or Pravednaya Anna (Anne).

PROROK/PRO: "Prophet"; used often of Old Testament prophets such as Prorok Avvakum (Habbakuk) and of the New Testament Prorok Ioann Predtecha (John the Forerunner, i.e. the Baptist (Krestitel).

MITROPOLIT/MITROP: "Metropolitan"; used of those holding that office in the Church, such as Mitropolit Iona (Metropolitan Jonah).

EPISKOP/EP: "Bishop"; used of bishops such as Episkop Arseniy (Arsenius).

ARKHIEPISKOP/ARKHIEP: "Archbishop."

SVYATITEL/SVYATIT: "Enlightener"; may be used as an alternate to the term episkop.

TSAR: "Emperor"; used of rulers such as Tsar Konstantin (Constantine). The feminine TSARITSA is used of such as Tsaritsa Alexandra (Empress Alexandra). One may occasionally encounter the terms Tsarevna, meaning "daughter of the Tsar" and Tsarevich, meaning "son of the Tsar."

CHUDOTVORETS/CHUDOT: "Wonder-worker"; this title is given miracle-working saints such as Nikola Chudotvorets (Nicholas the Wonder-worker."

BEZSREBRENNIK/BEZSRE: "Unmercenary"; used of those such as the physician Panteleimon, who performed medical services without asking recompense.

STOLPNIK/STOLP: "Stylite"; used of ascetics who lived at the top of a pillar.

ZATVORNIK/ZATV: "Hermit"; used of recluses who lived solitary lives.

IGUMEN/IG: "Abbot"; used of the head of a monastery. The feminine form is IGUMENYA, "Abbess."

DIAKON/DIAK: "Deacon"; used of those who perform that office in the Church.

MNOGOSTRADALNUIY: "Much-Suffering."

STRASTOTERPETS: "Passion-Bearer."

A "CONDENSED" ICON TITLE (see illustration p. 310)

The title of an icon type was usually painted in ornate letters above, below, or beside the image. Many were written in a special calligraphic form that elongated some letters and shortened others. All were joined or pushed together to create what I call "condensed inscriptions." This joined (vyaz) form is very beautiful but sometimes makes reading difficult. Once the simple principle is understood, one will have no great difficulty in deciphering this fascinating Russian calligraphic form.

When reading titles and inscriptions, remember to note curved lines above some words, indicating abbreviation. Also notice any small letters written above words, with or without the curved line; such letters are to be inserted into the abbreviated word.

Do not expect a letter to always look exactly the same. Russian calligraphers were

very creative! And be aware that some titles and inscriptions on very late icons may be in Russian rather than Church Slavonic. With a little experience the reader will soon recognize such variations.

Here is the inscription found in the accompanying illustration: PRINESENIE [The Bringing] OUBROUSA [of the Cloth] NEROUKOTVORRENAGO [NOT MADE BY HANDS] — "The Bringing of the Cloth 'Not Made By Hands.' " The inscription is shown first as written; below it is shown again, divided into its component letters.

AN ORNATE CONDENSED INSCRIPTION (see illustration p. 311)

This example is typical of many found in late Russian icons. It reads GD VSEDER-ZHITEL, in full GOSPOD VSEDERZHITEL — "The Lord Almighty." The "extra" letters at the end of each word, not shown in the transcription, are "soft signs" affecting the preceding consonants. In this book a simple form of transliterating Church Slavonic is used, in which hard and soft signs are generally not indicated because this book is oriented toward reading basic Slavonic rather than perfect pronunciation. Those who wish to pronounce Church Slavonic accurately would do well to buy a copy of the Liturgy of John Chrysostom in an English-Slavonic bilingual edition, adding to this a recording of the liturgy, so that one may coordinate the printed words with the sounds of the liturgy as it is sung. Suppliers of such materials can often be located by calling any Orthodox Church.

Scholars use a system of transcription often confusing for beginners. It is not used here because it makes learning basic Church Slavonic initially more difficult.

"Icon readers" soon become accustomed to the many variations in the spelling of icon titles, and to the differences between Church Slavonic and Russian forms. The "Joy of All Who Suffer" icon of the Mother of God, for example, is Vsem Skorbyaschim Radost in Slavonic, but Vsekh Skorbyaschikh Radost in Russian. Type names of the Mother of God often end in " -iya" in Slavonic ("Kazanskiya"), but in Russian they end in " -aya" ("Kazanskaya"). This book generally uses the Russian form simply because it has become so established in icon literature; nonetheless the " -iya" ending is used on the majority of icons.

пѣснь оу гꙋсли нⷬукотворенаго

грⷯесенїе оубрꙋса

нⷬерꙋкотворен̾ наго

A FINAL WORD

We have reached the end of our overview of Russian iconography. Some readers may find the amount of information overwhelming; others may wish I had added just another bit here or there. To the first I say take only what you need; to the second I wish enjoyment and success in further exploration.

I hope readers will find the information I have provided useful, and that they will look forgivingly on any errors or oversights.

SELECTED BIBLIOGRAPHY

Archbishop Benjamin of Pittsburgh and West Virginia, Editor, BOZHESTVENNAYA LITURGIIA SV. IOANNA ZLATUSTAGO/THE DIVINE LITURGY OF SAINT JOHN CHRYSOSTOM Alumni Association of the Russian Theological Seminary of North America

Felicetti-Liebenfels, Walter, GESCHICHTE DER RUSSISCHEN IKONEN-MALEEREI Akademische Druck und Verlagsanstalt Graz, 1972

Filimonov, G.D. (editor), SVODNYI IKONOPISNYI PODLINNIK XVIII VYEKA Vyestnik obshchestva drevne-russkago iskusstva Moskovskom lublichnom museie, 1876

Haustein, Dr. Eva, IKONEN UND KIRCHENSCHAETZE: 13.-19. JAHRHUN-DERT, Burg Rode Herzogenrath, 1987

Heuser, Angela, IKONENMALEREI HEUTE, Verlag Aurel Bongers, Recklinghausen, 1988

Hordynsky, Sviatoslav, THE UKRAINIAN ICON, Province Association, Philadelphia Pa., 1973

Ivanov, Father Vladimir, RUSSIAN ICONS, Rizzoli International Pubs. Inc., New York, 1988

Kondakov, N.P., IKONOGRAFIIA BOGOMATERI, Tovarishchestvo P. Golike i A. Vilborg, Saint Petersburg, 1911

Kondakov, N.P., LITSEVOI IKONOPISNYI PODLINNIK, tom I: IKONOGRAFIIA GOSPODA BOGA I SPASA NASHEGO IISUSA KHRISTA, Toverishchestvo P. Golike i A. Vilborg, Saint Petersburg, 1905

Kutschinski, Stanislaw, and Jochen Poetter, RUSSISCHE IKONEN UND KULT-GERAET AUS ST. PETERSBURG, Staatliche Kunsthalle Baden-Baden, 1991

THE LIFE OF THE VIRGIN MARY, THE THEOTOKOS, Holy Apostles Convent and Dormition, Skete, Buena Vista, Colorado, 1989

Meyer, Thomas, 1000 JAHRE CHRISTLICHES RUSSLAND, Verlag Aurel Bongers, Recklinghausen, 1988

THE NORTHERN THEBAID, St. Herman of Alaska Brotherhood, Platina, Cal., 1975

Poselyanin, E., BOGOMATER', Knigoizdatel'stvo P.P. Soikin, St. Petersburg

SBORNIK' IZOBRAZHENII IKON PRESVYATYIIA BOGORODITSY, Knigopro-davtsa Manukhina, Moscow, 1866
(Reprinted by Izdanie Bratsva prep. Iova Pochaevskago Montreal, 1980)

Priest Pimen Simon, Pr. Theodor Jurewicz, Hieromonk German Ciuba (editors), DREVNEPRAVOSLAVNYI MOLITVENNIK/OLD ORTHODOX PRAYER BOOK, Russian Orthodox Church of the Nativity of Christ (Old Rite), Erie, Pa., 1986

Puhalo, Rev. Lev and Vasili Novakshonoff, GOD'S FOOLS, Synaxis Press, Chilliwack, B.C. Canada; second edition, 1981

Puhalo, Rev. Lev, and Vasili Novakshonoff (trans.), THE KIEV CAVES PATERIKON, Synaxis Press, Chilliwack, B.C. Canada, 1980

Skrobucha, Heinz, DIE IKONENMALEREI: TECHNIK UND VORZEICHNUNGEN, Verlag Aurel Bongers, Recklinghausen, 1978

Skrobucha, Heinz, IKONENMUSEUM RECKLINGHAUSEN (catalog), Verlag Aurel Bongers,Recklinghausen, 1981

Smirnova, Engelina, MOSKAUER IKONEN DES 14. BIS 17 JAHRHUNDERTS, Aurora Kunstverlag, Leningrad, 1989

Sokolof, Archpriest D., A MANUAL OF THE ORTHODOX CHURCH'S DIVINE SERVICES, Holy Trinity Monastery, Jordanville, N.Y., reprint 1975

Tal'berg, H., PROSTRANNYI MIESIATSESLOV RUSSKIKH SVYATYKH I KRATKIIA SVIEDIENIIA O CHUDOTVORNYKH IKONAKH BOZHIEI MATERI, Holy Trinity Monastery, Jordanville, N.Y., 1951

Uspenskiy, M.I. and V.I., DREVNIIA IKONY IZ SOBRANIIA A. M. POSTNIKOVA, St. Petersburg, 1899

Uspenskiy, M.I. and V.I., MATERIALY DLIA ISTORII RUSSKAGO IKONOPISANIIA, St. Petersburg, 1900

Uspenskiy, M.I. and V.I., OBRAZTSY DREVNE-RUSSKOI IKONOPISI, St. Petersburg, 1899

Uspenskiy, V.I., PEREVODY S DREVNIKH IKON IZ SOBRANIIA A.M. POSTNIKOVA, St. Petersburg, 1899

The Nun Taisiya, ZHITIYA SVYATUIKH: 1000 LYET RUSSKOY SVYATOSTI (2 vols.), Holy Trinity Russian Orthodox Monastery, Jordanville, N.Y., 1984

AN UPDATED CAVEAT

In the time it took to write this book the number and nature of icons available in the United States have changed significantly. There are more dealers, more buyers, and many more icons. Unfortunately the increased demand has led to authenticity problems.

Until very recently, buyers could feel relatively safe in purchasing icons costing $2,000 and under. Sadly, that is no longer true. There has been a sudden increase of interest in icons of the 18th to early 20th Century, and an increase also in the number of "doctored" icons and outright fakes.

A "doctored" icon is one which, though authentic, has suffered damage sufficient to lower its monetary value. To raise the value lost paint is replaced, sometimes skillfully, sometimes crudely. The intent is often to deceive the buyer into thinking that

the icon is relatively undamaged. Sometimes icons sold are more than 50% repainted. They may look great, but they are no longer to be considered old. The difference between restoration and "doctoring" is that restoration is done with honest intent to preserve an old icon. "Doctoring" is done to deceive for monetary gain.

Icon buyers must now not only beware of "doctoring," but also of the presence of outright fakes — new icons, often beautifully painted, but offered as old images. A fine new icon in an old style can be bought at present in Russia for under $100. That makes it worthwhile for the dishonest to artificially age such icons and thereby greatly increase the asking price.

New icons are aged in several ways — by giving them artificial crackling (*craquelure*) of the paint surface (which occurs naturally as gesso and paint age over a period of one hundred years and more), by artificially darkening the paint surface and panel, by "distressing" the icon with candle burns and obvious but minor restoration, and significantly, by buying up authentic old icons that are too damaged to restore, removing the paint and gesso, and painting a new "old" image on the surface, resulting in a fake image on an authentic panel. Not only are new icons made to look old, but old icons are altered to make them look even older.

Ornamental metalwork added to icons is also part of this unfortunate trend. A completely new but apparently old metal basma is often nailed on an icon that did not have one originally. The fake basma adds the impression of age and frequently covers severely-damaged areas, as does metalwork added to the surface of the image. New *rizi* are being placed over icons to disguise damage and increase value. Some are stamped with forged silver marks — fake dates, fake hallmarks, fake silver grade, and fake makers' names. *Rizi* are also being electroplated to add a thin layer of silver or even gold.

Old *rizi* are sometimes added to new icons of the same size and image, a practice made possible by the standardization of patterns and size common in Old Russia. So an icon of the Kazan Mother of God may be a new forgery covered by an authentic old *riza*.

"Enriching" is also practiced. An interesting but rather ordinary 19th-Century icon may be "enriched" by adding copious gold highlights and lines to the garments of the saints, or by adding a brilliant gold *svyet* to an icon that had either a painted or badly-damaged *svyet*. Many saints bear newly-added decorative halos.

New cast metal icons are also a problem. Cast from old examples, they are very difficult to distinguish from authentic pieces. Some are created legitimately to sell at fair prices as new religious objects, but the unscrupulous will offer new casts as antique. Some plain examples, both new and old, are being "enriched" by fired-on decorative enamel, etc.

One must also be wary of dates on icons. It is a simple matter to paint a 17th-Century date on a 19th-Century icon, or to paint an 18th-Century date on a forged new icon.

All these examples of flim-flam are not a new phenomenon. Much thought and wile was given to forging "Pre-Nikonian" icons for Old Believer collectors long before the

fall of the Romanov Dynasty. Now that icons of the last three hundred years have been discovered by Western enthusiasts, all the skills of old Russian fakery, as well as new variations, are being practiced vigorously.

Most of these fakes can be recognized by careful examination. It is helpful to buy from dealers who offer a return policy if, after examination, the icon does not prove to be "right."

It is, however, most important to keep in mind the reverence in which Orthodoxy holds the icon and the central position it occupies in the Orthodox home. For the Orthodox believer the value of the icon is not at all a monetary one.

Color Plates

Cover: *SVYATUIY PREPODOBNUIY SERAPHIM SAROVSKIY CHUDOTVORETS*
"The Holy Venerable Seraphim of Sarov, Wonderworker." Seraphim (1759-1833) is the most renowned 19th century saint. He was canonized or "glorified" on July 19th, 1903. The arched "field" and colorful incised border decoration are characteristic of icons produced near the turn of the 20th century.

Page 5: *BOGOYAVLENIE GOSPODNE*
"The Theophany [Baptism] of the Lord." This example preserves early stylized elements while incorporating fluidity of line borrowed from the West. Late 18th Century.

Page 29: *SVYATUIY NIKOLA CHUDOTVORETS*
"Holy Nicholas the Wonderworker." There are countless icons of this popular patron of Old Russia. Here he blesses with fingers held in the position favored by the Old Believers. Circa 1700.

Page 88: *UVYERENIE SVYATAGO APOSTOL FOMUI*
"The Convincing of the Holy Apostle Thomas." This is the touching of the wound of Christ by Thomas, who doubted the Resurrection. 19th Century, preserving 17th century style.

Page 153: Clockwise from upper left: *[IZBAVLENIE] OT BYED STRAZHDUSHCHIKH PRESVYATUIYA BOGORODITSUI* — "The Deliverance of the Suffering from Distress Most Holy Mother of God" (sometimes written as *OBED STRAZHDUSHCHIK*, "The Supper of the Suffering"); *UTOLI BOLEZNIY PRESVYATUIYA BOGORODITSUI* — "The Sooth the Ills Most Holy Mother of God"; *NECHAYANNAYA RADOST PRESVYATUIYA BOGORODITSUI* — "The Unexpected Joy Most Holy Mother of God"; *VZUISKANIE POGIBSHIKH PRESVYATUIYA BOGORODITSUI* — "The Seeking of the Lost Most Holy Mother of God." "Four-field" icons comprising various types were very popular in the 19th century.

Page 202: *ROZHESTVO PRESVYATUIYA BOGORODITSUI*
"The Birth of the Most Holy Mother of God." Anna, mother of Mary, reclines and is served by attendants as midwives wash the newborn child Mary. This example adds depictions of Joachim and Anna praying (top), Joachim seated (Lower left) and Joachim and Anna embracing at the Gate called "Golden."

The buildings in this example preserve a late 17th-Century form. Mid-19th Century.

Page 246: *TIKHVINSKIA PRESVYATUIYA BOGORODITSUI*
"The Tikhvin Most Holy Mother of God." This is one of the famous "Wonderworking" icons that have been re-created endlessly. The border saints are the "Holy Guardian Angel" and *MUCHENITSA STEFANIDA*, the female Martyr Stefanida, commemorated on November 11. Stefanida blesses with her fingers held in the manner of the Old Believers, by whom this example was probably painted. 18th Century.

Page 296: *NERUIDAY MENYE MATI*

"Weep Not for Me, Mother." This is the Russian *Pietà*. The border *figures are SVYATUIY ANGEL KHRANITEL*, "The Holy Guardian Angel," and *AGIOS APOSTOL IAKOV ALFEEV*, "The Holy [Greek form] Apostle Jakob (James) Alphaeus." 19th Century.